CARTOON AMERICA

CARTOON AMERICA

Harry Katz

COMIC ART IN THE LIBRARY OF CONGRESS

Abrams, New York

CONTENTS

FOREWORD

James H. Billington, Librarian of Congress

Cartoon art, a truly democratic art for a democratic society, has always played a special role in America. Cartoons have helped spark revolution, sway election campaigns, reveal corruption, and promote reform. They educate and entertain, inform and enlighten. Artful or awful, they are the graphic snapshots of our times, spontaneous and accessible to all.

Caricatures and cartoons often depict the principal events and figures of the day. Like jazz and baseball, they are an indelible and indigenous part of American culture. In the best hands they become topical and timeless, unique and universal.

Usually created under short deadlines for reproduction in a commercial format such as newspapers or magazines, they reflect their creator's attempts to enlighten, amuse, provoke, or persuade. They provide insight into universal features of human nature, and make complex social and political issues comprehensible.

In the effort to express themselves and engage their audience, cartoonists often produce original works of extraordinary historical and artistic interest, shedding vivid light on their times and, in retrospect, our own.

Few people realize that the Library of Congress is home to one of the world's great collections of original cartoon art. These representative works and acknowledged masterpieces by generations of great graphic artists include numerous "debuts," "earliest appearances," and "one-of-a-kind" pieces seen previously in museum exhibitions and historical publications. Looking through these riches, one has a sense of endless plenty–a cornucopia of cartoon treasures and great creative genius–drawn from the American past and the Library of Congress' superlative collections.

The Library began to collect and preserve cartoons and caricatures within decades of its founding in 1800, recognizing their value as vehicles of social and political commentary and as original works of art.

In recent years, the Internet has evolved into a virtual global classroom, and the Library is in the vanguard of educational contributors to the World Wide Web. The cartoon components of our award-winning Web site (*www.loc.gov*) are among our most popular. Teachers tell us how helpful cartoons can be in teaching history and social studies to their students, while professional scholars routinely mine our copious cartoon collections for visual documents of world events and issues.

The Library has also become an international center for cartoon studies: administering the prestigious Swann Fellowship, which offers a generous stipend to graduate students; supporting a state-of-the-art cartoon conservation and cataloging program; and providing online access to tens of thousands of original prints and drawings, as well as numerous books and exhibitions produced by our curatorial staff.

Recently the Library's already outstanding cartoon holdings have been vastly enhanced by the acquisition of several notable collections including the Art Wood Collection–the most comprehensive private collection of original, historical American cartoon art known to exist. The collection was assembled over a lifetime by J. Arthur Wood, Jr., a great friend to the Library, whose interest, experience, and expertise as a cartoonist drove him to collect this magnificent legacy of original art. Comprising 32,000 works by more than 3,000 artists, the Art Wood Collection includes a comprehensive array of political cartoons, caricatures, comic strips, humor cartoons, illustrations, and animation cels. An award-winning professional cartoonist in his own right, Art Wood began gathering original cartoon art as a youth, contacting past masters and contemporary colleagues seeking examples of their work. Over time he compiled an extraordinary collection encompassing virtually every aspect of the genre and every era of our nation's history. Overwhelming in size and scope, the Art Wood Collection will engage scholars and attract the public for generations to come.

When his longstanding effort to establish a museum gallery for his world-class collection ended in 1996, Art Wood turned to the Library of Congress to preserve, promote, and present to the

OPPOSITE: Gluyas Williams, "National Capital. Library of Congress," from *The New Yorker* (March 20, 1943)

Art Young, "World of Creepers," from *Life* (1907)
Art Young began his career as a conservative, mainstream cartoonist but soon became one of the country's most committed socialists. During World War I he, along with Boardman Robinson and Henry Glintenkamp, became the first and only cartoonists ever indicted for sedition by the U.S. government (the charges were later dropped). Here, in a transition piece for the first *Life* magazine, a journal then devoted to graphic humor and satire, Young comments on what he perceives as the meek modern character of men and women.

public the massive group of drawings he had acquired. Until recently, Art lived in the D.C. area. He had worked at the Library during his high school years, and knew of its cartoon riches and outstanding programs in the preservation and study of original cartoon art. Working closely with our curatorial staff, Art offered his magnificent collection to the Library for a fraction of its appraised value, donating the vast bulk of drawings in honor of his colleagues who had made gifts of their works to him in support of his museum dream. With financial support from Fred Krimendahl, a member of the Library's Madison Council, we were able to acquire this amazing assemblage and secure it in its entirety for the nation and for future generations. We are indebted to both gentlemen for their outstanding generosity to the Library and its collections.

Examined within the context of the Library's other cartoon holdings, the Art Wood Collection shines as a jewel in a crown, glowing with quality and creativity, shedding light on our history and ongoing fascination with graphic humor and popular culture. There are other jewels as well, however. In the 1970s, New York ad man and Broadway promoter Erwin Swann left his fine collection of almost 2,000 caricatures and cartoons to the Library. More recently the Library acquired the George Sturman Collection of American comic-strip drawings, as well as the Ben and Beatrice Goldstein Collection, and the Sam Willner Collection, each of which includes hundreds of seminal political works by leading American artists. It is acquisitions such as these that keep our collections and institution growing and vital, a treasure chest of human history, knowledge, ingenuity, and achievement, keeping pace with public interest and contemporary scholarship.

Cartoon America draws from all of the diverse cartoon-related collections in the Library, housed principally in the Prints and Photographs Division, the Rare Books and Special Collections Division, and the Serial Record Division. The Library's cartoon collections are unsurpassed in depth and scope, spanning five centuries and the globe. This book features a host of highlights encompassing two hundred and fifty years of American cartooning, from Benjamin Franklin's crude yet ingenious political woodcuts of the 1750s through the moving and meaningful responses of cartoonists and

JAMES H. BILLINGTON

Paul Revere, "The Bloody Massacre" (March 28, 1770)

Al Hirschfeld, "The Stage Door Canteen Reopens" (1944)
This is at once a fine example of the artist's high style and an exuberant evocation of night life in New York City during World War II. The Stage Door Canteen was established by the American Theatre Wing and the USO during the war to entertain soldiers free of charge. The bearded sailor at right with his back to the viewer is Hirschfeld himself, dancing with his first wife, the actress Dolly Haas.

illustrators to the terrorist attacks of September 11, 2001. No other institutional collections speak so eloquently of our nation's creativity and resilience, our desire to educate and entertain, laugh at our quirks and foibles, or challenge our political leaders and public figures to do better.

As you will see, *Cartoon America* is not just about cartoons and caricatures. It chronicles our history as a nation, our dreams and aspirations, our collective memory and shared past–the icons of popular culture we all grew up with and remember from our earliest years. Common ground we all appreciate and learn from. I am truly delighted to bring to you this engaging and insightful exploration of great comic art treasures from the Library's collections, selected and discussed by a distinguished roster of writers, creators, collectors, curators, and historians. Prepare to laugh, wince, and wonder at the best of the best of American cartoon art.

OPPOSITE: Miguel Covarrubias, "The Paul Whiteman Cycle" (1924)
The young, handsome Mexican caricaturist Miguel Covarrubias took America by storm in the early 1920s. By 1925, critic Carl Van Vechten wrote, "At the present moment, Miguel Covarrubias is about as well known in New York as it would be possible for anyone to be." Here, Covarrubias brilliantly employs the Cubism of Braque and Picasso to evoke the syncopated rhythms of modern jazz in this stunning caricature portrait of musician and conductor Paul Whiteman with his signature viola.

JAMES H. BILLINGTON

HE MADE SOME HOOTCH AND TRIED IT ON THE DOG.

A.B.Frost

PREFACE

Harry Katz

American cartoon art evolved from varied historical sources: funny vignettes from the margins of illuminated medieval manuscripts; Renaissance grotesques drawn by Leonardo da Vinci and Pier Leone Ghezzi; the English and French print satirists of the eighteenth century, nineteenth-century narrative continuity strips by Thomas Rowlandson and Wilhelm Busch, and the sensational broadsides of Mexican populist printmaker José Guadelupe Posada, to name a few. Yet America developed its own native talent early on, and cartoon art blossomed in the United States in the twentieth century with the development of commercial color printing and the subsequent creation of the modern editorial page, the newspaper strip, the comic book, Broadway and the vogue for celebrity caricature, *Vanity Fair* and *The New Yorker*, and Hollywood. We now look back on the legendary careers of Al Hirschfeld, Herb Block, Bill Mauldin, Dr. Seuss, Charles Schulz, Will Eisner, and so many other great recent American cartoonists, each of their lives a history lesson and an inspiration. Their drawings–day after day, year in and year out–take us to places we otherwise never would go.

I came to know their work well during the many years I served as graphic arts curator in the Prints and Photographs Division, which houses virtually all of the original cartoon drawings held in the Library of Congress. This book is the culmination of more than a decade spent caring for one of the world's best cartoon collections and sharing it with many of the country's most influential cartoonists and collectors.

At the Library I was part of a dedicated team of administrators, curators, and conservators supporting the production of numerous books and exhibitions featuring contemporary and historical cartoon art. I learned a great deal and met many wonderfully intelligent and creative people along the way.

The recent acquisition of Art Wood's spectacular collection more than doubled the Library's already outstanding cartoon art holdings, and provided the opportunity to publish a history of American cartooning featuring treasures from the Library's collections. Some of these treasures are in fact entire collections: for example, the Cabinet of American Illustration, formed during the Depression and comprising four thousand original drawings; hundreds of cartoon drawings by artists of *The New Yorker*; and thousands more by American political cartoonists from Thomas Nast to 2001 Pulitzer Prize-winner Ann Telnaes.

Amidst these collections are many individual items of singular interest, but there is one I'd like to mention here. It concerns one of the most moving experiences of my Library career. Several years ago, shortly after the publication of a newspaper article featuring the Library's original drawings for the comic strip *Peanuts* by the late Charles Schulz, my colleague Sara Duke and I were contacted by the sister of a woman named Elizabeth Swain. Miss Swain had seen the article and wondered if the Library might be interested in acquiring a manuscript letter written to her by Schulz in January 1955, just a few years after *Peanuts* debuted in American newspapers. Elizabeth Swain had initiated the correspondence by detailing in a letter to Schulz her disappointment with a new character he had introduced into the strip called Charlotte Braun, a female counterpart to Charlie Brown. Schulz responded to her critique, writing that "I am taking your suggestion regarding Charlotte Braun [and] will eventually discard her." He added, however, a warning that young Elizabeth Swain "will have the death of an innocent child" on her conscience. "Are you prepared to accept such responsibility?" He embellished his note with a drawing of little Charlotte Braun looking somewhat dismayed by the ax buried in her curly locks! The story took a sad turn when the sister told us that Elizabeth was dying and that this letter was a treasured possession, one she dearly wanted preserved in the national collections. In 2000, after Miss Swain had passed away, the illustrated letter did arrive at the Library, fulfilling her wish. Charlotte Braun, Elizabeth Swain, and indeed, Charles "Sparky" Schulz, one of the most compassionate and thoughtful people I've known, are now memorialized together in the Library of Congress collections.

OPPOSITE: A. B. Frost, "He made some hootch and tried it on the dog." (1880s)

Charles Dana Gibson, "Summer Sports," from *Life* (June 2, 1904)
"Gibson Girls" were the ideal of feminine beauty in turn-of-the-twentieth-century America. Yet they
were not the passive beauties one might expect—Gibson consistently imbued his women with keen
intellects, musical talents, sporting skills, and, as shown here, the ability to keep helplessly enchanted
young men constantly dangling on the end of a very long string.

OPPOSITE, TOP: Walt Kelly, *Pogo* (May 5, 1953)
Pogo creator Walt Kelly was the first modern cartoonist to introduce explicit and spe-
cific political caricature and commentary into a nationally syndicated comic strip. In
May 1953, he created the character of Simple J. Malarkey, an evil-minded wildcat
with the same dark, menacing eyebrows and heavy five-o'clock shadow found on the
face of United States senator Joseph R. McCarthy, whose ruthless tactics and
unfounded attacks against alleged American Communists wreaked havoc on the
personal lives and political careers of numerous citizens.

OPPOSITE, BOTTOM: Garry Trudeau, *Doonesbury* (November 10, 1970)
Garry Trudeau brought pot and politics into the funny pages, carrying on good work
begun decades before by Walt Kelly and Jules Feiffer. This strip appeared just two
weeks after *Doonesbury*'s debut in American newspapers. Trudeau later grudgingly
confessed, "Yes, dammit. I'm the model for Michael."

As Brian Walker relates later in this volume, every picture tells a story. In the case of comic art at the Library, every acquisition tells a story as well, and this book is filled with them. In fact, most of the artwork discussed and illustrated in this book came to the Library as gifts, often selected for the national collections by the artists themselves as representative of their best work. Bill Mauldin donated more than 1,700 drawings, including the one for which he won the 1958 Pulitzer Prize for editorial cartooning. Charles Dana Gibson chose dozens of works from his personal collection, while Jessie Willcox Smith gave all of her magnificent illustrations for *The Water-Babies*, a classic of children's literature. Walt Kelly placed 130 of his favorite *Pogo* drawings at the Library, including his influential caricatures of Senator Joseph McCarthy from the early 1950s. Garry Trudeau has made numerous gifts throughout his remarkable career, representing *Doonesbury* from 1970 to the present. These examples represent the thousands of drawings given by generations of great American graphic artists, or by their families and heirs.

Behind every great cartoon is a great cartoonist. In spring 2000 the Library named three Living Legends–Al Hirschfeld, Herb Block, and Jules Feiffer–in recognition of their remarkable lifelong

contributions to American culture. Each of these artists enlightened generations of Americans with their own particular genius: Hirschfeld defined the art of theatrical caricature, Herb Block led the nation's editorial cartoonists, while Feiffer's efforts as social critic and satirist–through cartoons, books, plays, and films–continue unabated to this day. All have made important gifts to the Library's collections, and all have been featured in exhibitions.

The masters of comic art represented in this book are as diverse as their works and equally as compelling. Two major early influences on American cartoon art, William Hogarth and James Gillray, both Englishmen working primarily in the eighteenth century, established high standards for the genre, while another important source, Honoré Daumier, active in nineteenth-century France, outraged his king, Louis-Philippe, with graphic satire that belittled the monarchy and its achievements. At the turn of the twentieth century in America, Rose O'Neill did the unthinkable for a woman, carving out a successful career as a cartoonist while exhibiting more sophisticated work in the Paris salons. Miguel Covarrubias arrived in New York from his native Mexico in 1923 and astounded audiences with his pointed caricatures. Bill Mauldin brilliantly championed the American foot soldier during World War II as Oliver Harrington, an African American, labored in obscurity, his cartoon genius and exceptional draftsmanship was only revealed to a widespread audience decades later, at the end of his life.

The work of these artists has been studied before, but each individual's sheer abilities is fully revealed only through the study of their *original* art. Through examination of these originals we gain insight into their working methods and the technical limits imposed on them by time, place, and mode of publication. The earliest printing techniques, involving copper plates, lithographic stones, and woodblocks, reproduced images with painstaking labor that took days or weeks. Caricatures, cartoons, and illustrations appeared either as separate sheets for sale by printsellers or within periodicals that audiences could savor over time; artists created more complex images because audiences had time to read and learn from them. In the twentieth century, photomechanical techniques permitted reduction from the original. In general, artists began to create larger, simpler drawings that could be reduced and still retain their impact, as well as accommodate the ever-more fleeting attention span of modern readers. Such diversity of methods, materials, and formats, however, does not obscure the shared legacy of graphic wit, creativity, and ingenuity, that is so amply represented in the Library of Congress collections.

To those who might wonder why the Library of Congress should devote so much time and energy to cartoons, to me it seems vitally important. Cartoonists in America enjoy unprecedented and unequaled protection and latitude under the Constitution. They can legally say what other commentators may not. It is remarkable then to find at the heart of American political life, in the Congressional Library, this profusion of pictorial humor and satire created by legions of comic artists, critics, and dissenters of all eras, preserved and protected by the national government. The symbolism is clear: a strong democracy thrives on creativity and discourse, diversity and dissent. Cartoons can be powerful weapons of education, progress, and reform: they may make us laugh but they also help keep us free.

OPPOSITE: Walt Disney Studios, *Snow White and the Seven Dwarfs* (1937)

HARRY KATZ

For Art and Sally Wood and cartoonists everywhere

EDITOR'S ACKNOWLEDGMENTS

This book encompasses a vast array of art and talent and I am indebted to a host of good friends and colleagues for their help in bringing it all together.

At Harry N. Abrams, I am deeply grateful to Eric Himmel and Deborah Aaronson; they believed in the book and gave it big, beautiful life. Charles Kochman sharpened my decisions, matched my enthusiasm, overtaxed my energy, and made this a much better book in every way. Thanks as well to Isa Loundon. And to Laura Lindgren, who made all the right decisions in her elegant design.

In the Library of Congress's publishing office I want to thank director Ralph Eubanks for taking me in and supporting this project from its inception; also, Peggy Wagner, Anjelina Keating, Linda Osbourne, and Aimee Hess. Thanks to Ed Owen for photographing many of the drawings reproduced in the book.

I was blessed with great colleagues during my tenure at the Library and want to thank the following for their contributions to this book. In the Prints and Photographs Division, chief Jeremy Adamson and his assistant Lori Watlington cleared administrative hurdles and facilitated my work. Without the assistance and expertise of Library curators Sara Duke and Martha Kennedy the book simply could not have been done. I also want to thank former colleagues Maja Keech, Woody Woodis, Richard Herbert, and Lucia Rather for their contributions. Thanks as well to my coffee buddies: Phil Michel, Gay Colyer, and Elena Millie, curator emeritus. In the conservation office I enjoyed working with Holly Krueger, Lida Husik, and Elmer Eusman.

The Library's cartoon collections were significantly enhanced under the stewardship of James H. Billington, who has always appreciated their potential as classroom teaching tools. Along with the Librarian I want to thank a number of past managers for their support: Steve Ostrow, Bernie Reilly, Winston Tabb, and Diane Kresh.

Much of my thinking for this book came from discussions I had over several years with Ed Sorel about plans for another book that we never completed. I am grateful to Ed for all those conversations. Thanks also to Jules Feiffer, David Levine, Brian Walker, Pat Oliphant, Draper Hill, and Jerry Robinson. Special thanks to Louise Kerz Hirschfeld and David Leopold. And to Wendy Wick Reaves, curator of prints and drawings at the National Portrait Gallery, and Lucy Caswell, founder and curator of the Cartoon Research Library at the Ohio State University.

WHO ARE YOU LOOKING AT?

I wish to thank all of the artists and writers who contributed their illustrations and essays to the book–the lineup of talent and topics is impressive and unprecedented.

Thanks to Richard Williams for his clever, lovely book cover painting, now part of the Library's permanent collections. My deepest appreciation to Susie MacNelly and MacNelly estate archivist Philip Rosemond for arranging a gift of Jeff's drawings to the Library, and to Pat McDonnell and Karen O'Connell for their wonderful, timely gift of drawings for the book.

Thanks to the Swann Foundation and the Swann advisory board for their support of cartoon-related programming at the Library of Congress. The Swann Collection remains at the heart of the Library's ongoing program in the preservation and study of cartoon art.

Finally, at the end of a long, hard day looking at cartoons, I turn to my family for love and support: my wife, Annie; son, Devereux; mother-in-law, Charlotte Aladjem; and father, Arthur Katz.

ABOVE: David Claypoole Johnston, *Scraps* (1832)
An undeservedly obscure comic artist, David Claypoole Johnston created a delightfully urbane annual of humor and satire during the 1830s called *Scraps*, based on a similar title published in England by Robert Cruikshank.

OPPOSITE: Detail, Cliff Sterrett, *Polly and Her Pals* (1933)

A Cartoon Odyssey

J. Arthur Wood, Jr.

I love cartoons, and as a child I learned to read stretched out on the floor scanning the comics. My grandmother in Virginia subscribed to the Sunday papers and I clipped all my favorites–*Maggie and Jiggs*, *Flash Gordon*, *Prince Valiant*, and others, filing them safely in large cardboard boxes for reference. When I was twelve I wrote all of the leading cartoonists, asking for an original drawing. To my delight most did a special sketch or sent along an original daily or Sunday page. Ham Fisher, creator of *Joe Palooka*, wrote me a long hand-written letter advising me to send postage when contacting others. From then on, I did.

At that time, most of the cartoonists worked at a newspaper or syndicate office lined up in individual studios. It was therefore possible to meet a number of artists at one time. In New York, the newspapers and syndicates were in close proximity. This made it easy to go from one to another. Before long, I had met a large number of cartoonists and syndicate executives. Consequently, with frequent visits I became close friends with many in the business.

In addition, to broaden my horizons, a lovely cousin of mine, Aleen Buchanan, whose stage name was Tony Stuart, added a helping hand. She was a model for many of the famous illustrators and a dancer in Broadway musicals with Vera Zorina and Ray Bolger. She gave me a booklet with the addresses and private phone numbers of every noted illustrator. The first one I got to know well was James Montgomery Flagg. He generously called Charles Dana Gibson, Howard Chandler Christy, Dean Cornwell, John Gannam, Arthur William Brown, Harrison Cady, Gilbert Bundy, and a few others, to introduce me and lay the ground for a personal visit. I followed up on all of them to add an original to my growing collection.

I also made the rounds of the major New York dailies and every syndicate in town. Discovering that when the drawings accumulated–as many as 365 per artist per year–the syndicates confiscated and destroyed the originals to make space for the oncoming work, I was horrified! In short order, I met with the top executives to plead with them to put aside a group of originals for my collection. All the syndicates I contacted agreed. I volunteered to go to New York to choose the best examples, or have the syndicate do the same and mail the drawings to me at my expense. On numerous occasions I did go to the Big Apple to select originals on file, or the syndicates packaged the art and sent it to me in Washington.

In the Navy in World War II, I was assigned to work as a cartoonist for *All Hands Magazine* and the worldwide syndicate Ships Editorial Service. Here, with other staff cartoonists–nationally

ABOVE: Bud Fisher, *Mutt and Jeff* (1913)

OPPOSITE: George McManus, *Bringing Up Father* (1912)

Charles Dana Gibson (c. 1905)

James Montgomery Flagg (1920s)

Alex Raymond, *Flash Gordon* (September 1, 1935)

known artists also creating many types of artwork–I was able to salvage their illustrations, which would have otherwise been thrown away.

In a visit to a friend at the Office of War Information, I passed in the hall a large trash basket crammed full of cartoons done for the War Bonds campaign. I carefully removed each drawing and stacked them in neat piles on the floor. Included were splendid drawings by Rube Goldberg, Daniel Fitzpatrick, and Bud Fisher. Then I went to see

the head of the department, a gracious gentleman by the name of Burns Lee, who agreed it was necessary to preserve these originals. He saved the ones in the trash, as well as future ones, for my collection.

The Smithsonian asked me to organize a lecture series on graphic art to bring prominent practitioners to the nation's capital. For a number of years I moderated Giants of Cartoon Art, featuring leading cartoonists and illustrators, Pulitzer Prize-winners, and caricaturists.

I also lectured on caricature at the National Portrait Gallery, which put me in close touch with the Washington art community.

With the encouragement and help of many noted cartoonists and illustrators, gallery owners, art authorities, local foundations, and political leaders, a cartoon gallery was established in downtown Washington, D.C., across F Street from the National Press Club and close to the White House. My collection formed the foundation for the new gallery, which was warmly received by the media and art community. Unhappily, lack of sustained funding caused the gallery to close after two-and-a-half years.

It was then that I turned to the Library of Congress, where I had worked in the summers for several years while attending high school. During the Library's bicentennial year, 2000, my donation of the collection was designated a "Gift to the Nation," presented to the American people and the national collection. Although some drawings I had purchased through the years were paid for by the Library, the overwhelming mass of drawings, more than 30,000, were an outright gift honoring the artists and illustrators who had so generously shared their talents and artwork with me through the years.

I hope you enjoy looking at them as much as I've enjoyed collecting them.

ABOVE, TOP: Walt Disney Studios, model sketch for *Snow White and the Seven Dwarfs* (c. 1937). Walt Disney built his empire on animated films, and *Snow White and the Seven Dwarfs* was his first full-length feature. It is listed on the National Film Registry compiled by the Librarian of Congress. This model sketch for the lovable little men is attributed to Gustav Tenggren, art director for the production.

ABOVE, RIGHT: Art Wood, "Memorial Day" (May 29, 1962)

OVERLEAF: George Herriman, *Krazy Kat* (April 1944). Herriman worked on these two strips, from the last week of unfinished *Krazy Kat* dailies, shortly before he died on April 25, 1944.

A CARTOON ODYSSEY

A Brief History of American Cartooning

Harry Katz

Benjamin Franklin created the first political cartoon published in America in 1754, urging the colonies under British rule to "Join, or Die" in defense against France and her Indian allies.

Franklin's America, conceived as a belligerent snake segmented but poised to strike, became an early emblem of national pride. In 1774 Paul

Benjamin Franklin, "Join, or Die," from *The Pennsylvania Gazette* (May 9, 1754)

Revere embellished the masthead of the patriotic journal *The Massachusetts Spy* with a snake fighting a British dragon and a year later, when the Revolutionary War broke out, the first Continental Navy Jack and Marine banners were emblazoned with the rattlesnake along with the battle cry "Don't Tread on Me." The English satirist James Gillray validated the image in 1782, portraying the British armies trapped within the coils of "The American Rattle Snake" to represent the surrender at Yorktown. More than 225 years later the symbol and accompanying warning are in use once again, targeting America's enemies in the war on terrorism.

Franklin's initial efforts were carried forward only haltingly as the independence movement gathered momentum. The earliest American cartoonists, emerging in the 1750s, were in earnest, and for the most part unfunny. Creating a new republic from a disparate group of colonies is hard work; no time for laughter and no market for it, either. Printers and publishers reached only a small audience of literate and enfranchised citizens, mostly in urban areas. Comic art appeared intermittently and sporadically as cheap woodcuts in monthly magazines or more laboriously and expensively engraved on copperplates to be issued for sale as individual prints.

It was the Revolutionary War generation, led by patriot and propagandist Paul Revere, who applied Franklin's lesson, using sensational text and vivid imagery to inflame public sentiment against British rule. A silversmith and engraver, Revere was also a popular printmaker and made a commercial killing depicting the Boston Massacre. He shamelessly copied his brother-in-law's sketch of the incident and issued a sensational portrayal of the redcoats as cold-hearted killers, when in fact they had been provoked into violence by an unruly crowd. Widely distributed throughout the colonies, Revere's Bloody Massacre print dramatically displayed the power, immediacy, and effectiveness of political art.

After the Revolution, American cartoonists produced precious few images satirizing George Washington and John Adams, reflecting collective national goodwill toward the heroes of the Revolution. Thomas Jefferson, however, was not exempt from controversy. He bore the brunt of numerous graphic invectives, signaling the vulnerability of American politicians, from the top down, to personal attacks and the vigorous good health of a democratic system founded on the principles of free speech and a free press. Native-born James Akin was one of the first cartoonists to satirize an American president and the Library's impression of his satire on

James Akin, "The Prairie Dog" (c. 1804)
Thomas Jefferson's controversial administration produced the first spate of American presidential caricatures, this one criticizing his decision to spend several million dollars on the purchase of Florida from Spain.

William Charles, "Josiah the First" (1812)

Akin, Charles, and their American contemporaries were all inspired by the work of their London counterparts. In fact, all Europe looked to London for satire as England's golden age was well under way by the time the U.S. Constitution had been signed. It was the Englishman William Hogarth who, between 1720 and 1760, revived the art of caricature from the Renaissance, elevating comic art to an unprecedented seriousness of purpose.

Hogarth defined and popularized caricature in England beginning in the 1720s. He was the first to introduce social and political commentary into the rarefied realm of British academic art, nervily balancing his wickedly humorous allegories on a tightrope between high art and low humor. He set the stage for cartooning in America both literally and figuratively, creating a repertoire of caustic comic characters often presented within curtained settings reminiscent of contemporary London theaters.

Hogarth's success opened the door to a new generation of print satirists who soon rejected his high-mindedness in favor of scathing commentary, pointed personal caricatures, and pure scatological outrage.

Jefferson's purchase of Florida from Spain is the earliest-known signed example of his work.

In the newly minted United States, with England sent packing and the Constitution in place, Americans began to enjoy "life, liberty, and the pursuit of happiness" and graphic humor edged warily into public consciousness. Ironically, the leading satirical cartoonist in America following the Revolutionary War was British. Scotsman William Charles immigrated to the United States in 1806 and during the War of 1812 he took up the cause of his adopted land, producing numerous inflammatory satires, including a brilliantly understated parody portrait of Massachusetts senator Josiah Quincy, who was criticized for arguing against war and soon resigned under pressure from public displeasure.

William Hogarth, "Characters & Caricaturas" (1743)

L'ASSEMBLÉE NATIONALE; — or — Grand Cooperative Meeting at St. Ann's Hill: — Respectfully Dedicated to the admirers of a "Broad Bottom'd Administration"

James Gillray, "L'Assemblée Nationale" (June 18, 1804)

James Gillray flourished representing the first full flowering of graphic satire in England and its subsequent influence in America. He was among the most revered and reviled cartoonists of his time, routinely offending the royal family and prominent public figures with rude imagery ridiculing their pomp, policies, and personal habits. While Gillray walked the earth politicians paled, kings cringed, and crowds gathered in the streets around display windows of London printshops to see his latest efforts.

His generation, encompassing Thomas Rowlandson and the Cruikshanks, among so many others, produced prodigious quantities of work in the effort to meet a growing demand for comic art and graphic satire. Libel laws were relatively lax and caricaturists took advantage.

British cartoonists generally employed the medium of softground etching, a print process more fluid while less time-consuming and expensive than engraving. Their work brought new vigor to cartooning, promoting spontaneous imagery, quick studies, and rapid sketches. Their prints were fresh, colorful, topical, trenchant, vulgar, and irreverent. They appealed to a diverse urban audience, those who could read and appreciate the subtleties of text and allusion as well as less-sophisticated citizens who simply appreciated a rude gesture, a witty caricature, and a good laugh.

An interesting by-product of the growing craze for satirical prints was the desire of their victims to possess the offending cartoons. The

William Heath, "The Royal Milling Match" (1811)
This scandalous image, depicting the pugilistic cuckold Lord Yarmouth punching out the Prince Regent for trifling with his wife, bears the contemporary inscription "suppressed," indicating that the Royal Family sought to buy up all the available impressions from the publisher, including the original printing plate.

British royal family was fascinated by the new phenomenon, at once repelled and attracted by the new art form. The Prince of Wales (later George IV), with occasional help from his father, George III, assembled at Windsor Castle an astounding collection of almost 10,000 satirical prints produced by British cartoonists and sold in London shops. The Windsor caricatures date largely from the period 1780 to 1830, years dominated by the prodigious talents and prolific efforts of James Gillray and George Cruikshank.

In 1921, in extraordinary fashion, the Library of Congress acquired the Windsor Castle collection. In the aftermath of World War I, with the British economy foundering, King George V approved the sale to finance other acquisitions and initiatives. Neither the king nor his librarian, John W. Fortescue, appreciated the satires, they let them go at a fire-sale price: $3,600 for the lot. Fortescue held back most of the prints by Hogarth and Thomas Rowlandson, apparently in deference to their transcendent reputations. A particularly galling image by Rowlandson, however, portraying a decadent, disheveled, and dissipated Prince of Wales lolling with prostitutes, was exiled to Washington with the rest of the collection.

The Windsor Castle collection also includes eighteenth-century French satirical prints, most from the era of the French Revolution, a

Thomas Rowlandson, "Prodigal Son" (c. 1785)

period as potent politically as any the world has ever seen. If paintings and sculpture were the art of kings, prints were the art of the people; they could be reproduced in large numbers, sold, and distributed cheaply. In revolutionary France violence, terror, and death–the currencies of political upheaval and anarchy–were common themes. Mobs ruled; heads rolled. Provoking fear, not laughter, was the order of the day.

Back in America, cartoonists were profoundly influenced by their European counterparts. Their prints were more restrained, however, due to the fragility of the new republic and the desire of most Amer-

icans to work together, in concert with their leaders, to build a unified nation.

Commercial forces and technical advances soon altered the look of American cartoons. Change came during the 1820s, when increasing immigration and the invention of lithography enhanced the ability of publishers to expand their market and print cartoons quickly, cheaply, and in greater numbers, just in time to meet the ferocious demand for satire created by Andrew Jackson's polarizing administration.

Jackson was the first "people's president," loved by many but loathed by others. Personally and publicly his life was newsworthy

Le Calculateur Patriote.

Unattributed, "Le Calculateur Patriote [The Patriotic Accountant]" (c. 1792)
French satirical prints of the revolutionary period offer grim
evidence of the brutal terror and dark humor that ruled the era.

and cartoonists took advantage of the popular demand for images defending or deriding him. Playing on Jackson's name, cartoonists depicted him as a jackass, creating the earliest portrayals of a Democratic politician as a donkey.

Commercial lithography encouraged topical imagery by facilitating quick production of larger, cheaper print runs than were possible with the more labor-intensive, costly engraving and etching processes. Stylistically, despite the potential of lithography for innovation, for two decades American cartoonists remained true to eighteenth-century British conventions, content to imitate through the new medium the sketchy, wavering soft-ground lines and dialogue-filled word balloons typical of previous generations.

The earliest American satirical magazines were published in New York City during the 1840s. The first notable American cartoon journal was *Yankee Doodle*, published in New York between 1846 and 1847. Appearing during the buildup and prosecution of the Mexican War, *Yankee Doodle* supported Whig candidate Henry Clay's saber-rattling militarism toward its southern neighbor and lampooned the incumbent Democratic president, James Polk. *Yankee Doodle* looked a lot like the English *Punch* which, in fact, it was modeled after. While the journal lasted just two years, it was a promising start for American cartoonists.

During this period the comic artist David Claypool Johnston created an early prototype for humorous publications with his annual offerings of *Scraps*, compilations of cartoon etchings covering a wide range of social and political subjects with great wit and humor. Called "the American Cruikshank," Johnston's *Scraps* brought wit, irony, and a surprisingly modern sensibility to American cartooning.

Boston and Philadelphia developed early and distinctive communities of lithographic artists, but New York City soon asserted itself as the nation's foremost center for the new art form. There such prolific print publishers as H. R. Robinson and Currier & Ives dominated the growing market for popular prints, creating hundreds of cartoons each year satirizing politics and politicians, portraying celebrated comic actors and performers, and depicting humorous events that captured the country's collective imagination. Even in these early years of American electioneering, negative campaigning was raised to an art form.

Artists came to be recognized for the quality of their work. Winslow Homer, who began his career as a lowly lithographer's

Anthony Imbert, "Let Every One Take Care of Himself" (1833)
The Democratic donkey debuted during Andrew Jackson's tumultuous presidency, when cartoonists transformed Jackson into a jackass and one of the nation's most enduring political party symbols.

MR. CLAY TAKING A NEW VIEW OF THE TEXAS QUESTION.

Now for one I certainly am not willing to involve this country in a foreign war for the object of acquiring Texas. Honor and good faith, and justice, are equally due from this country toward the weak as toward the strong.—*Mr. Clay's Raleigh Letter.*

FA, FE, FI, FO FUM !
I SMELL THE BLOOD OF A MEXICUN !
DEAD OR ALIVE I WILL HAVE SOME !

I feel as if I yet must go and slay a Mexican !
Mr. Clay's Speech at New Orleans.

Unattributed, "Mr. Clay Taking a New View of the Texas Question," from *Yankee Doodle* (February 6, 1847)
This unidentified *Yankee Doodle* cartoonist caricatures U.S. senator and three-time presidential candidate from Kentucky Henry Clay looking hungry, armed, and delighted at finding a tiny terrified Mexican in the cupboard. In September 1847, after eighteen months of war, Mexico surrendered to the United States all of Texas along with the territories that would soon become the American Southwest.

"THE SYMBOL OF THE NORTH IS THE PEN; THE SYMBOL OF THE SOUTH IS THE BLUDGEON." — *Henry Ward Beecher.*

TOOMBS DOUGLAS CRITTENDEN KEITT BROOKS

ARGUMENTS OF THE CHIVALRY.

Winslow Homer, "Arguments of the Chivalry" (1856)
America's "Old Master," Winslow Homer began his career in Boston as a lithographer's apprentice. This print, probably a unique proof impression, depicts the brutal beating of Massachusetts senator Charles Sumner by his South Carolina colleague Preston Brooks, and reveals the artist's innate talent and the influence of Honoré Daumier.

apprentice in Boston in the 1850s, showed early signs of his prowess in a cartoon portraying the brutal caning of Massachusetts senator Charles Sumner by South Carolina senator Preston Brooks over the issue of slavery. This sensational incident fanned the flames of sectional antagonism and Homer's print found a ready market. The Library's impression of this early and important work is apparently unique.

It was about this time that Homer and his compatriots became aware of Honoré Daumier and his Parisian circle, who had already recognized in lithography the potential for strong, bold imagery that carried the message visually through fluid, gestural strokes of the crayon or brush on stone rather than the more tentative lines created by pushing an etching needle through a liquid ground. Daumier and his French colleagues operated under far more restrictive conditions than their American counterparts, however. Homer, were he so disposed, could have libeled a political figure with impunity while Daumier was jailed for the same outrage. American democracy has ever shown a special grace to cartoonists and satirists.

THE TIMES.

Edward Williams Clay, "The Times" (1837)
Sharp-penned Edward Williams Clay gave us this derisory Fourth of July "reality show" depicting the effects of the Panic of 1837, his Hogarthian perspective on New York City in the midst of recession.

The Civil War brought conflict and controversy and a golden age in American political cartooning. The southern press, what little there was, and Democratic editors in the North, published cartoons excoriating President Lincoln, a Republican, for his views on slavery and perceived callous disregard of civil liberties.

By contrast, the North drew from an apparently endless supply of paper, ink, and journalistic talent. Newly established illustrated weeklies, including *Harper's* and *Frank Leslie's*, produced thousands of cartoons during the war years. Supported by a national thirst for news and a more literate readership, these weeklies reached new

heights of circulation, in excess of two hundred thousand. Thomas Nast gained fame for *Harper's* and himself, inflaming northern sentiment for war with powerful editorial cartoons condemning rebels in the South and the influence of Democratic Copperheads in the North. His weekly diatribes against Confederate perfidy established his credentials as America's foremost cartoonist and foreshadowed his epic crusade against New York City politico William Magear "Boss" Tweed, in the 1870s.

On the eve of the Civil War a new comic magazine appeared, called *Vanity Fair* after the popular William Thackeray novel. Unrelated to the later celebrated London and New York fashion magazines of the same name, this small comic journal, published in New York City from 1859 through 1863, was a showcase for the considerable comic (and Copperhead) talents of Henry Louis

Honoré Daumier, "Émotions Parisiennes [Parisian Emotions]" (c. 1840)
Daumier was the most influential political artist in Europe during the nineteenth century, imprisoned
by authorities and celebrated by admirers for his scathing, impassioned cartoon commentaries. In
America, Daumier's influence reinvigorated the work of editorial cartoonists led by Robert Minor after
1900. The text at the bottom translates to: Gold is a pipe dream for those who don't have a penny.

SOCIAL QUALITIES OF OUR CANDIDATE.

Pub.d by John Childs, 64 Nassau St. N.York.

John Childs, "Social Qualities of Our Candidate" (1852)
Personal attacks on presidential candidates have a long, undistinguished history in American campaign prints, going back to Thomas Jefferson's alleged affair with his house slave Sally Hemings. Here, New York cartoonist John Childs attacks soon-to-be-President Franklin Pierce for alcohol abuse.

Stephens. Stephens was a Democrat, opposed to war with the South, and for two years in *Vanity Fair* he attacked Lincoln's Republican administration and the abolitionist movement. As the war progressed and Republican power grew, Stephens gave grudging support to the war effort in the North, but too late. The magazine folded in 1863, perhaps because of patriotic antagonism toward its pro-Democratic stance, or because two years into the conflict, with

the worst to come and no end in sight, nobody thought it was funny. The journal reminds us of the surprising diversity of opinion that characterized the northern states during the Civil War.

Winslow Homer produced some comic cards during the war and such Civil War sketch artists as Alfred Waud drew an occasional cartoon. Baltimore dentist and Confederate sympathizer Adalbert Volck was one of the few bright spots of southern satire. He drew numerous venomous caricatures of Union political and military leaders. Lincoln was his favorite subject and Volck's brilliant war etchings offer a compelling counterpart to works by Nast and his northern colleagues.

Winslow Homer, "Life in Camp," Part 2 (c. 1864)
During the Civil War, Winslow Homer intermittently drew images of camp and soldier life for the
weekly pictorial press. He also drew these collectible comic and sentimental cards, gathered together
here in a lithographic proof set (including a self-caricature in the top left corner).

THE KNIGHT OF THE RUEFUL COUNTENANCE.

Adalbert Volck, "The Knight of the Rueful Countenance" (c. 1861)
The menacing, spiteful anti-Union caricatures of southern sympathizer and
dentist-turned-etcher Adalbert Volck of Baltimore represented one of the few
bright spots of Confederate graphic art during the Civil War.

"I KNEW HIM, HORATIO; A FELLOW OF INFINITE JEST. * * * WHERE BE YOUR GIBES NOW?—*Hamlet*, Act *IV*., Scene 1.

J. H. Howard, "I Knew Him, Horatio" (1864)
George MacClellan didn't cut it as Union general under President Lincoln or as a Copperhead candidate opposing Lincoln for the presidency in 1864. Shakespeare, however, makes for great cartooning.

During the Reconstruction era that followed the war, Thomas Nast, *Harper's*, and the *New York Times* combined to produce the most stunning example of investigative, crusading journalism the world had ever seen. At the time, New York City was run by the powerful Democratic political machine known as Tammany Hall, run by "Boss" Tweed, which controlled the city's services and citizens with the muscle of its rank-and-file membership and generous graft from its overflowing coffers.

Between 1867 and 1871 Tweed and his cronies bilked city residents and investors of an estimated thirty million dollars, equal to

perhaps a billion dollars today. *New York Times* publisher James Gordon Bennett and Nast's boss, Fletcher Harper, independently began to campaign against the Tweed Ring in their publications. Bennett's newspaper sleuthed out the paper-trail evidence against the ring while Nast flogged the quartet in his weekly cartoons. Nast was then at the height of his fame, celebrated by two presidents: renowned as Lincoln's "best recruiting sergeant," while Ulysses S. Grant claimed that his 1868 election victory was due to "the sword of Sherman and the pencil of Thomas Nast."

In Nast's hands Tweed became the face of public corruption, the most recognized villain in America. He and his cohorts were forced from office in disgrace, although only Tweed ever saw the inside of a prison cell. While he railed from jail against Nast and his detractors,

Thomas Nast, original woodblock for "Let Us Prey" (1871)
Thomas Nast was the dominant political cartoonist in America during the second half of the
nineteenth century. The series of cartoons he drew for *Harper's Weekly* between 1869 and 1872
exposing the corrupt "Tweed Ring" of New York City's Tammany Hall contributed to the group's
ultimate indictment and became a landmark in crusading journalism. Nast himself carved the wood-
blocks from which the prints were made, several of which are preserved at the Library of Congress.

A GROUP OF VULTURES WAITING FOR THE STORM TO "BLOW OVER."—"LET US *PREY*."

Thomas Nast, "Let Us Prey," from *Harper's Weekly* (September 23,1871)

Thomas Nast, "His Attempt at Suicide" (1880s)

"TO BEGIN WITH, 'I'LL PAINT THE TOWN RED'."

Grant Hamilton, "To begin with, 'I'll paint the town red,' " from *The Judge* (January 31, 1885)
Judge cartoonist Grant Hamilton warns his staunchly Republican readership that the reunified Southern
Democrats are returning to Washington, D.C., twenty years after the Civil War and are apparently intending to raise hell.

PHRYNE BEFORE THE CHICAGO TRIBUNAL

ARDENT ADVOCATE.—"Now, Gentlemen, don't make any mistake in your decision! Here's Purity and Magnetism"

WITH APOLOGIES TO J.L. GEROME

you—can't be beat!"

cartoonists achieved unprecedented visibility and publishers quickly recognized the influence and attraction of political cartoons.

The great weeklies soon bred spinoff publications devoted to comic art, including such journals as *Frank Leslie's Budget of Fun*, which appeared monthly from January 1859 through June 1878. The *Budget of Fun* introduced Americans to Austrian-born Joseph Keppler, who within a decade would eclipse Nast as the country's leading editorial artist. Keppler grew in stature as the century progressed, his reputation enhanced by such timeless satires as his portrayal of a fallen minister, the celebrated Reverend Henry Ward Beecher, whose pious attacks on free love were given the lie by his near conviction for the alleged adulterous seduction of an attractive young female parishioner. Keppler cut to the chase with a wickedly simple caricature depicting the self-righteous clergyman looking nervous at the appearance of a Holy Bible which, according to Keppler, is "The Only Thing He Won't Kiss." Keppler's reduction of the cartoon to a single scene and separate short caption prefigures the future development of the cartoon gag panel in *The Masses* and *The New Yorker*.

The illustrated literary journals *Wild Oats* and *Every Saturday* also featured comic work by a new generation of American cartoonists aspiring to move beyond the shadowing influence of Nast and Homer. Despite the consistently good quality of these early journals, none prospered or even survived the 1870s. Their demise and the rise of a new kind of satirical weekly was due to the entrepreneurial talents of Joseph Keppler and the advent of quality color printing.

In 1876 Keppler published the first issue of a new comic journal, called *Puck* after Shakespeare's playful imp from *A Midsummer Night's Dream*. The magazine's motto was "What Fools These Mortals Be." And Keppler set out to prove it. His great innovation was the use of chromolithography, a lavish new color process, to draw the reader's eye. He surrounded himself with talented young cartoonists, producing for each week's edition a bright, bold color cover, back cover, and centerfold.

Puck's circulation took off in 1884 during Keppler's inspired campaign to defeat Republican senator James G. Blaine's bid for the United States presidency. Keppler and his stable of comic artists were relentless and ingenious in their attacks on Blaine's character and career. *Puck*'s Bernhard Gillam portrayed Blaine as the Tattooed Man, his political sins emblazoned on his flesh for all to see. Blaine lost the election in a tight race to Keppler's candidate, Grover Cleveland, and *Puck* subsequently portrayed the new president in a flattering light. Cleveland was pleased, publicly citing the journal for its contribution

Bernard Gillam, "Phryne before the Chicago Tribunal," from *Puck* (June 4, 1884)

HANNA: THAT MAN CLAY WAS AN ASS. IT'S BETTER TO BE PRESIDENT THAN TO BE RIGHT!

George Luks, "That Man Clay Was an Ass," from *The Verdict* (March 13, 1899)
George Luks, along with Robert Henri, John Sloan, and others, comprised the Ashcan School in American art—artists who introduced gritty urban realism into the dominant rarefied atmosphere of academic salon painting. Luks, like Sloan, started out as a newspaper sketch artist and cartoonist.

Carlo Pellegrini, "J. W. Bruce" (1870s)
The vogue for celebrity caricature which swept America after 1900 began in Europe where such journals as London's *Vanity Fair* published drawings like this one by Carlo Pellegrini, better known as "Ape."

to his victory. This spoke well for the journal's influence, if not its political independence.

The Republican party quickly learned the lesson spelled out in 1884 and searched for a satirical journal of its own. They found it in a rival monthly called *The Judge*, created by former *Puck* cartoonists seeking independence from Keppler. *Judge* cartoonists were masters of negative political campaigning; many of their most notorious cartoons leave us speechless, amazed, and amused at the sheer audacity of the message.

In 1886 the Republican party actually bought *The Judge*, using it to further party aims. What *Judge* cartoons from the period lack in *Puck*'s visual elegance and wit, they make up for in satirical venom.

Cartoons attacked African Americans, Jews, women, Chinese and Irish immigrants, Native Americans, and American presidents with equal zeal and no mercy.

By the 1890s, despite their old rivalry, *Puck* and *The Judge* agreed on most things. They agreed that William Jennings Bryan's silver party was dangerous and that McKinley should be president. They also agreed that monopolies were bad, but big business was good, and American workers should be content with their lot. A smaller rival called *The Verdict* disagreed, however, and became an early forum for cartoons that portrayed labor as the victim of capital and capitalists as arrogant, greedy monsters preying on the common people. George B. Luks, who would gain fame as leader of

John Tenniel, "The Old Story" (1884)
Sir John Tenniel won fame for his illustrations in Lewis Carroll's *Alice in Wonderland* books,
and for fifty years of contributions as staff cartoonist at London's illustrious *Punch*. His distinguished
service to queen and country, and his steady Conservative stance, won him a knighthood.

the Ashcan School of American art, drew for *The Verdict* a number of classic attacks on Republican party leader "Dollar" Mark Hanna.

Concurrent with the rise of the chromolithographic weeklies was the development of new mass-market magazines of literature and humor. Comic artists and illustrators found a new vehicle for their imagery in such magazines as *Scribner's*, *Harper's*, and *The Century*. Arthur Burdett Frost, Alice Barber Stephens, Charles Dana Gibson, Charlotte Harding, Edwin Abbey, and Jessie Willcox Smith, were among the artists featured in these new journals that, by 1900, boasted the first circulations surpassing one million. Such high numbers were due to low postage rates, improved communications and

ABOVE: John Tenniel, "A Contented Maid" (1894)

LEFT: Daniel Beard, frontispiece for *A Connecticut Yankee in King Arthur's Court* (1889)

a great asset to the nation, and that the Library would be an appropriate repository. In return for travel expenses and a modest daily allowance, Patten solicited donations to the Library from selected American illustrators or their heirs. The Cabinet of American Illustration proved to be a success, and in four years, until Patten's deteriorating health slowed the project, the Library amassed a collection of four thousand drawings by the nation's finest illustrators.

Although the Cabinet is devoted to the full range of the illustrator's art, cartoon and comic sketches abound. A. B. Frost's son John gave 125 examples of his father's work, including characteristically comic drawings portraying city and country bumpkins and their animal counterparts in varying stages of alarm, amusement, and befuddlement. Jessie Willcox Smith donated all of her spectacular painted illustrations for a deluxe edition of *The Water-Babies* by Reverend Charles Kingsley, a Victorian fairy tale of epic proportions and strong moral overtones. Charles Dana Gibson, whose turn-of-the century "Gibson girls" defined the ideal image of feminine beauty for a generation or more, selected dozens of drawings from his personal archives for the Cabinet. Other notable cartoonist-illustrators represented in the Cabinet include Edward Kemble, Frederick Church, Thomas Worth, and Frederick Opper.

By 1900 comic art had become an indelible feature of American popular publishing and two new genres emerged to great acclaim: the daily editorial cartoon and the comic strip. As early as 1872, the *New York Daily Graphic* featured front-page large-format editorial cartoons. The *Graphic*'s influence remained regional, however, and daily cartoons as a national phenomenon awaited the apocalyptic newspaper war between Joseph Pulitzer's *New York World* and William Randolph Hearst's *New York Journal*.

Cartoons were at the center of this epic battle for circulation and political influence. (After all, it was Hearst who famously told illustrator Frederic Remington in 1898, during the buildup to the Spanish-American War, "You provide the pictures and I'll provide the war.") The impact of their rivalry reverberated nationally through their newspapers, transforming American journalism by engendering a new visual culture.

Pulitzer first used editorial cartoons in his *New York World* in 1884. In 1896 his upstart rival Hearst brought Homer Davenport from the Hearst-owned *San Francisco Chronicle* to the *New York Journal*, where the young man became the prototype of the modern daily editorial cartoonist in America, a celebrity, and one of the highest-paid graphic artists in the country.

It was the era of the muckrakers, of those investigative journalists who sought to expose corruption and injustice in society and curtail

transportation, and increased literacy in America. Illustrated books became yet another outlet for comic art as American publishers expanded their markets. Between 1880 and 1920 the United States witnessed a golden age of book and magazine illustration as adults and children found edification and entertainment in lavishly illustrated publications–a precursor to later radio, film, television, and other forms of modern mass media.

The Library's collections of comic art and illustration from this period are outstanding, largely due to the efforts of William Patten, a former art editor for *Harper's Magazine* during the 1880s and 1890s. Patten conceived of a national collection devoted to original works by leading American illustrators. In summer 1932, Patten and Librarian of Congress Dr. Herbert Putnam agreed that such a collection would be

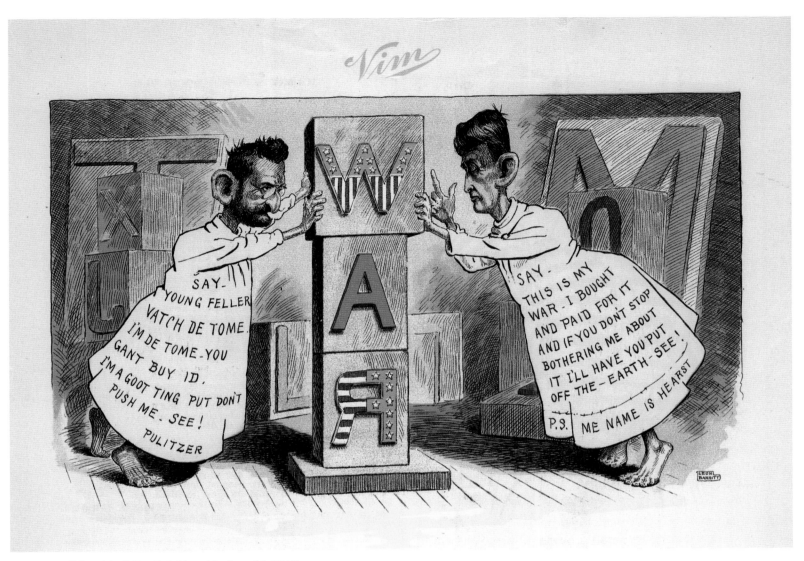

Leon Barritt, "War of the Yellow Kids," from *Vim* (June 29, 1898)
Did the Yellow Kid become a pawn in William Randolph Hearst's game to win the circulation war against Joseph Pulitzer and bring on a real war with Spain? Leon Barritt says as much in this witty response to the Yellow Kid fever then plaguing New York.

the excesses of the Gilded Age. Davenport became known for his depictions of the great American trusts–the early consortiums of oil, sugar, and railroad barons that seemed to control Congress and the American economy–as gluttonous, avaricious giants feeding off the hard work and suffering of the American people. John McCutcheon and Fred Opper, the brilliantly funny *Puck* artists, were among the first editorial cartoonists to become known nationwide.

For the first time, too, as the suffrage movement gained momentum, women broke the gender barrier and overcame the profes-

sional stereotypes that considered them only fit to illustrate fashion plates or children's stories. Rose O'Neill and Nell Brinkley, among others, became rich and famous along with the men.

Pulitzer was also responsible for America's first great comic-strip character, the Yellow Kid. The Kid came to life in color on Sunday, May 5, 1895, in a comic panel called "At the Circus in Hogan's Alley." Created by *New York World* staff cartoonist Richard Felton Outcault, *Hogan's Alley* was unlike anything newspaper readers had ever seen. By summer 1896, *Hogan's Alley* was a household name, and America had become obsessed with Mickey Dugan, the goofy-looking street urchin they came to call the Yellow Kid.

This national obsession translated into increased circulation and revenue for the *New York World*. As a result of its incredible success

Homer Davenport, "William Randolph Hearst" (1896)
Hearst brought Davenport to New York from San Francisco in 1896 to work at the *Journal*, where he soon became the highest paid editorial cartoonist in America. Here Davenport caricatures his new boss as a youthful patron saint of American cartooning.

Homer Davenport, "Dollar Mark Hanna" (1900)
Davenport and Hearst took on the money interests in their unsuccessful crusade against Republican presidential candidate William McKinley and his notorious campaign adviser and chief fund-raiser Mark Hanna, here caricatured in a sketch on letterhead.

the Yellow Kid became a pawn in the frenzied newspaper war then swiftly escalating between Pulitzer and Hearst. The newcomer Hearst aggressively sought ways to make inroads into Pulitzer's powerful established publishing empire. He quickly recognized the commercial import of Outcault's fantastic comic creation. In fall 1896, Hearst outbid Pulitzer for Outcault's artistic services and the Yellow Kid went to work for the *Journal*.

While working for Hearst, Outcault introduced the further innovation of serial balloons to his comic and by October 1896 all the essential ingredients for the modern newspaper comic strip were in place: color, narrative and thematic continuity, text balloons, and familiar cartoon characters to look forward to each week. The comic-strip revolution was under way and the stage set for an explosion of cartoon, caricature, and comic illustration in America.

Comic strips thrived, Outcault's Yellow Kid gave way to his equally popular, far more sanitized *Buster Brown*, and a new age of cartoon merchandising was born with comic characters selling shoes, ice cream, and candy. There was an intellectual side, too, to this commercial boon. Early on, almost a decade before American painters discovered European modernism, American newspaper comic-strip readers found it every Sunday in the color comic art work of Lyonel Feininger, George Herriman, George McManus, Winsor McCay, and others. These artists pushed the creative limits of the new genre.

Their editorial counterparts responded to the European avant-garde with the rest of American artists, after viewing the landmark Armory Show in New York City in 1913. In his cartoon "The Cubic Man" John Sloan made fun of modern art, but went back to the drawing board in his personal work. Oscar Cesare's "Rude Descending

Frederick Opper, *Happy Hooligan* (October 11, 1914)

Winsor McCay, *Dream of the Rarebit Fiend* (c. 1906)

Winsor McCay, *Little Nemo in Slumberland* (1910)

THERE WAS
A CUBIC MAN
AND HE WALKED A CUBIC
MILE AND
HE FOUND A CUBIC
SIXPENCE UPON A
CUBIC STYLE

HE HAD A CUBIC CAT
WHICH CAUGHT
A CUBIC MOUSE

AND THEY ALL LIVED
TOGETHER IN A
LITTLE CUBIC HOUSE

Drawn by John Sloan.

A SLIGHT ATTACK OF THIRD DIMENTIA BROUGHT ON BY EXCESSIVE STUDY OF THE MUCH-TALKED OF CUBIST
PICTURES IN THE INTERNATIONAL EXHIBITION AT NEW YORK.

John Sloan, "There Was a Cubist Man," from *The Masses* (April 4, 1913)

Oscar Cesare, "The Rude Descending on Sulzer" (1913)

Rea Irvin, "Clubs We Do Not Care to Join: The Professional Humorists' Club,"
from *Life* (October 22, 1914)

Stuart Davis, "Hoboken," from *The Liberator* (August 1922)

Ethel Plummer, cover for *Vanity Fair* (June 1914)

on Sulzer," a delightful caricature of a beleaguered New York governor, is a witty, accomplished drawing by an underappreciated editorial cartoonist.

Color had transformed the newspaper Sunday supplements and it transformed American magazines as well. Bold, pictorial covers beckoned from newsstands to a largely literate and newly urban readership. They advertised "smart magazines," like *Vanity Fair* and the old *Life*, featuring stylish covers and graphic humor by Rea Irvin and others. Ethel Plummer's 1914 breezy *Vanity Fair* fashion study seems just the type of thing Stuart Davis was thinking of when he painted *Hoboken* a year later.

Among mainstream American political cartoonists, many seemed spokesmen for the views of their powerful publishers rather than independently minded journalistic commentators. In fact, most at the time steered clear of controversy over foreign or domestic affairs, choosing instead to promote American progress and prosperity. Their large numbers (for in those years most large American cities and towns supported multiple daily newspapers) were offset by a small minority of more radical cartoonists who took the side of labor against management, socialism versus democracy, pacifism over militarism. Just prior to World War I these radicals, including Robert Minor, Boardman Robinson, and John Sloan, reached the height of their influence, producing highly charged drawings for socialist journals as well as watered-down versions for the mainstream press. Their antiwar work, in particular, hit home, precipitating a legal crisis unique in American history. Cartoonist Art Young and his colleagues at *The Masses*, an influential socialist journal, were indicted on sedition charges by the U.S. government. Young

Georges Lepape, cover for *Vanity Fair* (December 1919)

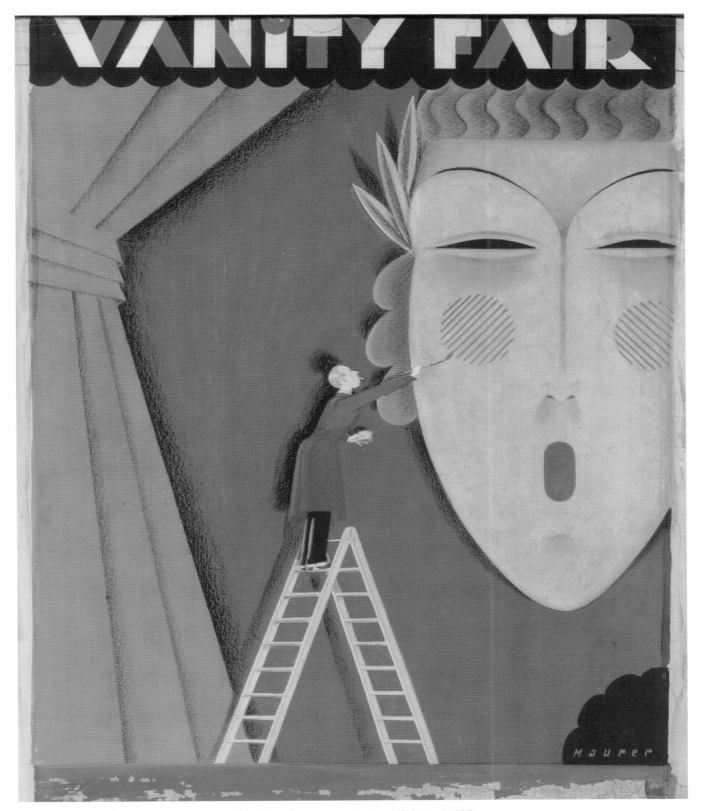

Alfred Henry Maurer, cover for *Vanity Fair* (April 1930)

You Can't EAT an
ACT of PARLIAMENT

John Sloan, "After the War, a Medal and Maybe a Job," from *The Masses* (September 1914)

and the others were ultimately acquitted, a clear victory for freedom of the press, although the postal service did manage to shut down *The Masses*, silencing a loud though limited voice for peace and progressive reform.

During the 1920s the funnies flourished, the jazz age blossomed, and prohibition was the law of the land. Liquor was on some people's

OPPOSITE, LEFT: Robert Minor, "Morgan, Mellon, and Rockefeller" (c. 1922)

OPPOSITE, TOP RIGHT: Boardman Robinson, "You Can't Eat an Act of Parliament" (c. 1915)

OPPOSITE, BOTTOM RIGHT: Henry Glintenkamp, "Physically Fit" (1917)

breath and everybody's mind. Miguel Covarrubias became as celebrated in New York City as the celebrities he caricatured. Harold Ross at *The New Yorker* created a new urbane publishing venue for comic art. If any one artist came to represent the twenties, it was John Held, Jr. His raccoon-coat-and-boater-wearing Joe Preps and bare-kneed college coed flapper cuties caught the carefree, alcohol-and-sex-driven mood of the decade that followed The War to End All Wars.

If John Held reflected the spirit of the jazz age, Ralph Barton reflected its excess: excessive talent, celebrity, and depression. Barton developed his own characteristically brittle linear style alongside Held. Both were brilliant and successful and they came to dominate the decade. Unhappily, Barton's strenuous private life, including a turbulent marriage to Latin beauty Lola Montez, gave

Ralph Barton, "Oh—do it again!," from *The New Yorker* (1927)

Ralph Barton, *The First Miss Fraser*, a play starring
Grace George and A. E. Matthews, from *The New Yorker* (1930)

Burne Hogarth, *Tarzan* (May 9, 1948)

Milton Caniff, *Terry and the Pirates* (April 8, 1945)

Hal Foster, *Prince Valiant* (May 13, 1956)

way to despair. Suffering from severe depression, Barton snuffed his own bright flame by suicide in 1931, just shy of forty.

Al Hirschfeld was the prodigal heir to Covarrubias, Held, and Barton, starting out as a precocious teen art director for Goldwyn Pictures. His early drawing of film star Betty Compson represents the "ear, nose, and throat" approach taken by Charles Dana Gibson. Under the influence of Held and Covarrubias, Hirschfeld later learned to reduce such fully rendered portraits to the sensuous abstract line drawings he became famous for. He could have drawn the *Mona Lisa*, he simply chose not to.

The Depression brought precious few reasons for laughter, but much need for it. Continuity and adventure strips were in their heyday, taking readers far from their cares to distant lands and other times. The great comic illustrators–Raymond, Crane, Foster, Hogarth, and Caniff–were in high demand. People clamored for their muscular storylines, handsome men, and alluring women. Hard-

boiled crime novelist Dashiell Hammett wrote scripts for *Secret Agent X-9.*

Characters such as Popeye, Dick Tracy, and Li'l Abner all appeared, each with their own unlikely cast of cartoon heroes and villains. Blondie debuted, got married, and set up housekeeping with Dagwood.

Humor magazines such as *Life*, *Ballyhoo*, *Americana*, *College Humor*, and *Judge* continued to publish cartoons. Theodore Geisel, aka Dr. Seuss, for example, contributed cartoons to *Judge* before his career as a children's book author took off.

Peter Arno and Helen Hokinson dined out for years on society manners in *The New Yorker*.

During the Depression, dominated politically by the Democrats and President Franklin Delano Roosevelt, editorial cartoonists divided largely along party lines and economic issues. Milt Gross wrote America's first comic wordless novel, *He Done Her Wrong*.

Harold Gray, *Little Orphan Annie* (1925)
Harold Gray's *Little Orphan Annie*, which began its remarkable run in 1924, featured Annie as rambunctious, restless waif traveling the world accompanied by her faithful dog Sandy, with only her wits and the intermittent protection of her benefactor Daddy Warbucks to help her survive in an unforgiving world.

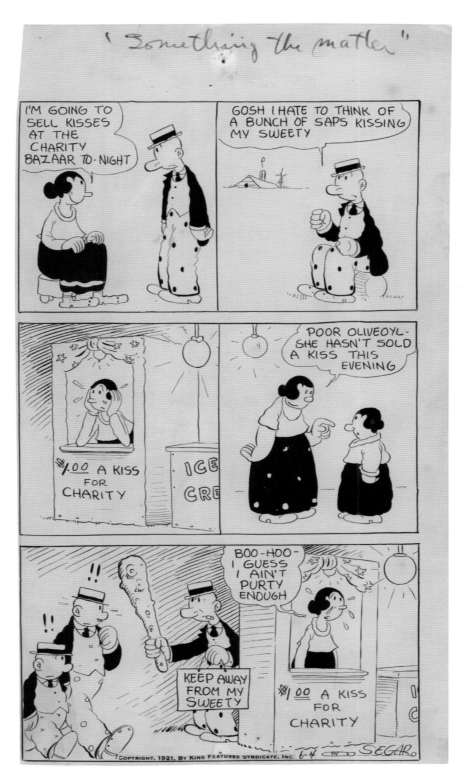

Elzie Segar, *Thimble Theatre* (June 4, 1921)
A decade before Popeye caught her fancy, Olive Oyl debuted in Elzie Segar's *Thimble Theatre.*

Alex Raymond, *Secret Agent X-9* (May 14, 1934)

ABOVE, TOP: Milton Caniff, character studies for *Terry and the Pirates* (c. 1941)

ABOVE, BOTTOM: Milton Caniff, *Terry and the Pirates* (November 3, 1934)

OPPOSITE, TOP: Elzie Segar, *Thimble Theatre* (January 2, 1932)

OPPOSITE, CENTER: Harold Gray, *Little Orphan Annie* (March 8, 1962)

OPPOSITE, BOTTOM: Chester Gould, *The Girl Friends* (1930)

American animation came of age as animated features appeared regularly in movie theaters and in 1937 Walt Disney presented *Snow White and the Seven Dwarfs*, the world's first full-length animated feature.

World War II united the country and cartoonists against the Axis threat. American cartoonists joined the fight as Arthur Szyk, Herb Block, and Rollin Kirby, among many others, stirred the nation to support the Allies and fight their common enemies. Bill Mauldin became a war hero by bringing humor to the front lines, enraging officers while entertaining the troops with his humorous and human portrayals of Willie and Joe, two foot soldiers in the war against fascism.

Chester Gould, *Dick Tracy* (December 18, 1931)

Theodore Geisel [Dr. Seuss], "So you're the __ __ __ who fouled me!" (1932)

"I love this country, Higgins! It's been good to me!"

Peter Arno, "I love this country, Higgins! It's been good to me!," from *The New Yorker* (April 4, 1959)

Milt Gross, *Banana Oil!* (May 28, 1924)

Rea Irvin, in the twilight of his stellar *New Yorker* career, rendered a Bayeux Tapestry tableau of the D-Day invasion commemorating the Allied victors.

Back home, Mauldin's humor turned serious when postwar shortages of jobs and housing left returning veterans in the lurch. For him and many of his countrymen, the good fight continued. In times of war and crisis it seems, cartoonists reach their full potential.

ABOVE, TOP: Milt Gross, *Dave's Delicatessen* (November 6, 1933)

ABOVE, CENTER: Cliff Sterrett, *Polly and Her Pals* (1933)

ABOVE, BOTTOM: Percy Crosby, *Skippy* (1926)

OPPOSITE: Milt Gross, *He Done Her Wrong* (1930)

Kenneth Russell Chamberlain, "Radio City Music Hall" (1935)

Mr. Wells evolving a Cosmic Thought.

William Cotton, "H. G. Wells" (1935)

Alice Harvey, "But, Mother! You haven't lived yet." from *The New Yorker* (March 15, 1930)

Helen Hokinson, "They're all staying for supper, Nora. Any inspirations?," from *The New Yorker* (c. 1940)

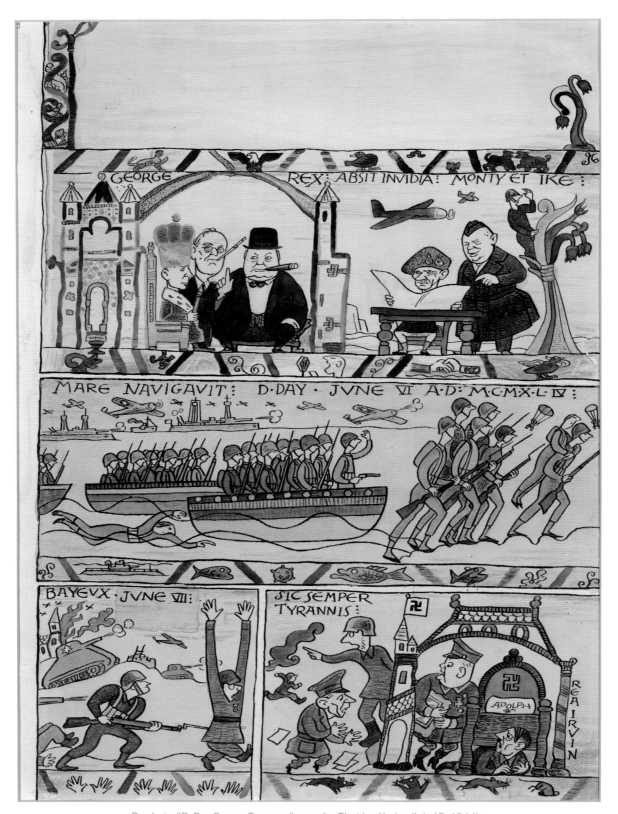

Rea Irvin, "D-Day Bayeux Tapestry," cover for *The New Yorker* (July 15, 1944)

Bill Mauldin, "I won the Nobel Prize for literature. What was your crime?"
(October 30, 1958)

Vaughan Shoemaker, "When Blackest, Remember Lincoln" (1963)

The subsequent Cold War of ideas and ideologies did not, however, spur American cartoonists to produce their best work. Most remained mired in partisan politics, unable or unwilling to challenge the status quo and address the larger issues facing the world and the American people.

Senator Joseph McCarthy's anti-Communist assaults on American institutions and individuals provoked few angry protests from newspaper cartoonists, with the notable exceptions of Herbert Block and Walt Kelly. They openly confronted McCarthy with satire and caricature, complementing the journalistic efforts of Edward R. Murrow; in fact, the term "McCarthyism" appeared for the first time in a Herb Block cartoon satirizing the Republican party platform. By 1952, too, Herb Block had identified House member Richard Nixon as a person of interest.

Comic books also came under Congressional oversight during the McCarthy era. They had only been around for little more than a decade but were already stirring up trouble. The first books, featuring Superman and Batman and other early super heroes, appeared in the late 1930s and during World War II. The books proved wildly popular, not only with kids but with soldiers, too, and adolescent girls wanted titles of their own. Publishers gave the people what they wanted: romance, action, adventure, cartoons, and gags, even classic literature. Soon, encouraged by their success, some publishers within the true-crime and horror genres pushed past the limits of public taste, featuring covers depicting horrific scenes of sex and gore. Already on the lookout for those engaged in "un-American activities," Congress demanded guidelines for the industry. A Comics Code was imposed. The rich, violent fantasy life

Herb Block, "It's okay—we're hunting communists." (October 31, 1947)
Herb Block won the first of his four Pulitzer Prizes in 1942, served in the Army during World War II,
and by 1947 was already warning his readers against attacks on their civil liberties by overzealous
anti-Communists. He was the first to target Senator Joe McCarthy and his new ruthless
political campaign in spring 1950. No other cartoonist challenged McCarthy's character
and motives as consistently and effectively as Herb Block.

Herb Block, "I have here in my hand——" (May 7, 1954)

Rube Goldberg Views the News for His Latest Invention

HOW TO CRACK A WALNUT

CHAIRMAN JACOB MALIK (**A**) CALLS SECURITY COUNCIL TO ORDER, AND GAVEL (**B**) HITS DOVE OF PEACE (**C**) — DOVE FLIES INTO DUDE RANCHER'S HAT (**D**), OPENING OLD LANDING BARGE (**E**) AND MOTHBALLS (**F**) FALL INTO MOUTH OF PENTAGON STRATEGIST (**G**), WHO CHOKES AND REACHES FOR GLASS OF WATER (**H**), TUNING IN DIZZY DEAN ON TELEVISION (**I**) — MOTHER (**J**), SHOCKED AT DIZZY'S GRAMMAR, PUTS HANDS OVER CHILD'S EARS (**K**), CAUSING STICK (**L**) TO RING GONG (**M**), STARTING JOE LOUIS (**N**) TRAINING FOR COMEBACK — JOE KNOCKS OUT SPARRING PARTNER (**O**), WHOSE STEEL HEADGEAR CRACKS WALNUT (**P**), KNOCKING WIND OUT OF TAXPAYER (**Q**), WHO WAS UNCONSCIOUS ANYWAY.

Copr. 1950, King Features Syndicate, Inc., World rights reserved.

Rube Goldberg (1950)

of adolescent boys went underground and wholesale comics became wholesome again.

The fifties may appear in hindsight a culturally suppressed decade, but it did give us Saul Steinberg and William Steig, Robert Osborn and Jules Feiffer. For them alone, we should be thankful.

The 1960s brought JFK, LBJ, Vietnam, and the generation gap. A new breed of young cartoonists came onto the scene. Paul Conrad, Pat Oliphant, Tony Auth, Paul Szep, and many others helped turn the tide of popular sentiment against the Vietnam War. Their passionate, pointed commentary combined with televised images of death and destruction to defeat LBJ and, ultimately, bring an end to the war. Black cartoonists, historically consigned to the African American press, became nationally syndicated. Ollie Harrington and Ron Cobb contributed their anti-Capitalist cartoons to the Communist press. David Levine flayed his subjects mercilessly in *The New York Review of Books*. Ed Sorel wielded Super-pen. From backroom presses in San Francisco and elsewhere, counterculture cartoonists, including Art

ABOVE: Robert Osborn, "Silence Dissenters!" (1954)

OPPOSITE: Burris Jenkins, "No Answer" (1962)
The death of Marilyn Monroe.

NO ANSWER

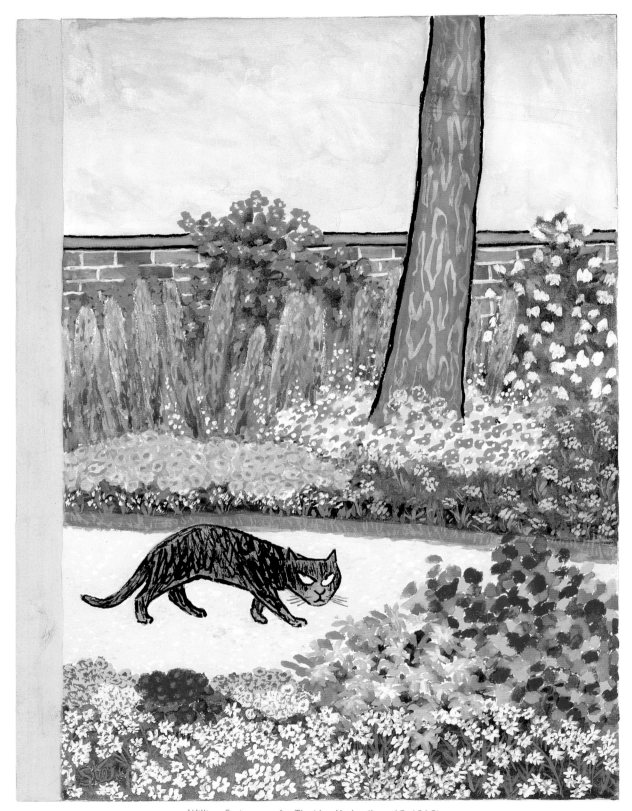

William Steig, cover for *The New Yorker* (June 18, 1960)

"And are you very wise, Grandpa?"

William Steig, "And are you very wise, Grandpa?" (March 27, 1965)

BLACK TEEN-AGERS 40% UNEMPLOYED. —NEWS ITEM

TOP: Paul Conrad, from *Los Angeles Times* (December 1, 1977)

BOTTOM: Morrie Turner, *Wee Pals* (May 13, 1968)

Al Capp, *Li'l Abner* (May 30, 1943)

Al Capp, *Li'l Abner* (September 25, 1943)

Johnny Hart, *B.C.* (February 5, 1969)

Spiegelman, R. Crumb, Bill Griffith, and many others collaborated cooperatively to publish and distribute existential, episodic anthologies of underground graphic comix. The sex and violence Congress had hoped to suppress a decade before came back with a vengeance. Ultimately, Bill Griffith's *Zippy the Pinhead* made the unlikely leap to mainstream syndication, positive proof of intelligent life in the cartoon universe.

During the 1970s cartoons helped bring down another president. Richard Nixon, preaching defeat with honor in Vietnam, soon dis-

honored the White House. Paul Conrad achieved immortality on Nixon's "enemies list" with his searing series of satires portraying Nixon as a tragic figure in the Shakespearean mold. Herb Block, unbelievably productive with five decades behind him and three more to go, won a fourth Pulitzer Prize for his contributions to the *Washington Post* investigation of Nixon's role in the Watergate scandal. Collectively, American editorial cartoonists enjoyed a golden age.

Change came with the 1980s when Ronald Reagan transformed the American political landscape. The Reagan years were captured in the work of Garry Trudeau who, like Walt Kelly before him, introduced politics into the comics page; Pat Oliphant, one of history's finest comic artists; and Jeff MacNelly, whose prodigious talent and

Garry Trudeau, *Doonesbury* (May 29, 1973)

Edward Sorel, "Milhous I," from *Rolling Stone* (March 14, 1974)

conservative outlook defied the notion that the best political artists have always been liberals devoted to reform. Presidents George H. W. Bush and Bill Clinton suffered grievously at the hands of cartoonists. Pat Oliphant added immeasurably to the elder Bush's image as a wimp, unforgettably accessorizing him with a lady's purse. Bill Clinton's doughy features and scandalous activities were a boon to cartoonists everywhere.

Recent efforts to remake America and fight a global war against terrorism have divided the nation and its cartoonists. Like the cartoons themselves, the issues have become black and white, not shades of gray. In 2001, just as President George W. Bush began

David Levine, "G. Gordon Liddy," from *The New York Review of Books* (July 17, 1980)

implementing his platform and cartoonists honed their portrayals, the 9/11 attacks shattered the world as Americans knew it and overwhelmed most commentators' abilities to make sense of the madness. Comic-book artists and illustrators were among the first respondents in a number of powerfully moving commemorative anthologies published in the aftermath of the attacks.

Although some editorial cartoonists seemed stunned into silence with the rest of us, Ann Telnaes, the 2001 Pulitzer Prize-winner, was a notable exception: her strong and stylish cartoons shed light on critical issues, including the separation of church and state and threats to civil liberties emerging from the war on terrorism. Garry

LEFT: Herb Block, "National Security Blanket" (May 27, 1973)

OPPOSITE: Robert Pryor, "Richard Nixon" (1974)

There were few bright spots in fall 2001 coming out of New York City, but the cartoonists rallied as artists will and author/illustrator Maira Kalman and *National Lampoon* alum Rick Meyerowitz created this gem. We even asked for the napkin sketch from the Century Club—a club cartoonists do care to join.

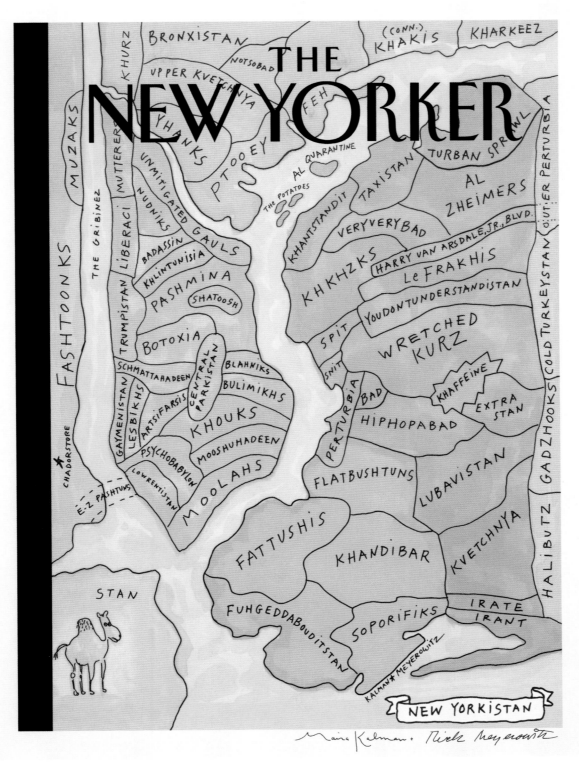

Maira Kalman and Rick Meyerowitz, "New Yorkistan," cover for *The New Yorker*
(December 10, 2001)

Anita Kunz, "Saint Hillary," from *The New York Times Magazine* (1993)

THE BOONDOCKS

Aaron McGruder, *The Boondocks* (January 6, 2002)

Trudeau took *Doonesbury* to Ground Zero and the war in Iraq, while relative newcomer Aaron McGruder's edgy comic strip *The Boondocks* openly questioned the administration's policies toward security and civil liberties.

As the nation has emerged from the shadow of 9/11, so too have American editorial cartoonists regained their critical voice. In an age when reality is defined by sound bites and spin doctors, pandering pundits and partisan politics, editorial cartoonists must remain above the fray, talking truth to power in all its forms, helping us to see old issues in a new light, and clarifying with insight, intelligence, and accuracy the difficult, complex issues and events that shape our daily lives. Meanwhile, the comics artists have their work cut out for themselves: they help us to forget our cares and laugh in the face of modern life.

Cartoon Connoisseurship:
What Makes a Great Cartoon Great?
Alan Fern

Most of us look at cartoons and caricatures uncritically. On the pages of our magazines and newspapers they quickly claim our attention. While we laugh at a joke the artist makes, delight in the recognition of a public figure, or become involved in the narrative, we rarely stop and think about what the artist did to get us so involved. But this is a crucial concern for the collector of satiric drawings–whether an individual like Art Wood or Erwin Swann, or a curator in a public collection such as the Library of Congress's Prints and Photographs Division. For them, choices are essential; not everything can be acquired and retained, so difficult judgments are involved, raising questions of quality, originality, and historical significance.

What, then, are some of the distinguishing features of an outstanding cartoon or caricature? We commonly see these drawings in reproduction. The artist knows that the subtleties of their work may be compromised by the process of reproduction. To fully grasp the quality of a cartoon we must see it in the original, where the integrity of the artist's line will be most evident. For example, Charles Dana Gibson delineated the charming delicacy of young women in gentle pen strokes and light shading. In contrast, Walt Kelly used a broader brush line to create the politically aware and socially concerned swampland animals that populate *Pogo*. Bill Mauldin consciously drew his Willie and Joe characters during World War II with maximum impact and a minimum of picky detail.

Robert Osborn's virtuosic, elegant brushwork infuses his characters with astonishing energy. Al Frueh, at the other end of the spectrum, evoked the unmistakable likeness of theatrical personalities with a few well-chosen lines and shapes (often geometric forms) or a telling gesture rendered in a single stroke. These artists all used their imagination and masterful technique to create works of unforgettable impact and striking individuality.

Jules Feiffer and Gluyas Williams prefer the pen. Feiffer wastes little effort on anatomical detail, making his figures dance across the page with expressive brilliance (accompanied by dialogue appropriate to the ecstasy or despair of the moment). Gluyas Williams was the master of the unbroken line of uniform width. He had an unsparing eye for facial expression, which he delineated with great efficiency, and he rejoiced in his characters' elaborate settings. Williams could evoke space and place with great exactitude without relying on the usual shading and reduction in strength of line: no cross-hatching or dot patterns invade its purity. This clean, strong line took powerfully to reproduction, whether on the coated paper of *The New Yorker* or on the rougher stock used by his book publishers.

Although these artists worked primarily in black and white, color has been available to cartoonists since the eighteenth century, when satiric etchings and engravings were hand-colored, to the early days of the four-color newspaper comic strip in the late nineteenth century, to the very high-quality reproductions of today's sophisticated lithographic presses.

Miguel Covarrubias, who often drew in black and white, also painted in color to create his extraordinary caricatures for *Vanity Fair* and other publications. The advent of high-speed color printing made the first funnies possible and allowed comic artists to create their characters in environments of unprecedented imaginative quality. The setting became an essential formal element of the cartoonist's work. George Herriman's *Krazy Kat*, Winsor McCay's *Little Nemo*, and Lyonel Feininger's *Kin-der-Kids* exist in landscapes and interiors related to those found in works by the German Expressionists and, later, the European Surrealists. There are cinematic elements in these early comics as well, reflecting the popularity of this new mass medium. From panel to panel the viewpoint is constantly changing, with frames moving from close-up to long-shot as the story unfolds.

There is pleasure to be found in looking for the many sources cartoon artists use in their creations. Pat Oliphant is only one of many artists who has drawn on John Tenniel's illustrations for *Alice in Wonderland* or Félix Vallotton's lithographs, while echoes of Maxfield Parrish murals appear in Winsor McCay's drawings. Many familiar works by Ed Sorel and other cartoonists represented in this

OPPOSITE: Detail, Miguel Covarrubias, "The Four Dictators" (1933)

book have their sources in earlier images and can be found by the alert and informed viewer.

And let us not forget the ferocity of feeling that erupts in some of the finest satiric artists. Thomas Nast's place in history owes as much to the apparent cupidity and greed of the politicians he attacked as to his brilliance as a caricaturist or his gift for visual drama. Like Nast, such artists as Oliphant, Osborn, Daumier, and Posada consistently infused their drawings with blazing outrage that seizes the viewer and never lets go.

Whether in the savage or affectionate caricature, the "illustrated simple remark" (to use Robert Benchley's phrase) that defined the classic *New Yorker* cartoons, or the four-color comic-strip excursions into new realms of space and time, the finest comic artists have always created drawings and paintings that–seen in the original– can hold their own as compelling works of art in the company of the great "serious" artists of the past.

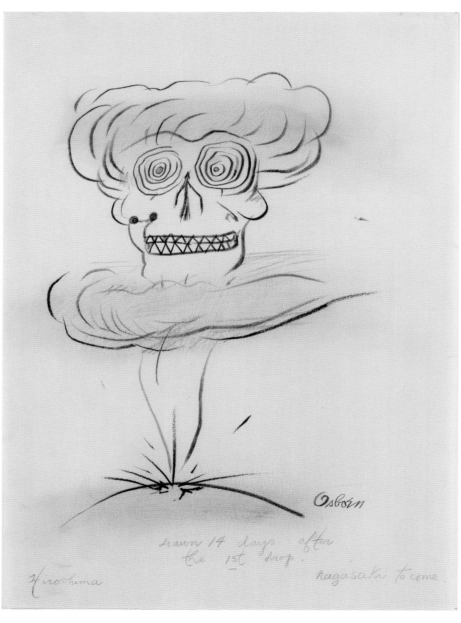

Robert Osborn, "Hiroshima. Nagasaki to Come" (1945)

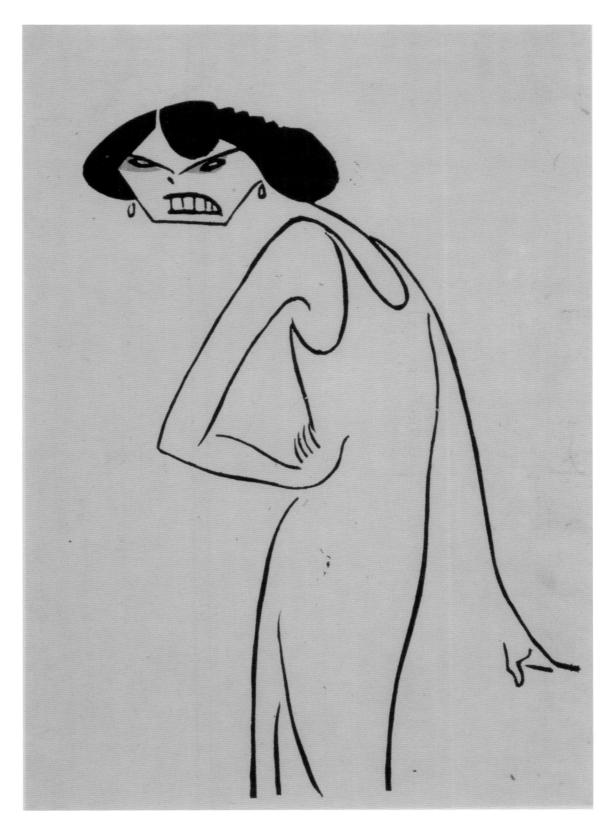

Al Frueh, "Mary Nash," from *Stage Folk* (1922)

José Guadelupe Posada Aguilar, "Galeria del Teatro Infantil: la almoneda del diablo [The devil's auction]" (c. 1910)

Miguel Covarrubias, "The Four Dictators" (1933)
Josef Stalin, Benito Mussolini, and Adolf Hitler with Huey P. ("Kingfish") Long of Louisiana.

Honoré Daumier and Censorship

Judith Wechsler

In 1867 Honoré Daumier drew two generals bowing to each other and gesturing to the door marked "Disarmament." The caption reads: "After you." That same year Daumier drew an allegorical figure of Europe as a harried woman balanced precariously on a lighted bomb. The caption reads: "European Equilibrium." These lithographs, done late in the career of Honoré Daumier (1808-1879), mark his return to political caricature after a long period of censorship. His focus had become international: Europe, diplomacy, war, and peace. Even if one no longer remembers the specific historical events, the context and references, Daumier's remarkably pithy caricatures, drawn with the draftsman's rapier pen, still speak to us today. Some four thousand of his lithographs, published up to thrice weekly in the illustrated press from about 1830 to 1872, set a standard for his time and for ours, both for subject and execution.

Daumier was a chronicler of Paris in a time of rapid political, social, and demographic change, when the population grew fourfold during the course of the nineteenth century, and populations shifted from country to city. Few artist-draftsmen have so eloquently captured the spirit of their times through such a running commentary on the fabric of contemporary social life and politics–when censorship allowed. Caricatures helped people make sense of their surroundings as they sought clues to reading their fellow citizens in new circumstances. Through physiognomy; bearing and gesture; and the exaggeration of salient clues to class, character, and circumstance, Daumier revealed the complicity of capitalism and government, the structure of bourgeois life, professions and avocations, street life, theaters, exhibitions, and the spectacle of spectators.

Daumier was the leading caricaturist of his time. His first works attacked King Charles X and his policies. With the monarch's downfall and the rise of Louis-Philippe, the bourgeois king, Daumier sharpened his viewers' awareness of the corruption of government. In "Gargantua" (1831), the king is pictured sitting on a throne being fed bribes and defecating honors. For this lithograph Daumier was given a six-month suspended jail sentence, subsequently imposed as his attacks continued. His charged portraits in "The Legislative Paunch" (1834) make the analogy between the political body and those of the somnambulant representatives. Daumier was pro-republic and anti-monarchist; when censorship constrained him from depicting the king, he and his editor, Charles Philipon, devised the pear as a pun, to stand for the pear-shaped monarch: *poire* in French, also means "fathead." When all political caricature was banned by the September laws of 1835, Daumier found a means of subterfuge through what the contemporary poet and essayist Charles Baudelaire called "plastic slang," capturing the "gait, glance, and gesture" of his subjects.

Daumier depicted the contrasts in society, the haves and have-nots, the aspirations big and small, the professions, particularly law and medicine and the relationship between practitioner and client-victim, that implied political complicity.

When censorship was lifted during the Second Republic, 1848-52, Daumier returned to political caricature and made his famous sculpture of Ratapoil (Rat-skin) an *agent-provocateur*, also the subject of some thirty lithographs. In 1852 Daumier had to return exclusively to social caricature until censorship was loosened in 1867, when Emperor Napoleon III felt sufficiently confident of his reign: he was soon toppled by the disastrous Franco-Prussian War of 1870.

Why should the United States government, and the Library of Congress in particular, provide resources to acquire, maintain, and display political art? It is part of the great tradition of freedom of speech, an extension of which is freedom of imagery. Daumier's contemporaries deemed images more powerful than words and the censorship was harsher for caricature than for texts–this in an age before newsreels. He set the standard, in particular, for the charged portrait as a staple of political caricature, for satirical allegory, and visual metaphor. Daumier took responsibility as a witness to the world he inhabited with seriousness and wit, averring, "One must be of one's time."

The force and appeal of Daumier's caricature was not only his astute and brilliant political and social satire, but the extraordinary quality of his drawing, which Baudelaire likened to the Old Masters. His gestural and expressive line brings his figures and history to life. Through selective exaggeration, caricatures capture contemporary events, often with humor. And if we can laugh occasionally in troubled times, it is all for the better.

Le Jardin des Plantes á Pékin : — Les Chinois admirant beaucoup un quadrupéde de France et un bipéde du même pays....

Honoré Daumier, "Le Jardin des Plantes à Pékin [Pékin's Botanical Garden]" (1854)
The caption refers to "four-legged and two-legged animals from the same country" (France) as
perceived by a crowd of outsiders (China). With characteristic wit and irony, Daumier invokes the
great clash of cultures that took place in the nineteenth century as the Chinese emerged from
their cultural cocoon to wonder at the modern inhabitants of civilized Europe.

LE VENTRE LÉGISLATIF.

Aspect des bancs ministériels de la chambre improstituée de 1834

Honoré Daumier, "Le ventre législatif [The Legislative Paunch]," from *L'association mensuelle* (1834)
Daumier produced these two masterpieces of political art in 1834 for a special series of large
prints issued to subscribers of the French satirical journal *La Caricature*. *Rue Transnonain* depicts
with neoclassical clarity and monumental humanity the murder of innocents by government
troops, while *Le ventre legislatif* presents a classic political group portrait à la Daumier:
arrogance, indifference, venality, corruption, and corpulence.

RUE TRANSNONAIN, LE 15 AVRIL 1834

Honoré Daumier, "Rue Transnonain," from *L'association mensuelle* (1834)

An Explosion of Color: The Age of the Chromolithographic Weekly

Richard West

In the latter part of the nineteenth century, before the advent of radio and television, there was but one medium that reached to all corners of the United States, the magazine. And among magazines, the most colorful and provocative were the chromolithographic political cartoon weeklies. Nothing quite like them had come before and nothing quite like them has been seen since. There were dozens of them, all told, but their format rarely varied: sixteen large (11 x 14 inches) humor-filled pages, with front and back covers and the center spread reserved for vibrant chromolithographic cartoons.

Puck, America's first successful humor magazine, led the way. The brainchild of artist Joseph Keppler and printer Adolph Schwarzmann, *Puck* was founded in New York in September 1876 as a humor magazine for the German-American community. It soon proved too good to be kept from the English-speaking world and, in March of the following year, Keppler and Schwarzmann launched an English-language edition as well. Within a few years, inspired by *Puck*'s example, chromolithographic magazines were sprouting up everywhere–not just in the nation's publishing capital, New York City, but also in Boston, Philadelphia, Chicago, St. Louis, New Orleans, San Francisco, and several other smaller cities. It seemed that every city that was home to a lithographic printing house was soon home to a political cartoon weekly as well.

The chromolithographic weeklies spoke the language of politics, brimming with combative words and pictures on such arcane subjects as the tariff issue and monetary standards. Even the humor in them that pretended to be apolitical was charged with political meaning. Suffused with the back-slapping parlance of the saloon, the magazines took on predictable targets: the underdog, which in that day meant the Irish, Jews, Chinese, blacks, and women (from the coquette to the battle-axe, from the inexperienced wife to the terrorizing mother-in-law, from the spinster crone to the mannish "new woman"), and the "type," such as the brainless athlete, the lisping aesthete, the carefree hobo, the demanding boss.

Puck's chief cartoonist, Joseph Keppler, set the standard for the art of the chromolithographic cartoon. He was a master of the ele-gant line and graceful composition. As art director, he trained a generation of graphic humorists, chief among them Bernhard Gillam, Eugene Zimmerman, James A. Wales, and Frederick Burr Opper, whose talents blossomed under his encouraging eye. Other artists who worked on chromolithographic weeklies included George Luks, R. F. Outcault, Harrison Fisher, and Rose O'Neill. They went on to triumph as fine artists, comic strip artists, and illustrators.

Few of the weeklies outside of New York boasted top-class talents; most of the artists were journeymen, plucked from behind their drawing boards in the lithographic firm's commercial art department. But there were exceptions: Fritz Welcker of the *St. Louis Hornet* and later the *St. Louis Lantern* was an accomplished caricaturist. Henry Barkhaus of the San Francisco *Wasp*, who died at the age of twenty-one, was perhaps the greatest natural talent of the nineteenth century. It must be admitted that little of lasting literary value appeared in these magazines. But a few of the editors, Henry Cuyler Bunner and Harry Leon Wilson of *Puck*, Ambrose Bierce of *The Wasp*, and Alfred Henry Lewis of *The Verdict* excelled at their jobs, creating reams of copy each week that was worth reading, if only to pass the time.

By the turn of the century, competition from Sunday newspapers, with their own magazine and comic-strip supplements, drove down the readership of the chromolithographic weeklies at the same time that the rise of the American mass market made them, with their partisan tone and constricting format, an unattractive advertising medium. When four-color printing was perfected in the first decade of the twentieth century, chromolithography was relegated to the back rooms of the printing trade. Increasingly the labor-intensive process was employed solely for producing such specialty items as posters and cigar labels. The golden days of the chromolithographic weekly were brief. But their influence persists. Defining characteristics of comic strips, animated cartoons, the art of *The New Yorker*, even the wry humor of late-night television can be traced back to the later part of the nineteenth century, when the chromolithographic weekly reigned supreme.

OPPOSITE: Frank Beard, cover for *The Judge* (September 27, 1884)

ENTERED AT THE POST OFFICE AT NEW YORK AS SECOND CLASS MATTER. COPYRIGHT 1881 BY THE JUDGE PUBLISHING CO.

Price NEW YORK, September 27, 1884. 10 Cents.

Another voice for Cleveland.

Joseph Ferdinand Keppler, "Editorial Conclave of *Puck*" (1887)
This drawing from a photograph of a Puck editorial meeting celebrated the journal's tenth anniversary.
Co-publisher and chief artist Joseph Keppler stands at left benignly looking over a staff of artistic talent
that includes C. J. Taylor (seated second from left), and Fred Opper (seated at right).

George Luks, "Annual Parade of the Cable-Trolley Cripple Club," from *The Verdict* (March 20, 1899)

Posada, Printmaker to the Mexican People
Ron Tyler

In the Mexico City of 1900, José Guadalupe Posada Aguilar walked the short distance from his shop behind the cathedral, down what is today called Calle República de Guatemala, to the shops of the several publishers who purchased his small engravings and etchings. He was a short, chubby, mustachioed Mexican who attracted attention only when his knowledge of the people and uncommon ability to communicate it graphically combined to produce the cover for a satiric weekly or the illustration for a penny broadside. He offered his services to the city's publishers, then frequently stood in their shops while he deftly engraved the illustration they had ordered. His prints appeared in many journals and on thousands of multicolored broadsides and were recognized throughout Mexico, yet he lived an anonymous, sedentary life and was placed in a pauper's grave at his death in 1913 by neighbors, only one of whom could sign his name.

We know little more of this common man of uncommon talent, of what he did or said or thought, for he left no diaries or manuscripts or descendants. Although he proved to be one of the most influential Mexican artists of the twentieth century, when the artists' unions reprinted one of his works in their newspaper in 1924 they credited it to an "unknown folk artist." And when he finally received the recognition due him in a monograph published in 1930, Diego Rivera, the most respected Mexican artist of the day, concluded that Posada's work was so ubiquitous that his name would one day be forgotten, that his work was so popular that his identity would become lost in Mexico's.

Fortunately, such has not been the case, for José Guadalupe Posada Aguilar soon became known as "the printmaker to the Mexican people," as artist and historian Jean Chariot wrote in the first essay published about the artist in 1925, the "bottleneck through which all Mexican artists must go to get from the nineteenth to the twentieth century." Since his rediscovery he has been called the greatest printmaker of Mexico, "the Mexican Goya," "the Mexican Daumier," and his artistic spirit imbues the great public murals of Mexico. Both Rivera and painter José Clemente Orozco recalled his influence on them while they were searching for an artistic identity.

His active years correspond roughly with the dictatorship of General Porfirio Díaz (1876-1911), and his strong, graphic style bridged the gap between nineteenth century documentary art and the emerging abstraction and simplification of the twentieth century with the "most extraordinary requests of the people": images to illustrate a prayer with indulgences, meat for the butcher, a chicken or rabbit to illustrate a cookbook, teeth to announce the opening of a dentist's office, or pharmacy utensils to advertise certain household remedies.

It was in his small shop, an enclosed carriage entry, that printer and publisher Antonio Vanegas Arroyo found Posada. Vanegas Arroyo had developed an inexpensive broadside format for the *corridos*, which were *ejemplos* (moral stories) that Posada's spirited compositions–usually zinc etchings–perfectly suited. For a few years they formed a team that, in retrospect, seems to visually define the emerging Mexico. Posada's compressed and dynamic designs seemed to burst with energy and vitality at the outbreak of the Mexican Revolution, the greatest social upheaval the country has ever known, earning him the further sobriquet "Artist of the Revolution." But he died in January 1913, a few days before the bloodiest battle, the Ten Tragic Days, during which the opposing forces cannonaded each other with Mexico City as the battleground. Without an artist to chronicle the biggest story of the young century, Vanegas Arroyo reused many of the thousands of Posada plates that he had wisely retained.

In the intervening decade, Posada was virtually forgotten until the young Chariot arrived in Mexico City in 1922 to be a part of the artistic renaissance then under way. Classically trained and a lover of folk art, Chariot saw Posada's prints for sale in a street stand–for Vanegas Arroyo was still printing them–and inquired as to the artist. The vendor led him to Vanegas Arroyo's shop, where Chariot found hundreds of the engraved and etched plates. After hours of investigation, he came to realize that most of the prints were the work of a single artist–José Guadalupe Posada Aguilar, the printmaker to the Mexican people, the artist who had perhaps more influence on twentieth-century Mexican art than any other person.

OPPOSITE: José Guadelupe Posada Aguilar, "Calaveras del montón, número 2" (1910)
"*Calaveras* from the heap, number 2."

NUMERO 2. CALAVERAS DEL MONTON.



CALAVERAS DEL MONTON.

Pasé por la primavera
Y me llamó la atención
El ver una calavera,
Que trajeron del panteón.
Daba pena y tentación,
Mirar que pelaba el diente
Era el dueño, el patrón;
Oh sin duda el dependiente.

Al otro lado un empeño
Mucha fué la admiración,
Tendido estaba su dueño,
Y con velas el cajón....
Este que fué empeñero,
Robaba sin compación
Que por amar el dinero,
Calavera es del montón.

Adelante el carnicero
En la mano su morcón,
Mas allá el tocinero;
Con su hediondo chicharrón
Estos pronto se murieron
Y se fueron al panteón,
Calaveras se volvieron;
Calaveras del montón.

En la esquina un pulquero
Tomando de compromiso,
Al otro lado del piso
Le acompaña un jicarero.
Brindo porque lo quiero
Decía con amor profundo....
Hoy calavera es el primero,
Y le acompaña el segundo.

El vicioso zapatero
Que alegre se emborrachó,
Por andar de pendenciero;
Hasta la zuela perdió.
En la calle se pelió
Pues insultava á cualquiera,
Otro como él lo mató
Y ahora ya es calavera.

Han corrido mala suerte
Los ambrientos peluqueros,
Ya se los llevó la muerte;
A tóditos por entero....
Se volvieron calaveras
Sentados en un sillón,
Y como estavan tan fieras;
Los quemó la cremación.

No corras tanto Madero
Deten un poco tu trote,
Porque con ese galope,
Te volviste narangero.
Ya no corras......detente
Acorta ya tu carrera,
Que te gritará la gente;
¡A que horrible calavera!

Madero, en esta ocasión
Es mucho lo que has corrido
Ferdistes ya la razón,
Y en muerte te haz convertido.
Ahora tu filiación
La tiene el nuevo partido;
Tu calavera han metido,
Al horno de cremación.

Adonde está tu viveza
Millonario y con dinero,
Alza un poco la cabeza;
Y dale vuelta al tintero,
Te llevan á la prisión
Más corriendo que de prisa,
Ya te volvió ceniza......
El horno de cremación.

De tu roída calavera
No queda ya ni pedazos
Al horno fué la primera,
Y se quemó á tizonasos.
Tu huesamenta hecha trizas
La metieron al montón,
Ahora sí que ni cenizas;
Recoje la cremación.

Por valiente el panadero
Y por andar de bribón,
Junto con el biscochero;
Tristes calaveras son...
Lo mismo es el dulcero
Y el que vende macarrón,
Uno y otro parrandero;
Calaveras del montón.

Quiero que sepan mi cuita
Porque el gañote me tuerzo,
Si quieren su propinita
No se olviden de este verso....
El decirlo no quiciera
Pues me duele el corazón,
Pero esta pobre calavera,
Los saluda en el montón....

En todas las fiestecitas
Se debe tener cuidado,
Que los crueles motoristas;
A muchs gente han matado.
Que sigan con sus tonteras
Que los espera el panteón
Todos hechos calaveras
Saliendo de la prisión.

Se acabaron los prensistas
No hay encuadernadores,
Se murieron los cajistas;
Ya no quedan impresores.
Con todos los escritores
Bailando la sandunguera,
Se volvieron calavera
En el panteón de Dolores.

Los toreros como sabios
Sufrieron su revolcón,
Vengó el toro sus agravios
Los mandó para el panteón.
También á los del expres
Y empleados de papelera
Sin br zos, manes ni pies
Los volvieron calavera.

El mundo va á terminar
Por el cólera enfurecido,
Que sea pues bien venido,
Si nos tiene que tocar.
Pues decirlo no quiciera
Me causa desesperación
Porque tenemos que ser
Calaveras del montón;

Imprenta de Antonio Vanegas Arroyo.—2a. Calle de Santa Teresa, número 43—México 1910.

José Guadelupe Posada Aguilar, "El Purgatório Artístico" (c. 1900)
"The artistic purgatory, where the *calaveras* of artists and craftsmen lie."

José Guadelupe Posada Aguilar, "Don Quijote" (c. 1910)
"This is Don Quixote the first, the giant *calavera* without equal."

The Yellow Kid

Jerry Robinson

Frederic Hudson, in his history of journalism published in 1873, wrote: "Our people don't want their wit on a separate dish. Wit cannot be measured off like tape, or kept on hand for a week, it would spoil in that time . . . no one can wait a week for a laugh; it must come in daily with our coffee." Humor in the some five hundred daily and weekly publications of the time were found mostly in columns; the more eye-catching visual humor, however, soon became dominant.

Numerous and varied factors contributed to the development of the comic-strip form: the evolution of narrative art, the welding of story and picture, the technique of creating the illusion of time, the refinement of social satire, the impact of advancing technology, and the ability of man, alone among the animals, to laugh at himself.

All the essential ingredients of the comic strip fell into place in New York City in the 1890s. The drama of the creation of the Yellow Kid began in 1893, when Joseph Pulitzer, publisher of *New York World*, bought a four-color rotary press in an attempt to print famous works of art for the Sunday supplement. The attempt was unsuccessful and Sunday editor Morrill Goddard proposed using the press to print comic art instead. Pulitzer, a pioneer in pictorial journalism, agreed. On Goddard's recommendation, Pulitzer hired freelance cartoonist Richard Felton Outcault, an inspired choice.

Many cartoonists develop a repertory company of character "types" (as Outcault himself referred to them) to draw upon as needed to populate a scene much as "extras" in a movie. Percy Crosby's Skippy began in *Life* magazine and Mort Walker's Beetle Bailey appeared in *The Saturday Evening Post* in background roles before they were elevated to star in their own comic strips. One of Outcault's freelance cartoons for *Truth* magazine, "The Fourth Ward Brownies," reprinted in *New York World* on February 17, 1895, depicted a group of tenement children of various types. One of Outcault's repertory company, a small, bald tyke (youngster's heads were often shaved at the time to prevent or cure head lice) appeared in the picture–the same type as in other Outcault cartoons–can be seen as the genesis of the Yellow Kid.

Fewer than three months later, Outcault created "Down in Hogan's Alley," the title adapted from the opening words of a popular song, "Maggie Murphy's Home." The setting recreated the city slums with unsparing detail: squalid tenements, backyards crisscrossed by clotheslines with billowing laundry; vacant, refuse-strewn lots; stray dogs, scrawny cats and goats; and various ragamuffins. One of the street urchins was to become one of the most unlikely heroes in popular literature: a flap-eared, one-toothed bald kid with a slightly Asian look (although his name was later revealed as Mickey Dugan) and a quizzical yet knowing expression. His eternal attire was a nightshirt dirtied with handprints that extended to his bare feet.

The Yellow Kid's first appearance, on May 5, 1895, in "At the Circus in Hogan's Alley," was inauspicious. The backyard scene was full of activity as the tenement children reenacted an adult circus complete with acrobats, a juggler, clowns, animals (a goat and dog), musicians (a drummer and bugler), and Madame Sans Jane "der champion bare-dog rider of the world" waiting to go on. The appreciative audience lined the fence or peered from a window, and a favored group was seated on a makeshift front-row bench. The future star can be seen standing at the far right of the picture in a pale blue nightshirt, quite smaller than he soon grew to be.

In succeeding episodes the Kid, barely visible in nightshirts of various hues, continued to play a minor role. Eight months later, however, in the cartoon entitled "Golf–The Great Society Sport as Played in Hogan's Alley," Outcault made the Kid–now garbed in brilliant yellow–the star of the show. Employing a brilliant innovation, Outcault had the Kid make eye contact with the reader as he points out the mayhem swirling around him. The entire cast is caught frozen in action, at a "decisive moment," as in a photograph by Henri Cartier-Bresson, that gives a sense of the immediate past, present, and future.

In the tradition of Hogarth's London, Daumier's Paris, realist writings from Charles Dickens to Stephen Crane, and the gritty city scenes of the early twentieth-century American Ashcan painters,

OPPOSITE: Detail, Richard Felton Outcault, Buster Brown and the Yellow Kid, *Buster Brown* (July 7, 1907)

Richard Felton Outcault, *McFadden's Row of Flats* (1896)

Outcault didn't ignore the degradation, violence, and cruelty of tenement life. Although leavened by humor, his urban excursions faithfully captured the squalid, often courageous existence of Hogan's Alley residents–the ramshackle wooden dwellings, the ragged hand-me-down clothes, and desperate poverty–evoking the concurrent remarkable documentary photography of Jacob Riis. A typical Outcault tableau of tenement life also brings to mind the complex, earthy paintings of peasant life by Pieter Bruegel the Elder. Nothing like it has been seen in comic pages before or since.

Outcault also incorporated current events and politics into the strip, paving the way for the great American cartoon satirists to follow: Walt Kelly, Al Capp, and Garry Trudeau. Such sophisticated content suggests that *Hogan's Alley* was not aimed at children, but at the adult reader who buys the paper–nor primarily at the immigrant population that the cartoons portray, who were either too poor to buy newspapers or unable to read English.

Hogan's Alley encompassed the criteria that became the hallmark of future newspaper comic strips: a continuing series with a regular cast and title, and the written word integrated into the drawings. It firmly established the tradition of color in the Sunday comics. Outcault intermittently used speech balloons and in 1896 began to employ sequential narrative–the story told in a series of panels that became the characteristic structure of the comic strip.

The Yellow Kid became newspaper comics' first commercial success. Soon his image adorned cigar boxes ("Say! Dis is me offishal segar wot I doe's me tricks wit. See me smoking wit me ears"), whiskey, cigarette packs, gum, postcards, buttons, paperweights, baby clothes, and cracker tins. He was heralded in books, plays, and popular songs, even a prototype comic book. He could also be found on such unslumlike niceties as ladies' fans and fancy soap for those homes where we might presume the Yellow Kid himself would not be welcome.

It is doubtful that Outcault controlled much of this subsidiary usage of his creation. He wrote, rather naively, to the Honorable A. K. Spofford, Librarian of Congress, September 7, 1896, " I hereby make application for copyright for the Yellow Kid. It is not intended for an article of manufacture but to appear in my cartoons each week in the Sunday World . . . I desire to know if I can copyright this little

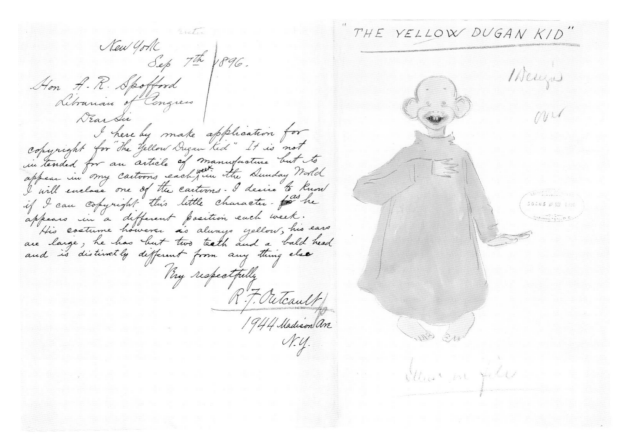

Richard Felton Outcault, "The Yellow Dugan Kid" (September 7, 1896)

character as he appears in a different position each week. His costume however is always yellow, his ears are large, he has but two teeth and a bald head and is distinctly different from any thing else." There is no record of a copyright being granted.

The success of the Yellow Kid didn't escape the notice of Pulitzer's great rival, William Randolph Hearst, who bought the moribund *New York Journal* in 1895 and set out to eclipse the *World*. In a raid that would have earned accolades from Captain Kidd, Hearst pirated the *World*'s entire Sunday supplement staff. In the ensuing fight over legal rights to the comic-strip properties the court decided that Pulitzer retained the title *Hogan's Alley* for the *World*, but that Hearst could publish another version of the Yellow Kid in a comic strip using a different title. The first cartoon for the *Journal* has the Kid and his entire neighborhood celebrating their move to McFadden's Flats. Pulitzer continued to publish his own Yellow Kid, drawn by Outcault's friend, the soon-to-be-celebrated Ashcan painter George Luks.

Outcault went on to profit handsomely from his cartoons in an era when, as Thomas Craven described it in *Cartoon Cavalcade*, "artists were bought and sold like baseball players." In 1902 Outcault launched another strip that caught the public's imagination, *Buster Brown*, whose protagonist became the ideal role model for American children. Soon it seemed that everyone's kid was named Buster and his dog, Tige. Outcault even had the Yellow Kid visit Buster's well-to-do home, and on another occasion Buster and Tige venture down to Hogan's Alley. There Buster is introduced by the Kid to Mrs. Murphy ("she mends me clothes") and Plato ("me pet goat"). To the dismay of the Kid, Plato kicks Buster and butts Tige. The cartoon concludes with an homage to Winsor McCay's *Little Nemo in Slumberland*: it was all a dream when Buster wakes up falling out of bed.

The comic strip performs one of literature's most important functions: to examine our morals, mores, and illusions. During its relatively short run from 1895 to 1898, *The Yellow Kid* burlesqued the fads, foibles, and pretenses of the society that bounded Hogan's Alley. Outcault's penchant for humor, combined with superb draftsmanship, an acute sense of social justice, and demanding eye for detail made *The Yellow Kid* a roaring success.

Richard Felton Outcault, Buster Brown and the Yellow Kid, *Buster Brown* (July 7, 1907)

Art, Architecture, and Abstraction: Feininger in the Funnies
Art Spiegelman

Lyonel Feininger, one of the lesser gods of modernist painting's heroic age, reached the highest pinnacle of that separate Olympus reserved for comic-strip artists. A founding member of the Bauhaus school of modern design, his early Expressionist paintings reveal his roots as a cartoonist for European magazines, while his mature paintings (a little too mature for my tastes) developed a luminous and romantic strain of Synthetic Cubism. Between 1906 and 1907 he produced two comics features totaling only fifty-one pages for the *Chicago Tribune*. His career as a comic-strip artist lasted less than a year and was a commercial fizzle, but his pages were characterized by a breathtaking formal grace unsurpassed in the history of the medium.

By 1906 the perpetual tug of war between European aristocratic values and our homegrown "vulgar" American culture had already begun to domesticate the raucous slapstick of the first comics: the Yellow Kid's mayhem in a lice-infested slum alley had given way to Buster Brown's mischievous pranks in the prosperous suburbs. When the dignified *Tribune* decided to hold its nose and publish a comic section, it looked to Europe for salvation, hoping to appeal to its large audience of literate German immigrants with a well-printed weekly supplement featuring artists recruited from Germany's highly respected cartoon journals. Feininger, an American of German extraction, living in Berlin and Paris since his teens, seemed especially well-suited to bridging the divide between the old world and the new. (In fact, *The Kin-der-Kids*, his first feature, begins with a full-page tableau of the kids departing lower Manhattan on an ocean voyage back to Europe in the family bathtub.)

Early in the twentieth century European artists seemed one step less reluctant than their more culturally anxious American peers to go slumming in the "low" arts. Only a handful of American painters of the period dabbled in cartooning (George Luks's work on *The Yellow Kid* comes to mind), but lots of esteemed European modernists–Picasso, Toulouse-Lautrec, Gris, Kirchner, Kupka, and Grosz, to name just a few–drew cartoons for publication either at the beginnings of

or throughout their careers. Feininger brought the most sophisticated tendencies in painting into the fledgling funny pages; his comics are thoroughly informed by the currents of Cubism, Expressionism, and Jugendstil as well, and evince the fascination for Japanese woodblock prints that he shared with many Post-Impressionists. Two large central blocks on one beautifully composed page, "The Kin-der-Kids make a lucky haul," show the kids reeling a ship-sized fish onto their seafaring bathtub-boat above a horizontal "footnote" panel in which Japansky, the kids' clockwork companion, kicks up perfect *ukiyo-e* waves. The shifting placement of the boat in each panel captures the feeling of a boat's swelling movement on the sea, using a painter's compositional language rather than the cinematic vocabulary that would eventually dominate the comics medium. Outbursts of pure musical abstraction that predate even Kandinsky's experiments in that direction occasionally dominate his pages.

The Kin-der-Kids was on some level intended as a response to those other comics kids with German roots, the sociopathic and wildly popular Katzenjammers, but Feininger clearly lacked the requisite lowbrow touch. The strip was unceremoniously dropped in mid-continuity. Feininger's mastery of shape, color, and line didn't quite carry over to the storyline, which wasn't much to write home about: the funereal Aunt Jim-Jam and inept cousin Gussie chase three kids around the world to dose them with castor oil.

Feininger's sense of story has more to do with the architecture of a comics page, a "story" in the sense of *stories* of a building. In one stunning example a kid is rescued from a dreaded hit of castor oil by a chimney sweep who hoists him up through the chimney to escape over gabled roofs. Abstract red architectural joints bind the individual panels into one large compositional unit. Here again, the panel-to-panel shifts are more related to musical movements than to movies.

Wee Willie Winkie's World, Feininger's second feature for the *Tribune*, eschews slapstick altogether and moves comics toward the realm of lyric poetry in pages about a very little boy who

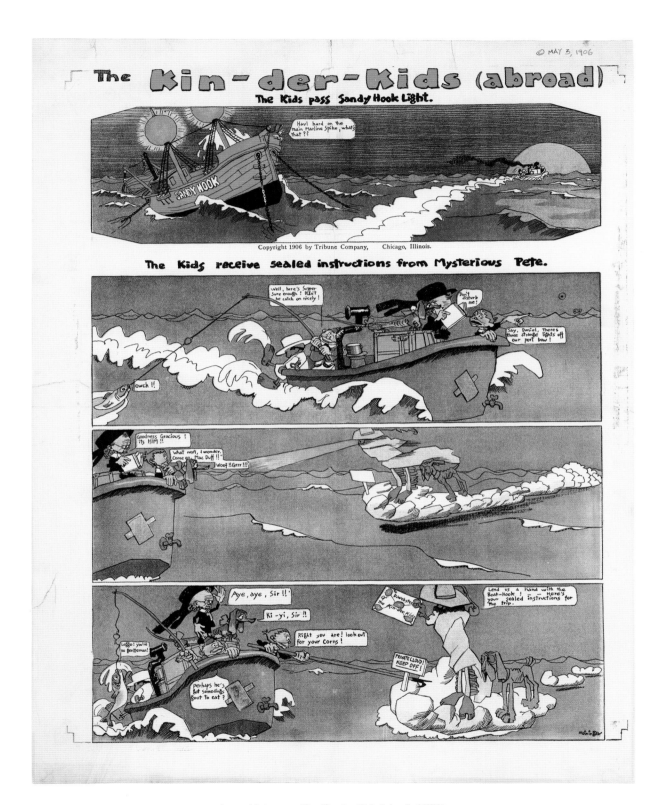

Lyonel Feininger, *The Kin-der-Kids* (May 3, 1906)

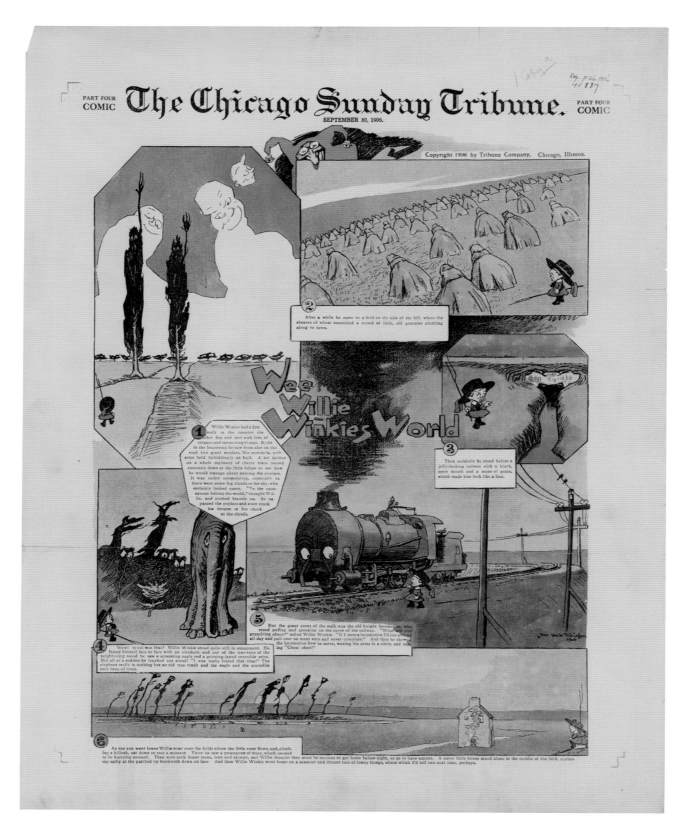

Lyonel Feininger, *Wee Willie Winkie's World* (September 26, 1906)

Lyonel Feininger, *Wee Willie Winkie's World* (November 25, 1906)

anthropomorphizes everything around him. The subjects of the pages are simply a sun yawning as it goes down, or a rain cloud that looks like an old woman with a watering can, or trees literally dancing in the wind. On one page, a small sailboat passes in front of the setting sun, seeming to haul the sun away. Wee Willie carries a real sense of animistic wonder as well as a genuine feeling of childhood anxiety. Wee Willie's fantasy life may be more subdued than the sumptuous dream world of Winsor McCay's *Little Nemo in Slumberland*, but the best of these pages are unequivocal masterpieces that demonstrate the most sublime visual possibilities of the comics form.

Lyonel Feininger, *The Kin-der-Kids* (September 1, 1906)

Lyonel Feininger, *The Kin-der-Kids* (June 29, 1906)

Rose O'Neill and Nell Brinkley
Trina Robbins

Rose O'Neill and Nell Brinkley, two of America's earliest women cartoonists, were household names during the first half of the twentieth century. Their work was collected and copied. Their names sold products and inspired popular songs. Like today's movie stars, their doings made newspaper headlines.

In 1896, at the age of twenty-two, having already drawn professionally for six years, Rose produced the earliest-known comic strip authored by a woman, *The Old Subscriber Calls*, for *Truth* magazine. At that time, ten-year-old Nell was skipping down the unpaved streets of Edgewater, Colorado, on her way to Ashland grade school, slate tucked under her arm. Three years later Nell would sell her first art, a set of decorated blotters, for five dollars, and buy a zither with the money. Prodigy Rose had also started at the age of thirteen, when she won a five-dollar gold piece in an art contest sponsored by the *Omaha World Herald*, with a drawing entitled "Temptation Leading to an Abyss."

By the time twenty-one-year-old Nell came to New York to draw for the Hearst syndicate, Rose had married and divorced twice, published a best-selling novel, and exhibited her more serious fine art in Paris. She had drawn illustrations in her unique Art Nouveau style for magazines such as *Harper's Monthly*, *Harper's Bazaar*, *Good Housekeeping*, *Cosmopolitan*, and *Leslie's*.

Nell caught up quickly, however. By 1909 the Brinkley Girls, Nell's signature Art Nouveau women, had become an act in the Ziegfeld Follies, and at least three popular songs had been written about her. The same year that Nell was being immortalized in verse, Rose created the Kewpies, who would make her immortal. According to Rose, the winged, Cupidlike creatures came to her in a dream. They ran in the *Ladies' Home Journal*, the *Woman's Home Companion*, and *Good Housekeeping* as free-form comics, usually accompanied by verse.

America gobbled up the cute, sentimental creatures and wanted more, so Rose obliged them with Kewpie children's books, picture frames, greeting cards, soaps, fabrics, handkerchiefs, wallpaper, suspenders, wall plaques, vases, tableware, a newspaper strip in the 1930s, and of course, the ubiquitous Kewpie dolls. She also drew ads for Ivory soap and Jell-O. Rose spent the money as quickly as it came in. She was supporting not only her entire family, but a contingent of Bohemian hangers-on who would come to visit at her salon at Greenwich Village's Washington Square (she is said to have been the inspiration for the song "Rose of Washington Square") or her rambling Connecticut mansion, Carabas, and they would stay on indefinitely.

Nell worked as hard as Rose, supporting her mother, who lived with her and managed her career, and she probably also sent money to her father in Florida. The sweat of her brow–and the products of her nimble fingers–paid for a big house in New Rochelle, horses, live-in servants, and an Italian gardener. Nell and her family lived well; she dressed for dinner every night. She produced a daily quarter-page or half-page of illustrated commentary for the Hearst syndicate, along with color Sunday pages. She illustrated stage and film reviews. She drew illustrations for magazines such as *Harper's Bazaar*, and ads for *Djer Kiss* face powder and *Hennafoam* shampoo. There were no Brinkley dolls, handkerchiefs, or cards, but women who aspired to the masses of curls on Nell's beautiful creations could buy *Nell Brinkley Bob Curlers* or *Nell Brinkley Hair Wavers* for ten cents per card.

When Nell traveled from New York to San Francisco and when Rose arrived home from Paris, journalists were on hand to quiz them, usually on topics of interest to women. "Pretty Girls? S.F. Full of Them, Says Nell Brinkley, Here" the *San Francisco Call-Bulletin* stated in a 1915 headline, while the *Los Angeles Examiner* wrote "Americans Are Funny Children and New York is Pastoral, Says Rose Cecil O'Neill." While the newspapers never printed their opinions on anything more controversial than fashion ("Nell Brinkley Scorns Dictates of Fashion: Too Many Frills, Lack of Individuality," screamed a 1913 headline), Nell communicated her politics in her daily illustrated commentary. Like most Americans, ardently patriotic during World War I, she nevertheless criticized the situation in Washington, D.C., where young women, flocking to take the desk jobs vacated by enlistees and conscripts, could not find housing because landlords would not rent to single young women. In Depression-era 1932, sym-

OPPOSITE: Detail, Nell Brinkley, "Golden Eyes with Uncle Sam" (1918)

Rose O'Neill, "Signs," from *Puck* (August 17, 1904)
"Ethel: He acts this way. He gazes at me tenderly, is buoyant when I am near him, pines when I neglect him. Now, what does that signify? Her mother: That he's a mighty good actor, Ethel."

pathizing with jobless and desperate veterans of World War I, Nell produced a passionate panel called "The Man of the Hour," writing "The public would like to see the government back the men it called heroes, now." After Franklin D. Roosevelt was elected, she produced enthusiastic portraits of a much-glamorized Eleanor Roosevelt.

Both women drew pro-suffrage cartoons. Rose, despite her bohemian lifestyle and liberated dress–she went corsetless and draped herself in flowing pre-Raphaelite robes–otherwise avoided politics in her art, favoring a relentlessly peppy optimism. Describing the Kewpies meeting a grumpy old man, she wrote:

They cleared his mind of views quite fearful,
Relieved him of reflections tearful,
And brought him home both bright and cheerful.

Despite the Ziegfeld Follies and the three songs, Nell Brinkley is forgotten today, save for a small group of collectors, while Rose O'Neill's name survives because of her Kewpies. It is regrettable that she will always be known for those saccharine little creations rather than for her exquisite fine art and illustrations.

Both women died in 1944. In a January 1945 obituary for Nell, *American Artist* magazine compared the two:

"The late Nell Brinkley, who died in October, attracted more amateur copyists than did Charles Dana Gibson. Like Rose Cecil O'Neill, who came before her, she was quite an eyeful herself and was past master as a cheesecake artist."

Rose O'Neill, *Kewpies* (October 12, 1935)

Nell Brinkley, "Uncle Sam's Girl-Shower" (1918)

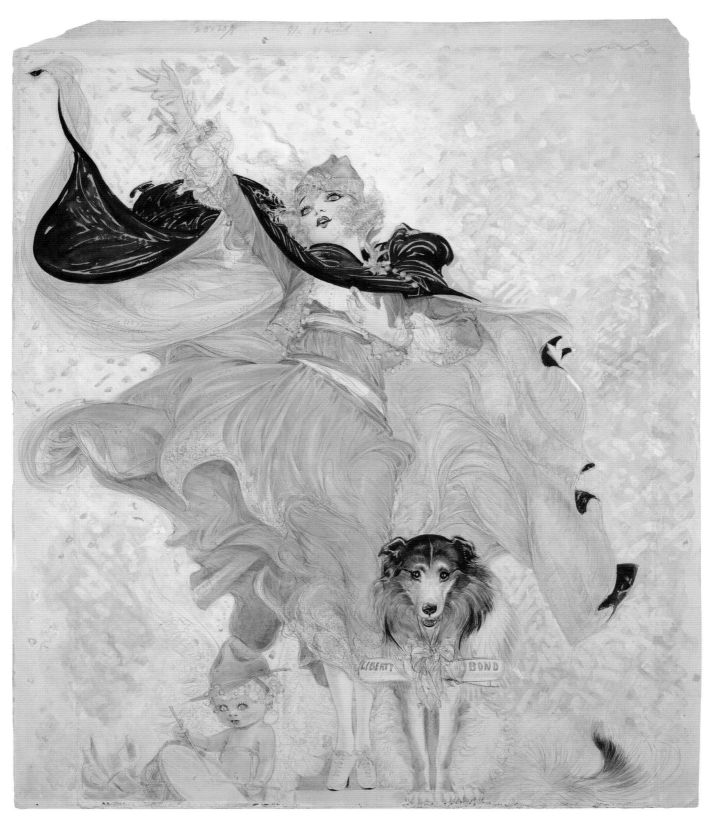

Nell Brinkley, "Golden Eyes with Uncle Sam" (1918)

Reginald Marsh's *New Yorker* Cartoons

Martha Kennedy

Reginald Marsh moved to New York in his youth and quickly became enthralled with the city in all its manifold aspects. Renowned later as a painter and printmaker of the American scene, he began as a freelance illustrator and a staff artist for the *New York Daily News*, then joined the staff of *The New Yorker* in 1925, the year it debuted. During the years he worked for the magazine (1925-1934), he covered movies and occasional plays, drew scenes of metropolitan life, and produced "Profile" portraits, all of which shaped the development of his humorous drawings.

Marsh's satiric cartoons for *The New Yorker* feature the foibles of the wealthy, the plight of urban lowlife, and the insignificance of individuals dwarfed by the vast energy and scale of modern American cities. In a 1925 cartoon he depicted two tiny figures observing the awesome, gritty backdrop of New York City with the wry comment, "Pretty,–isn't it?" His understated humor often relied on skillfully juxtaposed forms. He used broad strokes of crayon to define the massive skyscrapers, Brooklyn Bridge, and tugboats in a graphically bold, impressionistic manner, and incorporated crucial details in ink. The mechanical procession of automatons he drew in his graphical review for the Fritz Lang's modernist cinematic epic *Metropolis* astonishingly prefigures his later profoundly moving, iconic images of breadlines during the Depression. His acute, unsentimental observation of the city's people reflects an intense drive to capture their spirited vitality and variety within a sprawling, often inhumane, urban environment.

Reginald Marsh, "Metropolis at the Rialto," from *The New Yorker* (1927)

"PRETTY, — ISN'T IT?"

Reginald Marsh, "Pretty, Isn't It?," from *The New Yorker* (September 19, 1925)

Winsor McCay's Political Cartoons

Martha Kennedy

For decades Winsor McCay's bold, fine-lined drawings enlivened the editorial pages of leading newspapers such as the *New York American* and the *New York Herald-Tribune*. In spite of their superb draftsmanship, technical virtuosity, and imaginative conception, his editorial cartoons have yet to be given by historians the amount of time and attention they have lavished on his groundbreaking creations in comic strip and animation art.

McCay's political cartoons reflected the ultra-conservative viewpoints and self-righteous moralizing of his publisher, William Randolph Hearst, and editor, Arthur Brisbane. They treat issues of individual character and broad moral themes, pictured as allegories or parables set in otherworldly, fantastical settings that typically allude to past epochs of human history. His two-tiered composition "Mental and Moral Courage," for example, explores the Darwinian notion of life-threatening struggle and survival of the fittest. A monumental man personifying Mental and Moral Courage dominates a stormy, windswept vista struck by lightning bolts labeled "War," "Depression," "Calamity," and "Discouragement." McCay appeals to the human capacity for idealism in this somber vision rendered in

dazzling pen-and-ink work. His contemplative figure symbolizes hope that humanity's highest faculties, not physical might, will prevail in struggles with abstract, uncontrollable forces. Below this primary image he emphasizes man's ability to overcome physical, animal passions through an amazing frame-by-frame series of violent conflicts among scorpions, sloths, cocks, and pit bulls, and concluding with human boxers knocking heads.

He examines human ambition in another cartoon featuring a huge bejeweled pig labeled "Fortune Wealth" besieged by a horde of Lilliputian people who clamor to embrace it even as they drown in a sea of coins. In contrast, a few lonely figures attempt the rocky climb to the Temple of Fame beyond. The pig alludes to the sin of gluttony and biblical admonitions against the worship of idols or false gods, greed, and material excess.

In such dramatic, beautifully drawn compositions as these, McCay offered timeless moral commentaries during years bound by economic uncertainty, class conflict, social strife, moral indecision, and global conflict.

Winsor McCay, "Mental and Moral Courage" (1920s)

Winsor McCay, "Fame, Fortune, Wealth" (c. 1928)

OPPOSITE, TOP: Winsor McCay, "Wheels of Industry" (1920s)

OPPOSITE, BOTTOM: Winsor McCay, "City Crime Skyline" (c. 1930)

John Held, Jr.: The Jazz-Age Cartoonist

Elena Millie

The 1920s roared in under the heading of the Jazz Age. The Great War was over and the Nineteenth Amendment, giving women the right to vote, had been passed. It was a time of frivolity, syncopated rhythms, cars, "silents" with Charlie Chaplin and Greta Garbo, "talkies" with Al Jolson, jazz by Jelly Roll Morton and George Gershwin, such comic strips as *Little Orphan Annie*, *Thimble Theatre*, and *Tarzan*, and writings by D. H. Lawrence, T. S. Eliot, Eugene O'Neill, and F. Scott Fitzgerald, who is said to have coined the phrase "the jazz age." Fitzgerald's first two short story collections, *Flappers and Philosophers* (1920) and *Tales of the Jazz Age* (1922), set the tone of the decade. The up-and-coming artist and designer John Held, Jr., illustrated the latter and historians credit him with conjuring up definitive portrayals of the comic characters that defined the era.

Born in Salt Lake City, Utah, Held acquired and mastered the skills of drawing from his father, John Sr., a printer and musician. He learned about the stage and observing people from his mother, Annie Evans Held, who was an actress. At age nine, he sold his first cartoon to the *Salt Lake City Tribune* for nine dollars. At age twenty-

one, determined to become a successful cartoonist, Held moved to New York City, seeking a career in commercial art. In works ranging from advertising streetcar posters to film posters for the Metro-Goldwyn-Mayer studio, Held began to develop a style of his own. While working as a commercial artist, he continued sketching pen-and-ink cartoons on the side, which he sold first to *Judge* in 1922, and subsequently to other magazines.

These drawings portrayed the New Woman, called "chubby cuties," really the first flappers, which soon metamorphosed into "long-legged vamps," "Held's Belles," or "Betty Coeds," as these flat-chested flappers were called, were one-eyed, snub-nosed beauties, referred to as "shebas," wearing short skirts, showing panties and rolled hose, knees apart, and sporting long, tapered cigarette holders. Sheba's partners, referred to as "sheiks" or "Joe Colleges," wore bell-bottom pants, raccoon coats, porkpie hats, and sported pocket flasks filled with hooch while driving painted jalopies or maybe a Stutz Bearcat. Together they crooned and spooned and swung to the turkey trot, black bottom, or Charleston with abandon.

ABOVE: John Held, Jr., *Joe Prep* (1927)

OPPOSITE: Detail, John Held, Jr., "Julian and Julienne" (1916)

John Held, Jr., "Jazz Combo" (c. 1927)

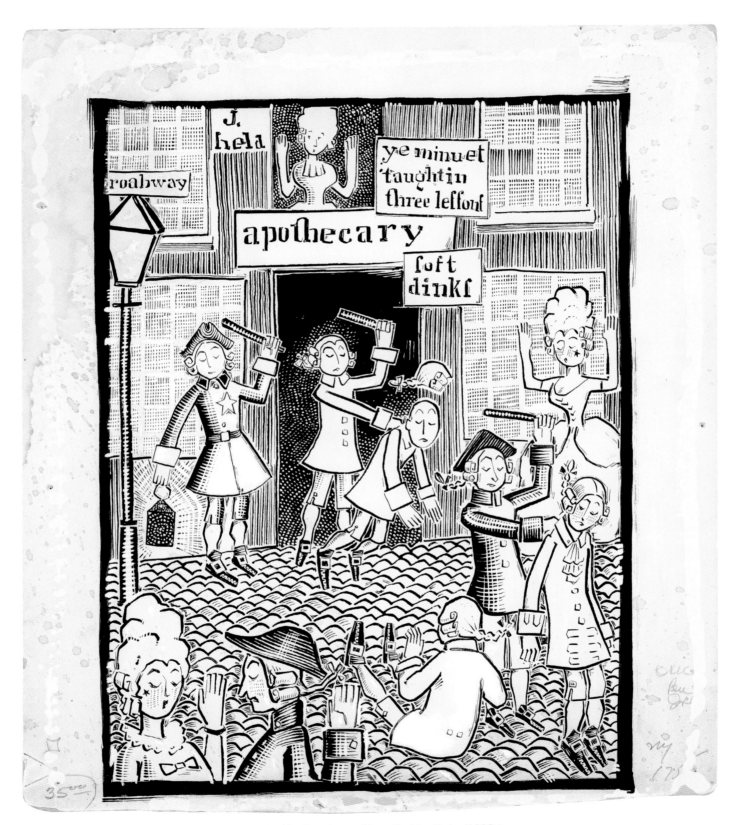

John Held, Jr., "Apothecary," from *The New Yorker* (1920s)

"The way he drew his flappers, what they wore, were all John's original ideas," Al Hirschfeld, a friend and colleague of Held's remarked. "I just imitated people," Held said, "and then they began imitating the people in my drawings." His pen-and-ink sketches were referred to as "thin-line drawings." "This was something new," said Hirschfeld, "and John was one of the first to use this style of drawing. His use of line communicated, determined the characters, created movement, and in turn defined the Roaring Twenties." So popular were Held's cartoons that William Randolph Hearst paid him $2,500 a week for his famous comic strip *Merely Margy* (1927). Later, he produced several other strips for Hearst, including *Joe Prep*, *Rah-Rah Rosalie*, *Sentimental Sally*, and *Peggy's Progress*.

In addition to his cartoon style, Held began imitating the early woodblock prints of English chapbooks, American melodrama theater posters, and nineteenth-century broadsides and ballads. Done in a nostalgic style, these linoleum cuts contained burlesqued

figures, puns, and witty sayings that appealed to his old schoolmate, Harold Ross, editor of the new magazine *The New Yorker*. Ross commissioned Held in 1925 to produce a steady supply of these images for his magazine. By the end of the decade, Held's name was also attached to almost every other major American magazine, including *Vanity Fair*, *Life*, *Harper's Bazaar*, *Redbook*, *Colliers*, *College Humor*, and *Judge*.

By the end of the era, as Held grew tired of drawing flappers, fashion and customs had changed. The Depression had come; long skirts, long hair, and conservatism were in. Russell Patterson, cartoonist of the "new look," took over from Held, who turned to his first loves: writing, sculpture, painting, and farming. He didn't regret the change. "Everything is an art," he said. "Art is art and shouldn't be classified so sharply. [Art] is the underlying theme of drawing, writing, designing and sculpture–all are interlocking. I came to New York looking for success, and I found it."

John Held, Jr., "Julian and Julienne" (1916)

Every Picture Tells a Story

Brian Walker

Words and pictures are the basic building blocks that comic artists use to construct entertaining and illuminating stories about the human experience in all of its remarkable variety. A gifted cartoonist can freeze a moment in time, suggesting previous events and future implications, relate a humorous anecdote, told in a sequence of images leading to a conclusive punchline, or unfold an epic narrative in daily or weekly installments.

Episodic continuity has been an essential element of newspaper comics almost from the beginning. The Yellow Kid went on an eighteen-week around-the-world tour in 1897 and Frederick Opper used the words "to be continued" in a three-episode sequence of *Alphonse and Gaston* in 1903. The cliffhanger approach, which required readers to wait until the next installment to see how a situation played out, was exploited by Charles Kahles in *Hairbreadth Harry* (1906) and Bud Fisher in *Mutt & Jeff* (1907).

By the 1920s, the majority of newspaper strips featured loosely constructed stories that could last a few days or ramble on for months. Thematic approaches varied from parody (*Minute Movies*) to pathos (*Little Orphan Annie*), slapstick humor (*Moon Mullins*) to situation comedy (*Thimble Theatre*). Extended travelogues were featured in *Barney Google* and *Bringing Up Father*. The "City of Gold" stories,

starring Chester Gump, and the globetrotting treasure hunts of Washington Tubbs II added the element of danger to the mix. All of these developments eventually led to the proliferation of serious storytelling in the golden age of adventure comics in the 1930s.

The cliffhanger strips, which were initially inspired by dime novels, serialized fiction, and vaudeville stage plays, eventually borrowed plotlines from motion pictures. Ed Wheelan created *Midget Movies* in 1918, but changed the title to *Minute Movies* in 1921, after switching syndicates. His troupe of paper players included the dashing Dick Dare, the lovely Hazel Dearie, the sinister Ralph McSneer, and the bumbling Fuller Phun. Wheelan Pictures, Ink, offered historical, western, detective, aviation, and sports scenarios, anticipating the major adventure genres of the 1930s. In 1923 Charles Kahles launched a daily strip version of his earlier Sunday-page creation, *Hairbreadth Harry*. These melodramatic morality plays revolved around the exploits of the dependably heroic Harry, the frequently distressed Belinda Blinks, and the predictably ruthless Rudolph Rassendale.

The picaresque (*picaro* is Spanish for "rascal") story strip evolved from early efforts by sports cartoonists like Tad Dorgan, Rube Goldberg, and Bud Fisher. Their creations typically featured con men and social pretenders who traveled the world in search of easy

ABOVE: Billy DeBeck, *Barney Google* (November 15, 1926)

OPPOSITE: Sidney Smith, *The Gumps* (October 17, 1926)

wealth and pretty women. Fisher was a former San Francisco sports cartoonist who launched the first successful daily strip, starring a racetrack gambler, Mutt, and his sidekick, Jeff. He won a legal battle with William Randolph Hearst for control of his creation and became the highest-paid cartoonist of the era. Mutt and Jeff fought in the trenches during World War I, visited such farflung locales as Turkey, Spain, and England, crossed paths with bootleggers, and dabbled in politics.

Another lovable rogue was Billy DeBeck's Barney Google, the "everyman of the jazz age." He mixed "Google highballs" in his kitchen the same month that prohibition was passed. He swam the English Channel with his racehorse Spark Plug in 1926 and sat on top of a flagpole for twenty-one days in 1927. DeBeck's rags-to-riches tales reflected the happy-go-lucky spirit of the times.

George McManus's *Bringing Up Father* represented an important transition between the slapstick humor of the early comics and the situation comedy strips of the 1920s. When it debuted in 1913, McManus's creation featured a repetitive gag formula that was typical of strips from the formative years of the Sunday funnies. Jiggs

was always sneaking off to Dinty Moore's tavern to eat corned beef and cabbage with his Irish working-class friends, frustrating his wife Maggie's efforts to civilize him. Her desperate striving for social status and financial success was a common theme in many of the family strips of the second wave of comic creations. *Bringing Up Father* was one of the first strips to be distributed internationally. Catering to their foreign clients, Maggie and Jiggs sailed off on a European tour in 1920 and traveled to Japan and Russia in 1927.

In addition to similar story lines, the new family strips featured a combination of stock character types. There was often a pretty daughter, a bumbling father, an all-knowing mother, a precocious younger sibling, and a trouble-making pet. Strips like *Polly and Her Pals*, *Toots and Casper*, *Tillie the Toiler*, *Winnie Winkle*, *The Bungle Family*, and *The Nebbs* incorporated many of these common thematic elements. Sidney Smith's *The Gumps* was the most successful creation in the emerging genre.

The Gumps debuted on February 12, 1917, before the term "soap opera" came into common usage, although Smith's creation is now regarded as the first strip to manipulate readers' emotions on a day-

to-day basis. The cast included Andy Gump, his wife, Min, their son, Chester, and wealthy Uncle Bim. In the first few years, the stories revolved around conventional domestic situations, but the tone of the strip began to change when Andy ran for Congress in 1922 and Uncle Bim was engaged to the conniving Widow Zander in 1923. *The Gumps* was one of the most popular strips of the decade and, in 1922, Smith signed a well-publicized contract with the Chicago Tribune-New York News Syndicate, guaranteeing him an annual salary of $100,000 and a new Rolls Royce every third year.

On February 1, 1925, seven-year-old Chester Gump embarked on a trip to the South Seas. This six-month Sunday-page continuity was written by Brandon Walsh and illustrated by Stanley Link. In the story, Chester, who was accompanied by his faithful Chinese servant Ching Chow, found himself in a gun battle with a native tribe, fired at the chieftain, and apparently killed him (the implied "death" took place outside of the panel borders). This event added a new element to the episodic continuity strip–the danger of life-threatening violence. During the next four years, Chester returned to the "City of Gold" for two more adventures.

Roy Crane's *Wash Tubbs*, which debuted on April 21, 1924, starred a mild-mannered, skirt-chasing grocery clerk who soon tired of daily laughs and set off to seek his fortune in the South Pacific. When Captain Easy entered the strip in 1929, Crane's feature had evolved into the definitive modern adventure strip, combining rollicking tales of hijinks in the far corners of the world with fisticuffs, gunplay, romance, and intrigue.

In the next decade, a new generation of artists continued to mold the story strip. Hal Foster introduced realistic rendering in *Tarzan* and Milton Caniff perfected his trademark cinematic technique in *Terry and the Pirates*. E. C. Segar (*Thimble Theatre Starring Popeye*) and Al Capp (*Li'l Abner*) further advanced the art of humorous story-telling. George McManus, Billy DeBeck, and Roy Crane remained among the leading contributors to the genre.

The Depression years are often called the "golden age of comics." Dozens of new features were launched, exploiting the entire spectrum of thematic possibilities and graphic styles. The artists of the 1920s set the stage for this fertile period. They showed that comics could do more than just entertain with slapstick humor. They took readers on adventures around the world. They told them stories that plucked their heartstrings. They introduced them to characters who would become lifelong friends. They created a fantastic world made of words and pictures. They were the early masters of a great American art form.

OPPOSITE, TOP: George McManus, *Bringing Up Father* (December 8, 1923)

OPPOSITE, BOTTOM: George McManus, *Bringing Up Father* (April 12, 1927)

ABOVE: Roy Crane, *Wash Tubbs* (1935)

Frank King's *Gasoline Alley*

Chris Ware

Every autumn, regular readers of the comic strip *Gasoline Alley* could at some point expect to join a plump Walt Wallet and his foundling son, Skeezix, on a twelve-panel walk through the reds, oranges, browns, and yellows of a crisply rendered midwestern fall landscape. Strolling through drifts of leaves painted by pats of sunlight or the blue dusk of a declining afternoon, the two would exchange idle remarks about what they saw or just happened to be thinking, and if there was ever any punchline to the strip, it was usually overshadowed by the natural beauty of the page as a compositional whole. An annual event, like autumn itself, this "walk" marked not only the approaching close of the year, but also highlighted the changes to its principal characters over the past twelve months as they'd grown and changed, because central to the imaginary world of *Gasoline Alley* was a simple, inevitable fact–its characters aged, week by week, month by month.

Just as the daily paper they were freshly printed on turned yellow, and then brown, Walt went from bachelorhood to adoptive fatherhood, to marriage; Skeezix grew taller, older, gained a brother, then a wife, and then a child of his own. Yet what seems a simple idea today was utterly unique when King thought of it; no cartoonist ever before had taken the regular commercial appearance of his feature and set it to running as the engine of the strip itself. Taken as a body of work, *Gasoline Alley* is not only a fifty-year-long comic strip novel that captures and distills the inevitable, ineffable passage of time through the regular touch of an artist's pen to paper, it was also a semi-autobiographical recreation of the feeling of life itself, which grew just as organically, for many of the people who lived on King's pages also lived in his real world; Walt Wallet was his brother-in-law, and Skeezix, his own son.

As cartoonists go, Frank King found success relatively late in life. Thirty-five years old when *Gasoline Alley* first appeared, he'd already been employed by various Chicago newspapers and advertising agencies for seventeen years, had suffered the loss of a stillborn child, and had seen the birth of another before the fame and artistic breakthrough of his strip took hold. Through this decade and a half, King worked his way through myriad crosshatched, lush, experimental, and flat-out virtuosic drawing styles, arriving in the mid-teens at a loose, thin-lined, simple mode of drawing that can best be described as visually transparent and unerringly unpretentious. Beginning in 1918 as a contributing feature to his

ABOVE: Frank King, *Gasoline Alley* (January 19, 1935)

OPPOSITE: Detail, Frank King, *Gasoline Alley* (June 24, 1923)

Frank King, *Gasoline Alley* (1921)

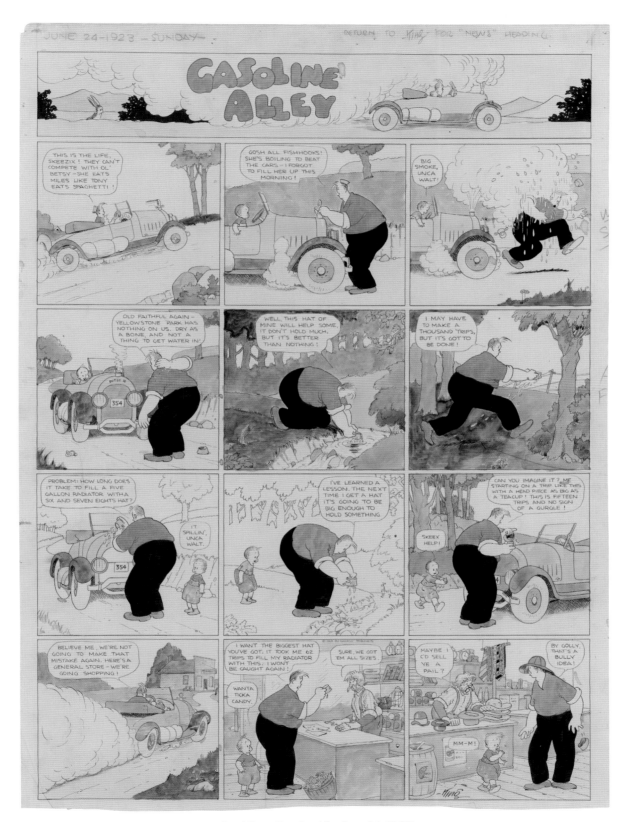

Frank King, *Gasoline Alley* (June 24, 1923)

catchall scattershot page "The Rectangle," *Gasoline Alley* was a banter-filled single-panel window into the world of a group of bachelors tinkering with their jalopies in a south-side Chicago back street. Within a matter of months, however, these men had resolved into distinct personalities, and one of them, Walt, into the strip's protagonist.

Had the feature stayed in that form, however, it would've died a quiet death on the junkpile of newsprint that had already buried many of King's earlier efforts: *Motorcycle Mike*, *Augustus*, or the *Little Nemo*-esque *Bobby Make Believe*. What changed *Gasoline Alley* forever was the now-famous appearance on Walt's doorstep of an abandoned child in February of 1921, a rough little explosion of the simple nature of life into a world of men not wanting to settle down and take something seriously. Before long, this foundling, nicknamed Skeezix, also began to take on a life of his own, talking and walking, and, right before the reader's eyes, making Walt and Skeezix into the first convincing love story ever to appear on the daily comics page. (Allowing, of course, for the ruling circadian triumvirate of Krazy, Ignatz, and Officer Pupp.) Though the strip was generally of the "gag-a-day" format, it was not unusual for King to suddenly left-turn from humor to genuine despair and drama, as when, early on, Skeezix took ill and Doc, an *Alley* regular, gave an uncertain diagnosis as to his survival. In his best moments, however, King perfected an odd balancing act between humor and drama, a condensation of the texture of life into reassuringly gaglike, though not necessarily funny, paper gems of experience.

This was not, however, the thrilling, high-octane experience that was increasingly finding its way into the movies (and which, in my opinion, would consequently ruin the comic strip for decades) but a series of seemingly unrelated niggling events, all overshadowed by a nagging feeling of something, somewhere, pushing it all forward. For example, the daily strip of April 7, 1921, concerning the seemingly disconnected topics of Walt worrying about finding a wet nurse for Skeezix while filling his radiator with a leaky, bent hose, has no clever gag or pun to fit it all together. A lesser cartoonist might've tried to make the hose "work" as some sort of metaphor or joke; in King's hands it simply is, and consequently feels real and utterly unforced; its very lack of contrivance is what holds it together as art. Walt is worried about finding help to look after Skeezix, his hose gets bent; that's what happens. To make an aesthetic analogy,

it's sort of like the difference between genuine writing and simple storytelling. The effect is oddly comforting, even affectionate. King's characters move forward, day after day, from left to right, leaving life in their wake, just like the rest of us.

Of course, there are big themes in *Gasoline Alley*, but they are universal ones, the functional undercarriage indistinguishable from the engine and tires of everyone else's car. The times that King did allow himself to introduce souped-up intrigue or melodrama to the strip, it felt out of place, as during a drawn-out custody battle over Skeezix's birth mother, or an inexplicable trip to Africa which Skeezix somehow managed with some school chums in the early 1930s. These were odd experimental blips, however, excusable for someone who must've realized that he'd devoted himself to a taken-for-granted calling that he'd essentially be stuck with for the rest of his life–some weariness and doubt must have periodically crept in.

Most of the time, however, the human concerns of love, marriage, happiness, and family were what kept the strip running just fine, all tempered through the partially biographical lens of King's own home life. The daily strip delineating the anxiety of Skeezix's imminently being shipped off to military school (page 162) was a topic painfully close to King's own; his son Robert was sent away to school and only returned home for summers. *Gasoline Alley* began as a strip about the fad of automobiles and ended up, through King's genius, a personal, modest mirror of his own experience.

The history of the preservation of the comic strip is now in its second generation, those interested in the medium now having no connection to the nostalgia associated with childhood Sundays spent sprawled on top of some freshly printed color section wondering whether Buck and Wilma were going to be vaporized or feathered Prince Valiant would vanquish his foes. And thus, I think, some of the quirkier and more personal strips that have lain dormant in the background for a few decades will start to come to life as the superior works of art that they are. I have no doubt that within my lifetime *Gasoline Alley* will be realized as one of the finest comic strips ever drawn, and that Frank King's heartfelt life's work will be recognized as being not only a rich source of inspiration to other aspiring cartoonists, as it has been to me and my generation, but also a source of comfort, solace, and reassurance for anyone, cartoonist or not, who reads it. Even the smattering of days presented here, I think, prove that point, quite humbly.

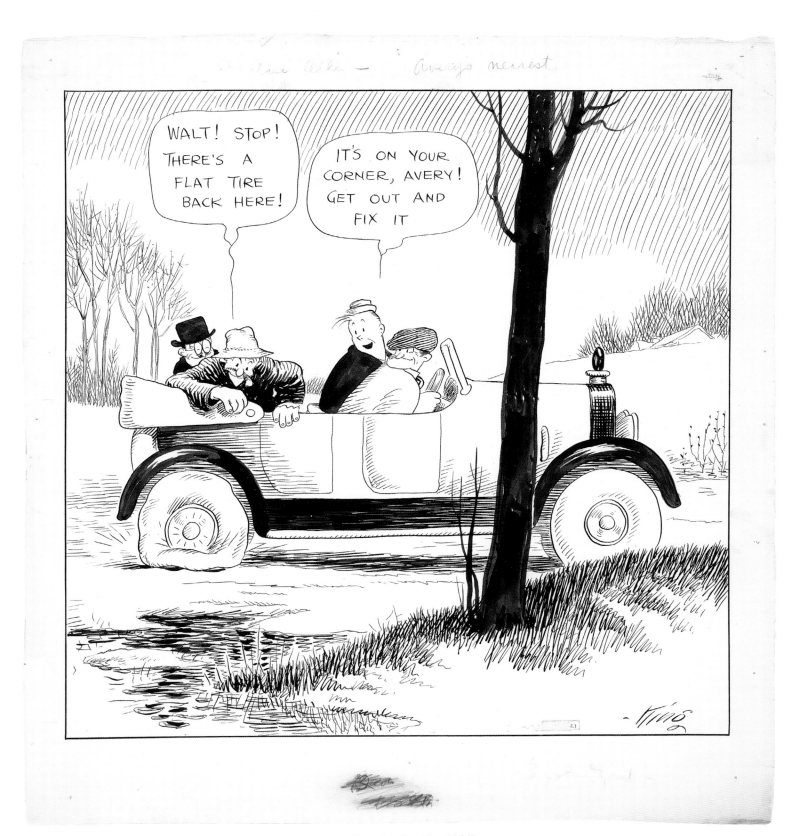

Frank King, *Gasoline Alley* (1921)

K'Mon "Klio" Tune Up the Old Harp, and Let's Go. Zip. Pow! (♥)

Patrick McDonnell

Krazy Kat is timeless. George Herriman conjured up his classic comic strip every day from 1911 through 1944. I first met the Kat much later–in the 1969 Holt reprint book. *Krazy Kat* was unlike anything I had ever seen. The art was organic and surreal, the wordplay pure poetry. The characters were alive on the page. Fantasy and nonsense–it was about nothing and everything. *Krazy Kat* seemed one with the flower children in the psychedelic sixties. It was like being hit by a brick–and falling in love.

In 1986 I collaborated on the Abrams *Krazy Kat* monograph. It felt as if I was again seeing the artwork for the first time. *Krazy Kat* was right at home with the alternative, edgy, punk comics that were alongside it in Art Spiegelman's *Raw* magazine. Now, twenty years later, in the age of the sophisticated storytelling of the graphic novel, I am still struck by how innovative the strip remains with sixty years having gone by since the last one was drawn. *Krazy Kat* hasn't aged a day. We who are "caught in the web of this mortal skein" have to deal with the "klock rock," but the Kat knows no time.

Time plays a big part in a daily cartoonist's life: we live and die by deadlines. But in the act of creating, time stands still. *Krazy Kat* lives in the now. It abides where all great art lives: in the cosmos, where time and space are merely toys to play with in the hands of a master cartoonist. Krazy is like "ectospasm running around william & nilliam among the unlimitliss etha," "unleashed, unfettered, and unbound a free spirit." And what of space? Herriman's world is in constant flux–backgrounds shifting and changing like mirages in the desert with majestic mesas and slivers of moon; night becoming day, and day night, all in the blink of a panel. Like the American southwest landscape of Monument Valley from which it is based, it is sacred ground that inspires awesome stillness where time is forever.

Krazy Kat is the stuff that dreams are made of. Herriman goes fishing for ideas in a deep inkwell. Improvisation made manifest by a truly creative and self-trusting, egoless imagination. Slapstick, vaudevillian, and crude on one level, but poetic and mysteriously profound on another. On the funny pages of American newspapers

ABOVE: George Herriman, *The Family Upstairs* (c. 1911)

OPPOSITE: George Herriman, *Krazy Kat* (1942)

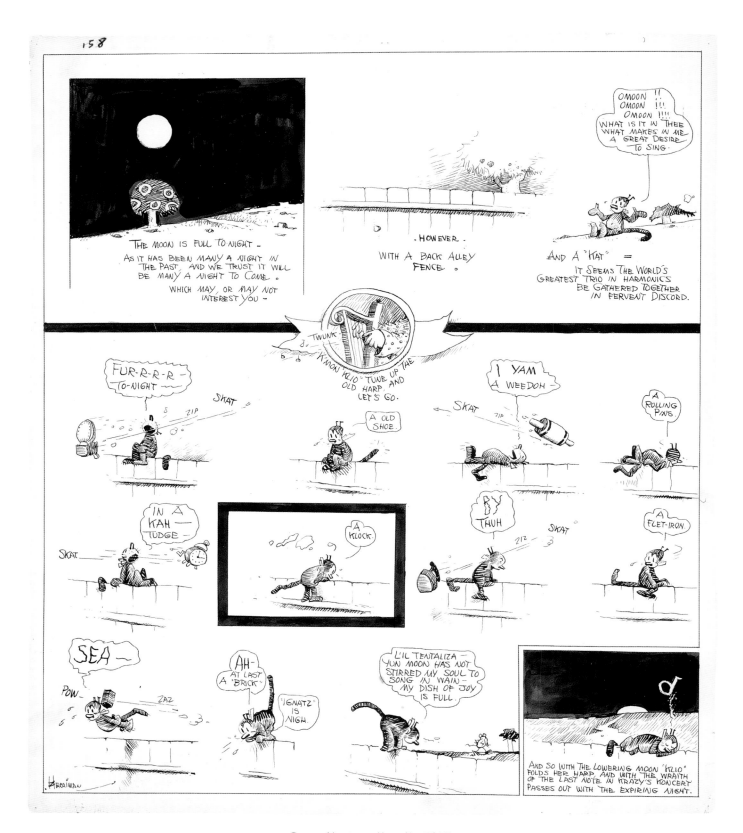

George Herriman, *Krazy Kat* (1917)

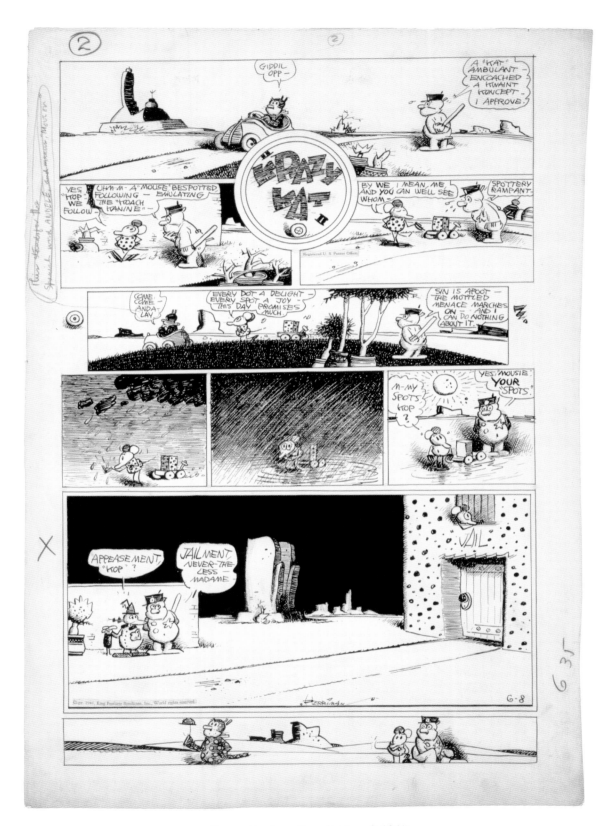

George Herriman, *Krazy Kat* (June 8, 1941)

Herriman explores such unlikely comic-strip subjects as the forces of nature, the creation of art, the wonder of science, the magic of mysticism, and the power of spirituality. His pen line flows like handwriting: strong, personal, unselfconscious. His words were "plain language, but in a higher plane." Everything plays in wonderful balance: layout, characters, backgrounds, the telling of a gag, to the delivering of the pow of the punchline–which brings us to the brick and the eternal triangle of Kat, Mouse, and Pupp.

Ignatz Mouse, who despises all cats, derives pleasure from "beaning that Kat's noodle" with a brick, an obsessive act he attempts to perform everyday. Offissa Pupp, unrelenting enforcer of order, seeks to protect "that dear Kat" from "sin's most sinister symbol."

Krazy Kat awaits each brick with joy, considering the hurled bricks "missils of affection."

Pupp follows the laws of society; Ignatz, his ego; and Krazy, her heart. Krazy believes "[i]n my Kosmis there will be no feeva of discord . . . all my immotions will function in hominy and kind feelings." Love, indeed, conquers all; it's the heart and soul of the strip. For thirty-three years Herriman created endless variations on this universal theme. For the only thing that is real is love and, thus an eternally heppy heppy kat.

George Herriman, *Krazy Kat* (March 19, 1944)

Blondie Gets Married

Sara Duke

Blondie Boopadoop entered the world more than seventy years ago, on September 8, 1930, the featured character of a new comic strip by Murat Bernard "Chic" Young (1901-1973). A flighty flapper, at first she dated playboy Dagwood Bumstead, son of the millionaire, J. Bolling Bumstead, a railroad magnate, and had several other boyfriends. The comic strip foundered, however, until Young decided to have the couple fall deeply in love. Desperate to wed Blondie, in spite of his father's objections to her lowly social status, Dagwood went on a hunger strike until the elder Bumstead grudgingly acknowledged their relationship but refused to continue to support his son. The couple married on Friday, February 17, 1933, and Dagwood, now disinherited, stripped of his wealth and family connections, was nonetheless blissfully happy with his sparkling, vivacious, yet unfailingly practical new bride. Americans, caught up in the woes of the Great Depression, immediately took to Chic Young's humorous daily reminders that love, not money, conquers all.

Blondie has been different from other comic strips from the start. Once she had married, Blondie ceased to be flighty; she had barely left the altar before asking Dagwood to help out with the housework, using flattery and gentle trickery to bend him to her will. Since 1933 he has done dishes, helped care for the children, cleaned the attic, and cooked an occasional meal. Shortly after their marriage, in fact,

Blondie organized local housewives and lobbied for an eight-hour day. She led Dagwood to the sink full of dirty dishes with a wink to newspaper readers, many of whom might have felt overburdened by long days of managing a household. Blondie is the center of the Bumstead family household, capable of stopping Dagwood's tirades with a single look. Yet it is Dagwood's zany antics and constantly foiled pursuit of personal pleasure that people remember: the huge sandwich made of apparently incompatible foods, the nearly missed bus, running into the mailman, Mr. Beasley, and the interrupted baths and naps. Dagwood is the perfect foil to Blondie's steady ways.

Chic Young's daughter, Jeanne Young O'Neil, recalls:

Each day, my very disciplined father went into his office (always in our home) to create his beloved comic strip, *Blondie*. For me that meant the unique privilege of having two loving and caring parents twenty-four hours a day. What it meant for Dad, I believe, was twenty-four hours of daily family life with all its unique activities, rituals, and interactions to observe and analyze. He was truly "in the trenches," to get ideas. His genius was in seeing the moment, knowing how and when to embellish or simplify, and how to cap it off with a rib-tickling punch line. Once he got the idea, Dad could whip all four panels out in a matter of minutes,

Chic Young, *Blondie* (February 17, 1933).

drawing with his hand and arm in constant motion . . . a fascinating feat!

My father would emerge from his studio each afternoon with the penciled "proof strips" in hand and run them by my mother, Athel Lindorf–an accomplished concert harpist and the consummate speller–to get her expert opinion and, if necessary, editorial corrections. I believe their lifelong teamwork was another reason for Blondie's great success. Dad really understood the man/woman relationship.

My father could send in ideas from anywhere, which meant we could travel a great deal. Every other year, we moved–kids, cars, dogs and all, from California to Florida and back again (except for the years in Europe, Hawaii, and the dude ranch in Tucson). Wherever we went, my shy and gentle father people-watched. We walked and watched with him . . . looking at people doing what they do and noticing where they did it. That unquenchable love of seeing, really seeing, made him a top-notch expert on ordinary folks everywhere.

As I write I have his 1919 McKinley High School Yearbook in hand, enjoying his early cartoons sprinkled throughout. By his name it says, "Hobby–drawing cartoons, Greatest Desire–to be funny." So simply stated. So clearly expressed. I know he fulfilled his dream every day when I think of him saying, "I've succeeded if I bring a smile to someone somewhere."

Chic Young produced more than fifteen thousand *Blondie* strips during his career, building an enduring legacy of inventiveness, humor, and creativity.

Clare Briggs's Small-Town Humor
Edward Sorel

Fortunately for young Clare Briggs, the new technology of halftone photography had not yet reached the *St. Louis Globe-Democrat*. They were still illustrating the news with pen-and-ink drawings, and in 1896 needed an artist. Briggs got the job. Compared with his birthplace in Reedsburg, Wisconsin, St. Louis was a sophisticated metropolis shimmering with opportunity, and two years later he succeeded to the elevated position of editorial cartoonist for the *St. Louis Chronicle*. But when the Spanish-American War ended, so did his job at the *Chronicle*. Worse yet, all newspapers now had the means to reproduce photographs, and no longer needed his skill at drawing in line.

After months of unemployment he landed a job as courtroom artist with Hearst's *New York Journal*, but it was obvious to the editor that Briggs was more a cartoonist than a sketch artist. In 1904 he was transferred to Hearst's *Chicago American* to create a comic strip. It was called *A. Piker Clerk*, and its hero was a racetrack tout. In one of the early episodes Briggs caricatured the Tsar of Russia. Hearst was not amused, regarding it as vulgar to ridicule a foreign dignitary in a comic strip. He axed it on the spot. Briggs packed up his pen points and moved to the *Chicago Tribune*, where he was allowed to work in a single-panel format rather than a strip. Now liberated from having to deal with one comic character, Briggs began turning out wonderfully evocative drawings about small-town life and the joys and tribulations of growing up, drawn essentially from his own childhood. These bittersweet drawings represent a unique departure from previous comics. For the first time sentiment and personal recollection replaced slapstick and punch lines on the funny pages.

Cartoons about rural life were not new by 1908, when Briggs arrived at the *Tribune*, but Briggs's humor was subtle, not broad. His view of the small town was warm, affectionate, and above all, personal. The public responded enthusiastically. Here were characters just like people they knew—and like themselves—in situations that seemed barely exaggerated. The public especially empathized with those cartoons called *The Days of Real Sport*, Briggs's nostalgic drawings about what it was like growing up in a small Wisconsin town. To judge by the careful attention to detail in this group of drawings, they had a special meaning for Briggs as well as his readers.

By the time his contract with the *Chicago Tribune* expired in 1914, Briggs was one of the most popular cartoonists in America. He had his pick of any newspaper, and eager to return to New York—this time as a big success—he chose the *New York Tribune*. Given a generous amount of space, Briggs alternated between strips and single-panel cartoons. His white-collar readers had no trouble relating to the characters in Briggs's cartoons: husbands who couldn't fix things around the house, wives who wouldn't concentrate on their bridge game, and executives beset by incompetent workers. In all of these, the skill he honed as courtroom sketch artist show up in the effortless way he handles gesture.

The picture of an innocent America presented was in sharp contrast with what *Tribune* readers saw all around them: flask-carrying boozers in raccoon coats, short-skirted flappers drinking and smoking, and chauffeur-driven Wall Street speculators. Briggs's cartoons reassured readers that there was once an America where boys got up early to do farm chores, where long-haired, long-skirted girls blushed easily, and where Mom made buckwheat cakes on a wood stove.

Briggs became rich, moved to the suburbs in the 1920s, and developed a passion for golf, like other upwardly mobile business men. He brought his suburban life into his cartoons, just as he had his earlier life in the Midwest, and it proved just as funny. Briggs's affluent middle age was, after all, just as typically American as his simple, rural childhood.

Clare Briggs, "The Days of Real Sport: The Valentine" (1920s)

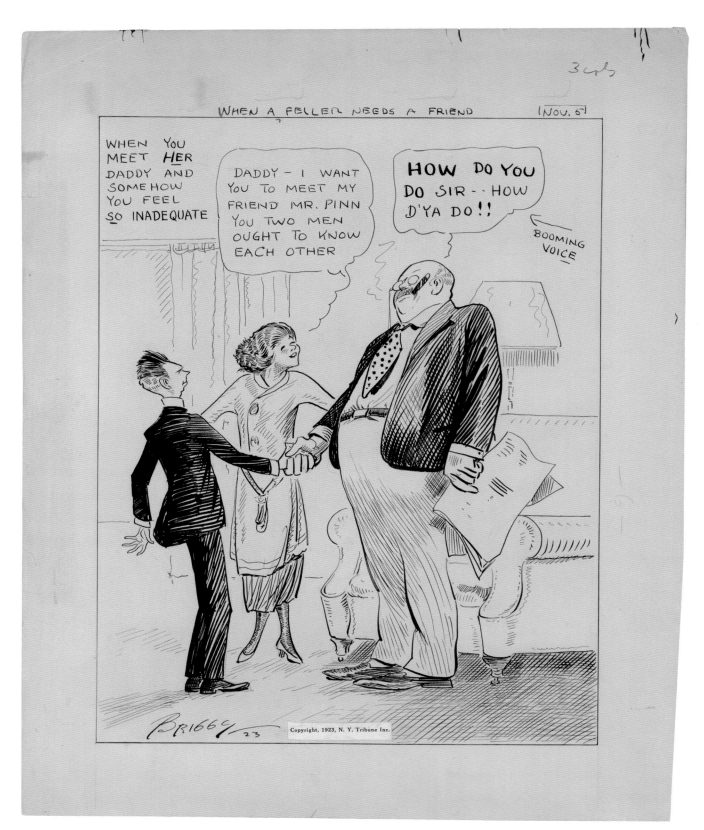

Clare Briggs, *When a Feller Needs a Friend* (November 5, 1923)

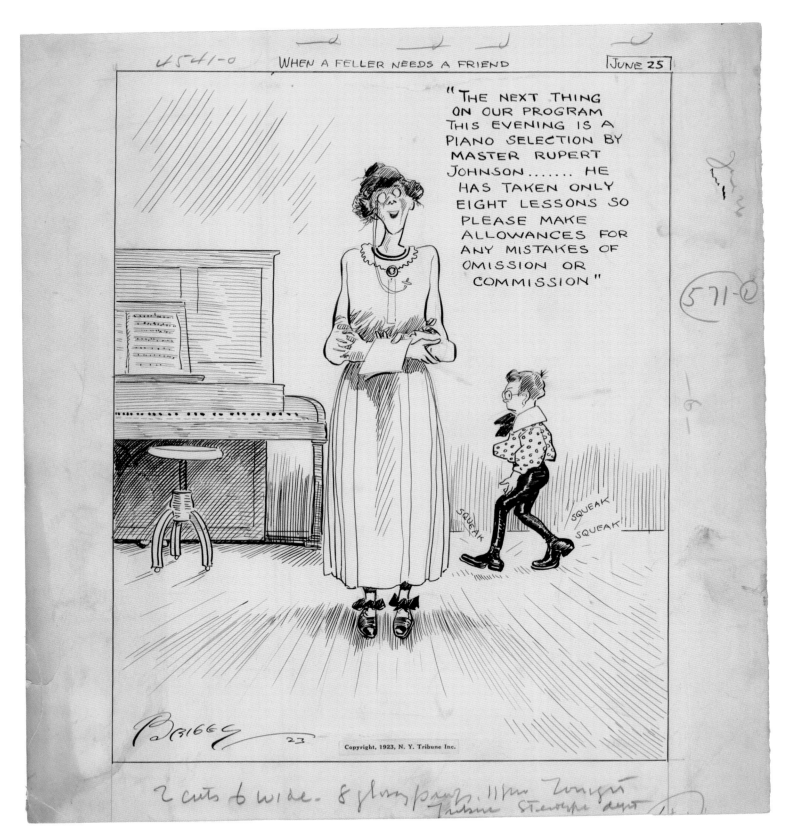

Clare Briggs, *When a Feller Needs a Friend* (June 25, 1923)

Humor Devoid of Nonsense: The Caricature Drawings of Miguel Covarrubias and Al Hirschfeld

Wendy Wick Reaves

How did the great masters of caricature do it? What gives us that little burst of joy and wonder when we encounter Miguel Covarrubias's *Paul Whiteman* or Al Hirschfeld's *Betty Hutton*? Covarrubias (1904-1957), who died in his fifties, helped invent the profession of celebrity caricature in the 1920s and played a dominant role for the next two decades. His contemporary Hirschfeld (1903-2003), who died nearly half a century later, captivated generation after generation over the course of seven decades of drawing. Even in today's era of digitally enhanced picture-making, their meticulous, hand-drawn portraits deliver a magical, timeless punch.

The new mass media-generated celebrity culture of the post-World War I era exalted those with "personality." So did an innovative generation of caricaturists, including Mexican-born Covarrubias, who began drawing café society notables shortly after his arrival in New York City in 1923. By 1925, newspapers and magazines were clamoring for his incisive caricatures, and his lighthearted portraits of the famous soon permeated the press. In a crowded field of contenders, Covarrubias's images stand out. His *Robert Benchley* and his *Paul Whiteman*, both from the mid-1920s, bristle with the sophisticated adaptation of international art trends: a sinuous Art Nouveau line, the sharp clarity and geometric stylization of Art Deco design, and Cubist reduction and conflation of features. But Covarrubias combined his ingredients with masterful draftsmanship and wit. He bent back the top of Benchley's nose into arched eyebrows. He conflated the bulbous side of the nose with the smile line above the mouth. And do those tiny spikes above the smile portray a thin mustache–or nose hairs? Covarrubias's iconic *Whiteman* goes even further in this visual punning, as he spoofs Picasso's and Braque's incorporation of musical instruments and conjures up the features of the band leader's compacted face with minute zigzags, circles, and arches. Somehow the humor never interferes with his high aesthetic standards. "They are bald and crude and devoid of nonsense," Ralph Barton wrote about Covarrubias's drawings, "like a mountain or a baby."

Vanity Fair magazine exploited its new printing technology in the 1930s by showcasing Covarrubias's work in color. His 1933 *Emily Post* appeared in a series entitled Private Lives of the Great. The propped-up feet, spoon in the teacup, *Police Gazette*, and other details hilariously undermine the etiquette maven's reputation. But Covarrubias nails the portrayal through his draftsmanship: concentric shadows under the eyes, frizzy spirals in the hair, corny pastel hues, and the absurd crook of a little finger. Color, form, and composition always add to his humor and the ingenuity of his portrayal.

Covarrubias, who briefly shared a studio with Hirschfeld in the 1920s, undoubtedly inspired him to become a caricaturist himself. In Hirschfeld's magnificent 1935 drawing *Jumbo*, the figure of Paul Whiteman on the far right pays tribute to Covarrubias's version from the chubby round face and swoop of a chin to the abstracted features. And throughout the drawing, Hirschfeld borrows Covarrubias's device of shading his figures with sharp, tapering black lines. But Hirschfeld's sensitivity to texture, pattern, and movement is all his own. Using only black ink and ingenious mark-making, he dresses Jumbo in the rough, thick skin of an elephant and sends him soaring with all the grace and weight of a giant leaping animal. The fondness for graphic patterning and witty, visual invention seen in *Jumbo* and the 1952 *Betty Hutton* emerges early and is a distinctive feature of his work.

No one tops Hirschfeld's understanding of body language. Consider the dancers of the 1944 *Stage Door Canteen*. Each dances differently: the men torque and spin with masculine brio while the women move with feminine grace. Betty Hutton catapults across her page with a similar compelling dynamism. Any of us, as Hirschfeld has noted, can recognize the figure of a friend from a distance; he has a nearly unique ability to translate that intuitive perception into line.

And what a line. The contours of Hutton's arms give the wonderful illusion that Hirschfeld can barely control his pen. While Covarrubias's line feels inevitable and immutable, Hirschfeld's is a living thing, ready to explode with whiplashing power and turn into someone else. No wonder these drawings retain the power to astonish and delight us.

OPPOSITE: Miguel Covarrubias, "Emily Post," from *Vanity Fair* (December 1933)

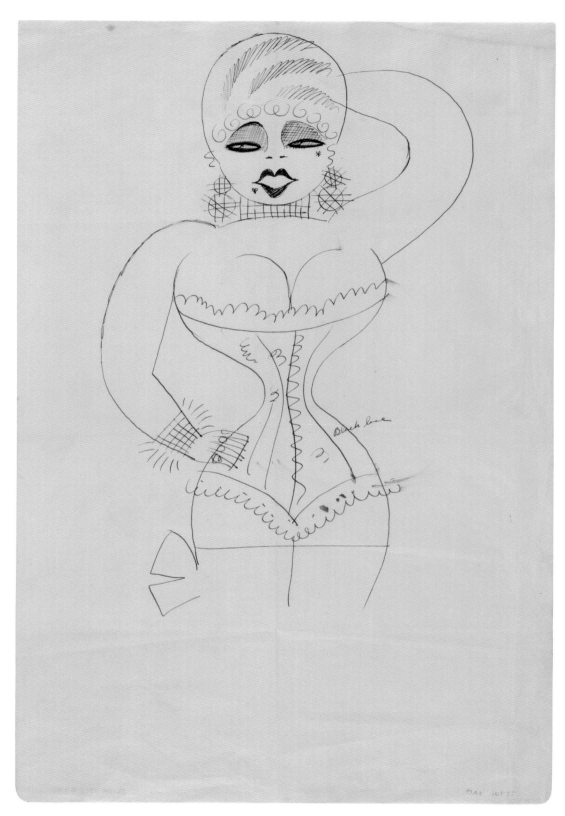

Miguel Covarrubias, "Mae West" (c. 1930)

Miguel Covarrubias, "Robert Benchley" (1920s)

Al Hirschfeld, "Jumbo Opens October 26th at the Hippodrome" (1935)

...RCH OF ANIMALS TRAINED BY JOHN T. BENSON) PAUL WHITEMAN ~ OPENS OCT. 26ᵗʰ HIPPODROME

JUMBO

HIRSCHFELD

Al Hirschfeld, "Betty Hutton at the Palace" (1940s)

604

Al Hirschfeld, "Marie Cahill in *Merry Go Round*" (c. 1927)

Animation Art at the Library of Congress

John Canemaker

Most animated films (even today) begin with conceptual or, as they used to call them at the Disney studio, "inspirational" sketches. The purpose of conceptual sketches of this type was to inspire others on the creative crew–the sequence director, the layout artists, the animators, among others. Such a dramatic drawing would have opened up visual possibilities regarding the scene's mood, mise-en-scène, lighting, character relationships, costumes, background, props, and so on.

The Library collections contain some wonderful examples, such as a gray charcoal drawing with touches of yellow and orange highlights from Walt Disney's first animated feature, *Snow White and the Seven Dwarfs* (1937). The scene depicts the princess Snow White looking quite small, lost, and confused in a dank and gloomy forest. She is alone except for a silhouetted wolf baying ominously on a not-too-distant hilltop. Barely decipherable faces within the background's trees and rocks add to the picture's ominous feeling.

This particular inspirational sketch was made by Ferdinand H. Horvath (1891-1973), a Hungarian immigrant who was a successful book illustrator in New York until the Depression made jobs in his field scarce. Reluctantly, he sought work at Disney's Hollywood studio in 1933, and for the next four years he contributed hundreds of idea sketches for the *Silly Symphonies* (a series of musical shorts) and *Snow White*. An accomplished and prolific artist, Horvath had a healthy ego to boot; he is one of the few artists who dared sign his work at Disney's studio, where anonymity was tacitly expected in deference to Walt. Mostly, though, his wit and sensibilities were too dark and weird for Disney and his staff. He left in 1938 without ever receiving screen credit for his many contributions to Disney shorts and first feature.

Tyrus Wong (b. 1910) was another inspirational sketch artist whose tenure at Disney was very brief indeed; his conceptual drawings had a considerable impact on a single film: *Bambi* (1942). In the Library there are two fine examples of this special artist's work from that film. Wong combined spontaneity with contemplative compositional balance, and the limitation of detail and pictorial restraint found in traditional Chinese art. His ideas for *Bambi*'s color, mood,

placement of characters within settings, and dynamic action are evident in a pastel of a stag on a distant mountain and a watercolor of two deer watching a raging fire. Such simple, direct, and beautiful imagery by Wong profoundly influenced the film's art direction. He went on to a lengthy career as a film production illustrator at Warner Bros. and a greeting card artist. At this writing, five years before his hundredth birthday, he continues to live a creative life by constructing and flying large, imaginatively designed kites.

Marc Davis (1915-2000) was among Walt Disney's favorite phalanx of animators whom he designated his Nine Old Men. It was Davis's versatility as an artist that impressed Disney, who put the artist's creative gifts to use on a variety of studio projects. As a master animator, Davis animated, for example, Tinker Bell in *Peter Pan* (1953), Maleficent in *Sleeping Beauty* (1959), and Cruella De Vil in *101 Dalmations* (1961), among many other characters; as an "Imagineer" he designed attractions and rides for the Disneyland and Walt Disney World theme parks, such as The Haunted Mansion and Pirates of the Caribbean). Early in his career, Davis was a story man and inspirational sketch artist for various feature films. The Art Wood Collection contains a dynamic pastel on black paper from the wartime feature *Victory through Air Power* (1943) that shows a damaged fighter plane spewing orange, yellow, and white flames that illuminate the clouds as it twists and pinwheels through the sky toward earth below.

Davis also made profoundly influential idea sketches and character designs for *Bambi*. His drawings of deer were, in fact, a breakthrough for the animators of that film; for Davis found a way to retain the deer's anatomy while allowing for the expression of believable human emotions and facial expressions. In one pastel sketch in the Wood Collection, Bambi is surprised while drinking from a small pond by his future mate, Faline; in another drawing the young stag emerges dazed from under a bush, obviously smitten and in love (or "twitterpated," as the animals describe it in the film).

In most animated film productions, after concept sketches were approved, a storyboard came next. Old-timers called this part of the

OPPOSITE: Marc Davis, *Victory Through Air Power* (1943)

Ferdinand Horvath and Walt Disney Studios, *Snow White and the Seven Dwarfs* (1937)

Tyrus Wong and Walt Disney Studios, *Bambi* (1942)

Max Fleischer Studios, King Bombo from *Gulliver's Travels* (1939)

process "hangin' out the wash"; that is, likening the drawings of the film's narrative pinned up sequentially on a corkboard to wet garments hung on a clothesline. Storyboards, however, more resemble a giant comic strip. In rows of sequential drawings, weak spots in the narrative are easily spotted and corrected; by merely substituting one sketch for another, the story line and characters are (hopefully) strengthened and developed. Story sketches can be drawn elaborately or simply, but all must "read" quickly and convey vital visual information to the viewer at a glance.

The Art Wood Collection includes an exuberant series of story sketches by an unknown story artist for *Gulliver's Travels*, the 1939 Max Fleischer feature. (The Fleischer studio was Disney's only rival in the area of feature-length animated films during this period.) These simple scribbles are a kind of graphic shorthand and appear to have been made in a hurry. Whether this was due to a looming deadline or a burst of creative imagination, we'll never know. The drawings convey a wealth of basic information regarding everything from camera angles to character relationships and dialogue.

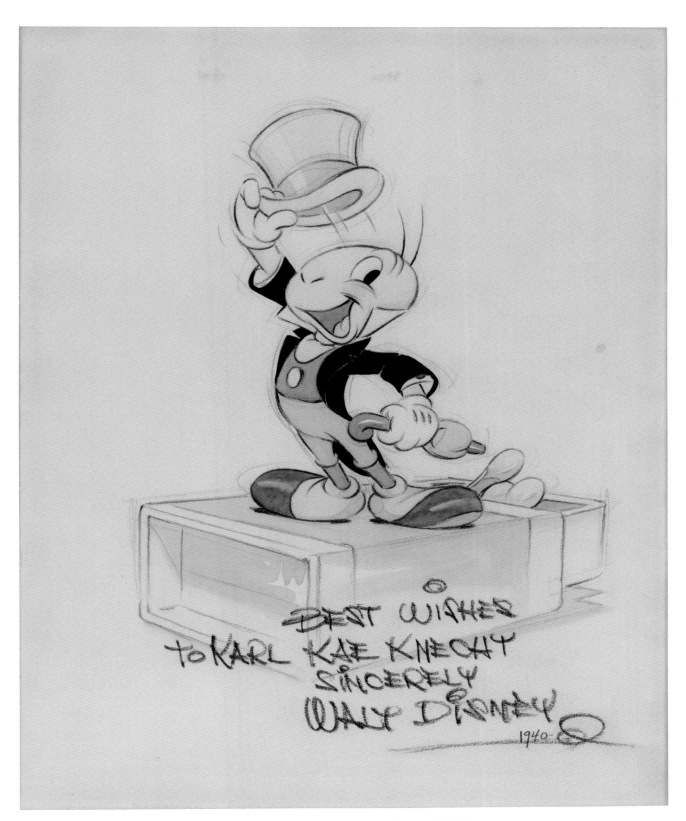

Walt Disney Studios, Jiminy Cricket from *Pinocchio* (1940)

Walt Disney Studios, Mickey Mouse as the Sorcerer's Apprentice, *Fantasia* (1940)

Another series of story sketches demonstrate the fragile nature and fate of story sketches and why story artists are warned to be detached from their highly disposable artwork–"never fall in love with your drawings" was a wise industry dictum. These particular sketches were drawn for a sequence in *Snow White* that was developed over a period of time but ultimately dropped from the final picture. Here, the Seven Dwarfs surprise the young princess by building her a queen-size bed. Preceding that decision, the little men each think of a gift suitable for the young princess, as seen in a series of exploratory sequential sketches. Happy, for instance, suggests "a crown of precious jewels." There are within the drawings suggestions for personality touches, such as Sneezy combing his fingers through his beard while thinking; and cantankerous Grumpy and pompous Doc arguing loudly. A subsequent sketch of Grumpy alone, looking toward

Walt Disney Studios, Mickey Mouse (1928)

the left with a strand of hay in his downturned mouth, is a perfect depiction of his typically angry disposition and crabby personality.

"Clean-up" drawings are refined, detailed animation sketches made from the rough animation drawings of the master animator. Assistant animators (called "clean-up" artists) trace onto new paper a spruced-up version of the rough drawings, conforming all loose pencil lines, adding details, and making sure characters are "on-model." Two fine examples depict Mickey Mouse at different stages in his long career; one is from the 1934 short *Two-Gun Mickey*, wherein the famed rodent dressed in cowboy garb tosses a gun into the air before disposing of bandits and rescuing his girlfriend, Minnie. The other was drawn six years later for *Fantasia* (1940), in which Mickey played (arguably) his most famous role as Sorcerer's Apprentice. Disobeying orders not to practice black magic, Mickey, with the help of an army of monstrous brooms, floods the sorcerer's cavern and almost drowns himself. Here, the sadder-but-wiser mouse cringes before the (unseen) wizard in anticipation of picking up a single now-harmless broom.

When we compare the look of Mickey in 1934 and 1940 we notice certain developments in Mickey's appearance: a larger, more childlike head, smaller ears, and (most obviously) the addition of eye pupils to replace the pie-wedge black ovals. The Mouse is now more emotionally expressive; to see just how dramatic a change occurred in this famous character's appearance over a mere dozen years, take a look at a 1928 drawing from one of his first films.

Ub Iwerks, a pal of Walt Disney's from Kansas City, created the original design for Mickey Mouse (seen here) and animated his earliest films single-handedly. The design, termed "rubber-hose-and-circle," consisted of simple forms (rigid circles for head and body, loose spaghetti tubes or rubber hoses for arms and legs). Felix the Cat is a prime example of a design that was favored by most of the silent-era animators because it was so easy to draw and animate quickly.

Mickey Mouse, however, became a star not because of his design, but because of his film's innovative soundtracks, which were an imaginative mix of music, voices, and sound effects. Other studios attempted to follow suit and the Art Wood Collection includes a binder containing fascinating documents for a 1929 Paul Terry sound cartoon called *Caviar*. A "time sheet" holds production information regarding how much film footage was allotted to each of fifteen scenes, which total approximately three minutes of screen time or less than half of the entire cartoon. There are descriptions of the action within each scene featuring mice, cats, and wolves in snowy Old Russia. The dates listed–"Begun 12/3/29, Finished 12/26/29"–indicate that this short was knocked out within a month, a hectic schedule for any studio and one reason why standards of quality were so notoriously low at Terrytoons. A separate music sheet holds part of the piano score for *Caviar* and some of the roughly drawn layouts can be matched to descriptions on the time sheet. ("Scene 5: Mice rowing boat as cat whips them.")

Art Wood also collected many excellent examples of cels, the celluloid acetate sheets onto which the character drawings were hand-traced with pen and ink and painted by teams of artisans. Particularly admirable is a cel of Mickey, again from *Fantasia*'s "Sorcerer's Apprentice," which showcases the artful craft of tracing. Cels were traced and painted mostly by women and it was a particularly arduous job. They had to float pens filled with various colored inks across a slippery plastic surface, while retaining the integrity of the animator's original pencil line drawings, while giving the lines a stylish thickness on a curve and, at the end, an elegant taper. A separate team of "opaquers" carefully painted the back side of the cels. Mickey's cel rests against a specially prepared watercolor background from the Courvoisier Galleries in San Francisco, which in 1938 became the sole representative for marketing original Disney art.

The Art Wood Collection of animation art is a valuable and rich addition to the Library of Congress, full of historical works to be admired by the public and studied by scholars. It provides a solid base on which the Library can continue to build a collection representing one of the world's great art forms.

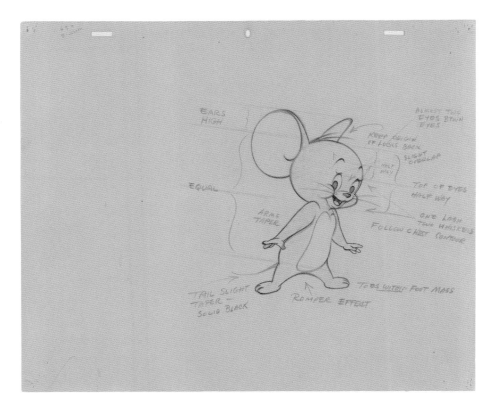

The Midwestern School of Editorial Cartooning

Lucy Caswell

A Midwestern School dominated American editorial cartooning during the first three quarters of the twentieth century. Anchored solidly in homespun values, these cartoonists combined social witticisms with political commentary. Because of the importance of print journalism during this period, their influence was considerable. Most newspapers had a resident cartoonist whose work had a wider impact through reprints and syndication. Among the notable cartoonists from the nation's heartland are John T. McCutcheon of the *Chicago Tribune*; Ohioan Fredrick Burr Opper, whose editorial work ran in Hearst's papers; Billy Ireland from the *Columbus Dispatch*; Ding Darling at the *Des Moines Register*; and Herb Block, or Herblock, who spent his early career at the *Chicago News* and then moved to Newspaper Enterprise Association, a Cleveland-based syndicate.

Not surprisingly, a hallmark of the Midwestern School is their sense of place. These cartoonists valued the ordinary as experienced in daily life. Homes, churches, fields, and schools represent shared experiences, just like watermelon and corn on the cob in the summer or apple pie in the fall. Billy Ireland said that he did not want to leave Columbus—what he wanted most was to get back to his birthplace of Chillicothe. Ding Darling went home to Des Moines after twice moving to the East Coast, once when he worked for the *New York Globe* and the second time after serving twenty months as head of the U.S. Biological Survey during Franklin Roosevelt's first term.

None of the Midwestern School enjoyed a privileged childhood. Public schools educated them, and the democratic values they learned stayed with them throughout their lives. Each can also be described as a naturally talented artist, a child who drew all of the time because that is what he enjoyed. This sense of fun is maintained in their professional cartoons years later. Despite the informal nature of their artistic training, members of the Midwestern School were masters in the use of the visual-verbal vocabulary that sets editorial cartooning apart from columns of text and photographs in newspapers. Each successfully exploited the interdependence of word and picture that results in a good editorial cartoon.

Although each had distinctive characteristics, the cartooning styles of the Midwestern School share a looseness of line that provides great energy to their work. Black is used sparingly with the result that its emphasis is used to good effect. They also were expert in using their allotted space to its best advantage, both by filling the drawing with images, as Ireland did in his cartoon "Soon the Shepherds Will Outnumber the Sheep," and by exploiting negative or white space, such as Darling did in "The Toughest Dictator of Them All." These cartoons are also examples of the wonderful use of design and perspective that typify the Midwestern School.

The use of symbols and labels was common among the Midwestern School. Opper drew The Trusts as an amiable, overweight man, and used this image with great success in his *Willie and His Papa* series. McCutcheon made the Solid South a white-bearded gentleman in "The Mysterious Stranger," his often-reprinted cartoon about Theodore Roosevelt's 1904 victory. Herblock's 1950s Mr. Atom symbol for the atomic bomb was threatening but almost cute, and because of this, it was an apt representation of the menace and allure of the atomic bomb.

Midwestern sensibilities, especially a strong sense of right and wrong, provided the moral outrage that fired the drawings of the Midwestern School. They understood that ridicule of the powerful, or to use Herblock's phrase "poking pomposity," was the inspiration for every good cartoon. Coupled with this is a wonderful sense of playfulness. It would be hard to choose whether Opper or Darling drew the cuter Republican elephant. These cartoonists also exemplify a strong belief in ordinary people, although they are not uncritical of their fellow Americans. Darling's Ordinary Man was taxpayer, voter, consumer, and, sometimes, he was bamboozled.

The Midwestern School valued capitalism and the entrepreneurial American. While endorsing the idea that a free press is vital to a democracy, they knew that their newspapers were businesses out to make a profit. They saw themselves as members of the team that could make the paper a success. Billy Ireland and Herblock were so

OPPOSITE: Detail, Frederick Opper, editorial cartoon (c. 1900)

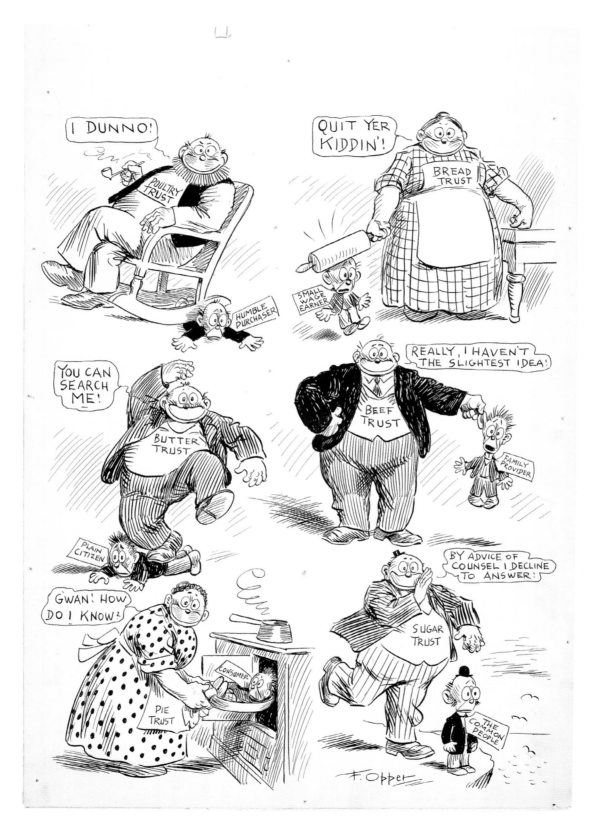

Frederick Opper, editorial cartoon (c. 1900)

John McCutcheon, "Becoming More Visible" (1913)

close to their publishers that they held stock in what were otherwise family companies.

Finally, an anecdote illustrates the impact of the Midwestern School on succeeding generations of editorial cartoonists. As a result of his Chicago childhood, Herblock acknowledged his debt to the Midwestern editorial cartoonists whose work he read as a boy. In 1995 when Pulitzer Prize-winner Tony Auth introduced Block as the featured speaker at a meeting of the Association of American Editorial Cartoonists, he observed that the noted *Washington Post* cartoonist had never married and had no children. Auth paused, gestured toward the roomful of editorial cartoonists, and then said, "Here are your children."

John T. McCutcheon, "The Mysterious Stranger" (November 10, 1904)

Ding Darling, "Caught in His Own Bear Trap" (1942)

Cartoonists Rally during World War II
Sara Duke

An enlisted man with a year of art school behind him, Bill Mauldin vaulted to fame during World War II with the creation of his Willie and Joe cartoons for the 45th Division News. While he was not the only cartoonist to work at the front, Mauldin combined sardonic dialogue and realistic imagery of the lives of enlisted men, editorializing about the war. The youthful Mauldin joined a roster of active cartoonists, conservative and liberal, who joined together in a patriotic effort to defeat fascism.

Editorial cartoonists in the United States commented on fascist politics in Europe and Hitler's rise to power almost as soon as he became chancellor of Germany in 1933, but most held the hope that more sage powers would hold fascism in check. While the United States government took an isolationist stance in 1938 and 1939, when Germany gained territorial control of Austria, Czechoslovakia, and Poland, cartoonists did not look the other way. They quickly ascertained that Hitler's aggressive policy of *lebensraum*, or acquisition of additional living space for Germans, could only lead to extraordinary bloodshed.

Unlike World War I, which divided left and right into antiwar and pro-war, cartoonists increasingly united to defeat Hitler and the forces of fascism well before the United States government changed its isolationist policies. While cartoonists on the left led the charge for entry into war to defeat fascist governments, it soon became apparent to cartoonists working for conservative papers that entry into the war was not only inevitable, it was necessary.

Most cartoonists focused on the political leaders and the war itself, not the internal politics of Germany. For the most part, they ignored the painful issues of Europe's Jews and the Nazis' increasingly strident efforts to demoralize and eliminate them. When Jews were the topic of cartoons, humor was not evoked, but rather sarcasm. The fate of those groups targeted by the Nazis for harassment and elimination was rarely an issue, except in the most oblique way, while Germany's war victims in other countries received much attention.

Talented cartoonists at the height of their careers produced extraordinary works for local newspapers and national distribution, and most frequently relied on humor to deflect the increasingly horrible news coming from the front. Humor served to motivate Americans to contribute to the war effort, as well as to belittle Hitler, Hirohito, Franco, and Mussolini. Humorous images increased as the Soviet army handed the Germans their first major defeat in 1942, as the Allies celebrated small victories with the optimistic expectation that things might just turn around.

American editorial cartooning received a new voice from the Old World when Arthur Szyk emigrated from Europe. He continued his prodigious efforts for the Allied war effort in his adopted home, creating editorial cartoons for the New York daily newspaper *PM*. The refined images brought a European sensibility and linear precision to American readers, who were more accustomed to the bold use of crayon or ink brush. As the German front retreated under Allied advances, Szyk made sure that Americans understood that the war was far from over.

As the Allied effort advanced in 1944 and 1945, the mood in editorial cartoons shifted from belittling the enemy to showing American muscle and know-how. Bold crayon strokes evoked the power needed to promote the war effort, as victory was not quite imminent.

Clever cartoonists used literary allusions and Japanese art to belittle the belligerent opponent in the East. Like the American public, cartoonists began celebrating victory over the Germans before the final moment of surrender.

World War II proved to be a rallying point for all cartoonists, whose talents shone under the unprecedented opportunity to explore literature, art, and history in pursuit of documenting both the European and Asian fronts to promote Allied victory.

OPPOSITE: Rollin Kirby, "Hanging on to the Demagogue" (February 1, 1933)

HANGING ON TO THE DEMAGOGUE

Clifford Berryman, "Spring 1939!" (March 21, 1939)

"Didn't we meet at Cassino?"

Bill Mauldin, "Didn't we meet at Cassino?" (c. 1944)

Arthur Szyk, "Hawaiian Melodies" (December 1941)

Richard Yardley, "The Lord High Self Executioner" (July 27, 1945)

Charles Schulz and Mort Walker
Robert C. Harvey

At the time, amid the fluttering cascade of fall foliage in 1950, no one could have known that two comic strips that debuted within a month of each other would, in retrospect, be viewed as harbingers of a new look on the funnies pages of American newspapers. The beginnings of Mort Walker's *Beetle Bailey* and Charles Schulz's *Peanuts* were not so auspicious. They appeared on September 4 and October 2 in twelve and seven papers, respectively. Not much of a splash. Within the decade, however, these two strips were among the nation's most widely circulated and their success paved the way for a simpler drawing style in the comics—a style strategically, albeit accidentally, more viable at the increasingly smaller size that newspapers assigned to their comic strips.

Launched as a jape on college life, Walker's strip didn't come to life until its eponymous antihero blundered into an army uniform. But Beetle Bailey is not really a strip about the military. Walker transformed the army into a microcosm of the hierarchy of authority that sustains the essential order of society and then indulged our belief that whatever flaws there are in the system are due to the incompetence of those who have authority over us. But the ridicule is gentle: it takes shape as Walker repeatedly shows us that everyone in his army—authority figure or not—is but a bundle of personality quirks. Hence, the strip is a great leveler. We're all equal: everyone has his frailties, his entirely human foibles.

In visual terms, *Beetle* achieves a highwater mark in the art of cartooning. Over the years, Walker refined his style, distilling simplicity into a unique comedic abbreviation. Not since Cliff Sterrett surrealized human anatomy in the futuristic manner have we had such engaging comic abstractions of the human form. Human dimensions are suggested by the simplest shapes. Beetle's head is a cantaloupe; Sarge's, a giant pear. Upon these pulpy craniums, Walker grafted billiard balls for noses. Bodies in repose hang limply from these heads like uninhabited suits of clothes weighted to the ground by monster shoes (not feet), and hands are doughy wads, dangling at the ends of empty sleeves. Clothing shows no wrinkles: sleeves and pant legs are simple tubular shapes vaguely approximating arms and legs.

Anatomy is wonderfully elastic in Walker's hands. A bent arm or leg is longer than when the limb is straight (you need length to show a bend). The illusion of the body in motion is achieved by means of a carefully orchestrated series of wild distortions. A person walking has only one leg—the one in front, which trails a second foot behind as if it were growing out of the lead leg's ankle. Running figures are all elbows and knees, perfect comic abstractions.

If I were in a poetic mood, I'd be tempted to say that Walker's style evolved to suit his subject. His representations of humanity are as abstracted as his microcosm of society. But that's poetry, not fact. Nice, but it reaches a little. The fact is that the drawings are that way so that the visuals will be funny. The pictures help the words achieve comedy by blending the visual and the verbal. But the pictures are comic in themselves, too.

Schulz began with a simpler style than Walker's, and once his strip became popular, its spare visuals began to set a new graphic fashion for gag strips. Gag strips had always been drawn in the caricatural rather than the illustrative manner, but even those comic characters bore more resemblance to real people than do the reductive renditions of characters in *Peanuts* with their tiny bodies and big, round heads. The strip was fated to presage yet another facet of the comic strip's future. Initially formatted 20 percent smaller than the regulation size of the day's strips, *Peanuts* was enthusiastically marketed to newspaper editors as a novel way to conserve valuable space in their papers. Thirty years later, all comic strips were being published at "peanut" size.

Neither simplicity nor size, however, is the strip's most enduring attraction. The achievement at the heart of the appeal of *Peanuts* is the trick Schulz played with the very visual-verbal nature of his medium. The pictures show us small children. But their speech reveals that they are infected with fairly adult insecurities and quirks and other often disheartening preoccupations. The dichotomy between picture and word permits us to laugh about heartbreak.

Because the *Peanuts* characters are kids, their problems seem relatively trivial compared to grown-ups' problems. As adults, we tend to dismiss kids' troubles. Or we chuckle because those problems

Charles Schulz, *Peanuts* (October 19, 1952)

Beginning in 1950, cartoonist Charles M. Schulz introduced newspaper readers to the gentle, sheltered postwar suburban world inhabited by the *Peanuts* gang. Through fifty years, lovable loser Charlie Brown, his indomitable dog Snoopy, and the unshakable Lucy Van Pelt led a community of kids in which parents, teachers, and other adult authority figures were virtually nonexistent. Children became philosophers, offering reflections on human nature with childlike simplicity and wisdom—a welcome tonic to a nation worn down by overwhelming military, political, social, and racial problems at home and abroad.

Mort Walker, *Beetle Bailey* (December 18, 1962)

Charles Schulz, *Peanuts* (January 20, 1963)

Mort Walker, *Beetle Bailey* (December 22, 1970)

seem so monumental to the kids plagued by them. We–older and wiser–see that the mountains are actually molehills. We understand that they will go away. Or slowly become less important. But even as we chuckle at the *Peanuts* gang, we realize that the same preoccupations that haunt them often stalk us as adults. Because these are kids, we can see the humor in their dilemmas. And because we can recognize their dilemmas as ours, we can see the humor in our predicaments, too. Before we know it, we are laughing at ourselves. With a giggle, we put our cares behind us (or beside us) and go on with our lives.

That's how Schulz worked his trick. And he worked it so well that it made his comic strip the most famous one in the world. Besides that, his kids, with their big round heads and Lilliputian bodies, are just plain funny-looking. And that makes their having problems all the more hilarious: that these goofy-looking characters could have real-life problems is incongruous and therefore funny.

If it weren't for the funny pictures–and the comedy that is born in the dichotomy of pictures and words–*Peanuts* would be pretty discouraging. The principals of its cast include a chronic loser, a cranky fussbudget, a precocious genius beyond the aspirations of us all, and an academically impotent pupil. But Charlie Brown always comes back; he is never defeated. Likewise his cohorts; they persist. And so the strip is also about human resilience and hope, hope that rises again like a phoenix from the ashes of each and every disappointment. Against this somewhat ordinary and certainly unglamorous assessment of the human condition, Schulz balanced the fantasy life of Snoopy, a blithe beagle whose seeming brilliant success at every endeavor reassures us that life is not only about disappointment and endurance: it is also about dreams and the sustaining power of the imagination.

Charles Schulz, *Peanuts*, March, 30, 1951 (top), November 6, 1958 (center), October 5, 1964 (bottom)

Technically Challenged Carefree Ineptitude: James Thurber
John Updike

James Thurber once told a newspaper interviewer, "I'm not an artist. I'm a painstaking writer who doodles for relaxation." Yet the drawings rival his writings in their fame and lasting appeal. It was his officemate at *The New Yorker*, E. B. White, who picked Thurber's doodles up off the floor, inked them in, and persuaded Eugene Saxon of Harper Brothers to use them as the illustrations for a 1929 book, *Is Sex Necessary?*, that Thurber and White had cowritten. After the book had been, with considerable success, published, Harold Ross, *The New Yorker*'s editor, began to run Thurber's cartoons in his magazine. By the mid-1930s they had become, with those of Peter Arno, Helen Hokinson, Otto Soglow, and William Steig, essential ornaments of its pages, where Thurber had been publishing "Talk of the Town" pieces and signed humor since 1927.

The author as his own more-or-less naive illustrator had twentieth-century precedents in Clarence Day, Max Beerbohm, and Hilaire Belloc; nineteenth-century writer/artists like Goethe, Thackeray, Victor Hugo, and Oscar Wilde date from an age when art lessons were an intrinsic part of a gentleman's education. Thurber surely drew as a Columbus, Ohio, schoolboy; but an accident at the age of eight led to the loss of one eye and to limited, deteriorating vision in the other, and his development as a picture-maker was arrested at a lively primitivism. Some of his best-known cartoons, indeed, were the product of a carefree ineptitude: the one captioned "All right, have it your way–you heard a seal bark" came about, by his own testimony, when an attempt to draw a seal on a rock came out looking more like a seal on the headboard of a bed; a similar improvisation titled "That's my first wife up there, and this is the *present* Mrs. Harris" turned a woman crouching at the head of a staircase into one crouched, or stuffed and mounted, on a bookcase. And in the cartoon captioned "You're not my patient, you're my meat, Mrs. Quist!" there seems no reason why the mustachioed medico leering down at the alarmed bedridden woman should be standing on a chair except that Thurber–who after White stopped inking in for him drew directly in pen and ink on the paper– had neglected to make him tall enough for his feet to reach the floor.

In his 1950 preface to his first cartoon collection, originally published in 1932, Thurber recounts how White, discovering him working at such refinements as crosshatching, exclaimed, "Good God, don't do that! If you ever became good you'd be mediocre." Yet one should not underestimate Thurber's conventional skills: in the drawing captioned "Well, what's come over *you* suddenly?" he took care to darken the other woman's shoe to show that the husband has been transfixed by a game of under-the-table footsie. Some of his captionless spots for *The New Yorker*, and his illustrations for his 1945 children's book *The White Deer*, carried out in Conté crayon when his failing sight no longer permitted pen and ink, show a care and balance considerably removed from the scratchy slapdash of his captioned cartoons.

Many of the captions provoke hilarity only because Thurber drew the picture: imagine "Touché!" by any other artist, or "What have you done with Dr. Millmoss?" Nor would his many treatments of what he called, in one droll yet ominous sequence, "The War Between Men and Women," be funny if the interchangeable men and women– "with the outer semblance," Dorothy Parker said, "of unbaked cookies"–were any more finely formed. The illustrated utterances savor of his sexually vexed first marriage to the stately and ambitious Ohio beauty Althea Adams, and of its boozy dishevelment: "When I realize I once actually *loved* you I go cold all over"; "Everybody noticed it. You gawked at her all evening"; "With you I have known peace, Lida, and now you say you're going crazy"; "I'm helping Mr. Gorley with his novel, darling"; "Your wife seems terribly smart, Mr. Bruce"; "Have you fordotten our ittle suicide pact?" [*sic*]; "You keep your wife's name out of this, Ashby"; "That martyred look won't get you anywhere with me!" "If you can keep a secret, I'll tell you how my husband died"; "Which you am I talking to now?"

Thurber's childlike drawings served up advanced adult fare; his men and women were libidinous to an extent that pressed *The New Yorker*'s youthful prudery to its limit. The Library of Congress is in possession of an exuberant pencil drawing, on lined paper, that

OPPOSITE: Detail, James Thurber, from *The Seal in the Bedroom and Other Predicaments* (1932)

"*Touché!*"

James Thurber, from *The New Yorker* (December 3, 1932), later collected in *Men, Women and Dogs* (1940)

"*That's my first wife up there, and this is the <u>present</u> Mrs. Harris.*"

James Thurber, from *The New Yorker* (March 16, 1935), later collected in *Men, Women and Dogs* (1940)

James Thurber, "Oh, Mr. Benholding, I never saw that look in your eyes before!"
(c. 1934)

didn't make it into mass circulation–the impending copulation of unbaked cookies. Thurber's head buzzed with not only sex but literature, especially the Victorian sort memorized in the Columbus, Ohio, of his youth. Popular chestnuts like Longfellow's "Excelsior," Sir Walter Scott's "Lochinvar," Tennyson's "Locksley Hall," and Whittier's "Barbara Frietchie" became weirdly endearing, with unexpected pockets of pathos, when he illustrated them, as did such literary cartoon captions as "I come from haunts of coot and hern!" and "I said the hounds of Spring are on Winter's traces–but let it pass, let it pass!"

Thurber's drawing is winning in the way of a man who does not know a language very well but compensates by speaking it very fast; he can't be stopped. His technically challenged style delivered a shock amid the opulently finished, subtly washed, anatomically correct *New Yorker* cartoons of mostly, in those days, art-school graduates; his more crudely amateurish successors in minimalism demonstrate by contrast how dynamic and expressive, how oddly tender, Thurber's art was–a personal art that captured in innocent scrawls a modern man's bitter experience and nervous excess.

"All Right, Have It Your Way—You Heard a Seal Bark!"

James Thurber, from *The New Yorker* (January 30, 1932), later collected in *The Seal in the Bedroom and Other Predicaments* (1932)

Comic Book Treasures
Paul Levitz

Some treasures shine brightest in memory. Those first seen in the unlikeliest hordes: a cardboard box in a musty garage, piled helter-skelter in a closet, forgotten in a basement, or even set out as a battered lure in a barbershop or dentist's waiting room. The real treasure was probably worn, both ill-used and oft-read, barely holding together. Then you got one of your own, perhaps from a babysitter bending the rules. But in memory, the colors are vibrant, the size somewhat larger than life, for your hands are still small.

That's how we recall comic books, which are among the secret treasures of the Library of Congress; from our childhood. From our first encounters. The big kids down the block with their accumulations (no one had a "collection" yet): Lester, Stuart, and Spencer, all with *Superman*, *Batman*, and their DC Comics companions aplenty. Alan arguing for the merits of *Fantastic Four* by Stan Lee and Jack Kirby. Bob and Joel, outgrowing their ducks and leaving Carl Barks's anthropomorphic fairy tales of *Uncle Scrooge* in a corner by the board-game boxes. A coverless *Legion of Super-Heroes* story with a few cut hairs sprinkled in, or the highly unlikely *The Adventures of Jerry Lewis*, read and reread, committed to memory to background creaks of a dental chair. And that copy of *Action Comics* no. 300 Jackie brought!

Your list of treasures are different, the experience the same. Comic book painter extraordinaire Alex Ross even produced a series of books in large tabloid editions, looking to re-create the experience of the size the art seemed to be when we were all little. A reporter once recounted the story from the comic he had been separated from as a child, sacrificed to the paper drives of World War II. His description of the final panel was clear enough that the issue could be easily identified, five decades later. The memories are strong.

Perhaps it was because comics were decisively our own. Not something our parents selected or pushed us toward. Perhaps it was the outrageousness of the worlds and the adventures caught between the covers. Perhaps it was the thousands of "facts" we learned our families didn't share, from science pages, plot points, and vocabulary not "controlled" for our ages. Or perhaps what we hadn't learned (how many years it took to get the joke that Matter-Eater Lad, who could consume anything, came from the planet Bismoll)?

The comic book was born to be discarded, a cheap and totally ephemeral form of entertainment. Conceived by immigrants, its pages largely filled for decades by first-generation Americans rarely credited for their work, it emerged slowly into the recognition that comics long held worldwide: that this unique combination of words and pictures was a form of art that traced back to the drawings on cave walls. Uncollected, unremarked, and unstudied, it lived on in childhood memories.

The Library of Congress developed a sizeable collection through an accident of copyright. In order to protect their commercial rights, publishers had to send two copies of each comic to the Library of Congress, and did, even if they kept no library of their own work in their offices. And so, nestled within the Madison Building, not quite cataloged, survives this chronicle of childhood. They've predicted the future (from atom bombs to desktop computers), provided travelogues (from places obscure to imaginary), chronicled wars and romances, scared us, amused us, and even let a generation use *Classics Illustrated* for book reports before CliffsNotes arrived. Now their value is official: debated as literature in the book review columns, celebrated as art in museums, and measured in price guides or sealed as collectibles in slabs of plastic to prevent their deterioration as their cheap newsprint disintegrates and colors fade.

But they are so vivid in memory that you can recall not only where you were when you found one, but how you felt as you did: these are surely treasures. Each a gem for a different person whose life it brightened, but as real a treasure as the seashell from the first time you walked the sands by the sea.

OPPOSITE: Bill Mauldin, "Better grab th' kid. He's been at them comic books ag'in." (November 10, 1948)

"Better grab th' kid. He's been at them comic books ag'in."

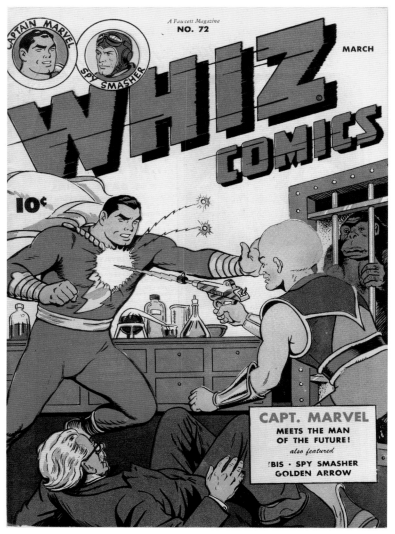

Fred Ray, *Superman* no. 14, DC Comics (January–February 1942)

C. C. Beck and Pete Costanza, *Whiz Comics* no. 72, Fawcett Comics (March 1946)

Al Hartley, *Girl Confessions* no. 21, Atlas/Marvel Comics (December 1953)

Lou Cameron, *The War of the Worlds, Classics Illustrated* no. 124, Gilberton Publications (January 1955)

Marie Severin, Frank Giacoia, and Sam Rosen, *The Incredible Hulk* no. 104, Marvel Comics (June 1968)

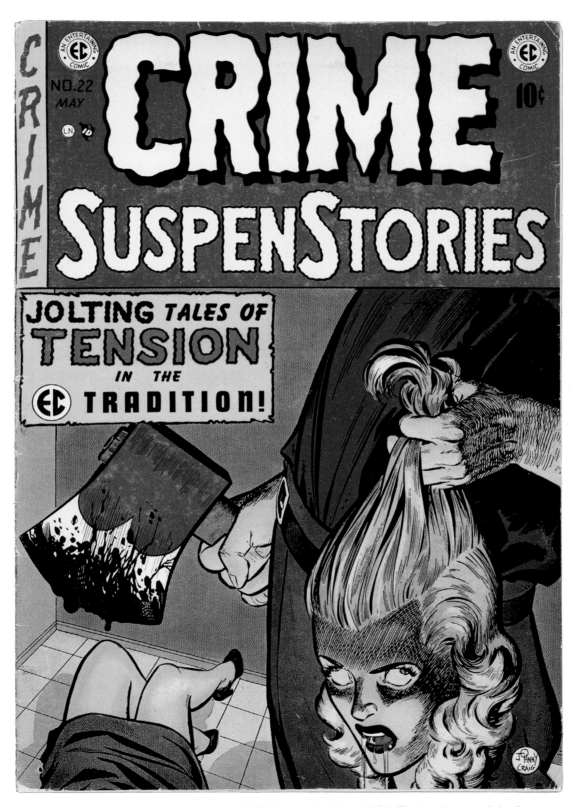

Johnny Craig, *Crime SuspenStories* no. 22, EC Comics (April–May 1954). This shocking cover helped to bring about a congressional committee investigation and a new Comics Code for the comic-book industry.

Consider Saul Steinberg

R. O. Blechman

Emblazoned on the Arts and Crafts fireplace of my former studio was the motto "Dulcius ex asperis" (loosely translated, "Excellence comes from hard work"). This was hardly news to me. My overflowing wastebasket proved that. Hard work, I had come to realize, was every artist's shadow.

But hard work alone does not account for excellence. Passion–and often pain, the pain from one's harsh life experiences–these must sometimes accompany the long hours of work in order to achieve excellence. Giving expression to pain affords relief, and giving it shape determines the motifs of an artist's work. Consider Saul Steinberg.

He was born in Romania, "that wound," he was to call his native land. "It does not heal easily. Perhaps never." Steinberg was born a Jew in that most virulent of anti-Semitic countries. Written into the Romanian Constitution of 1866 was the statute, "only Christians can become citizens of Romania." Jews were to remain technical foreigners for nearly a century, not to gain the franchise until 1923. According to Steinberg's friend, the Romanian-American writer Norman Manea, anti-Semitism remained "an inseparable part of his native geography . . . He treated it with disgust, as a hideous and incurable disease."

Steinberg's childhood and adolescence were, in his words, "a little like being a black in Mississippi." As a schoolboy, his uniform was a dark military jacket whose left sleeve bore the identifying numbers, LMB 586. "Like a license plate," he observed.

As a teenager, he fled the stifling and provincial society of Romania to pursue an architectural career in Italy, that most operatic and urbane of countries. They were years of fulfillment, years in which he was to publish his first cartoons. But less than a decade later he encountered the racist laws of an ascendant Fascist regime. Briefly interned in the Abruzzi region, he eventually found passage to the United States, only to find that Lady Liberty's welcoming torch had been replaced with the upraised sword of Kafka's *Amerika*. Turned away, he resided in Santa Domingo for many months, studying English with the only textbook available to him, the dialect-heavy *Huckleberry Finn*.

Finally gaining entrance to the States through the good offices of *The New Yorker*, he found himself drafted almost immediately into the Navy, hardly speaking a word of English.

The many traumas and misfortunes of Saul Steinberg's life account for the iconic images that form the front and back covers of his book *The Labyrinth*. They may be seen as bookmarks to his life. On the front cover a rabbit cowers in the cutaway face of a solid citizen. On the back cover, an impossibly knotted, convoluted line connects the nearby letters, *a* and *b*. What should be a brief stroll turns out to be a lifetime journey. That the journey was successful for Steinberg there can be no doubt. That it was painless and carefree is another matter.

Certain subjects were to obsess him: men in the gaping jaws of crocodiles; solitary manikins under a sky, glowering and studded with enigmatic, planet-shaped rubber stamps; ragged question marks; labyrinths; figures poised on precipices. Everymen, everywhere, in states of extreme despair or distress. These are some of the leitmotivs in Steinberg's art that were to preoccupy him throughout his life.

What accounts for his extraordinary and unique style? A photograph by Evelyn Hofer provides a clue. It portrays a middle-aged Steinberg holding the hand of a cardboard cutout of his boyhood self, the latter stiff and self-conscious in his best dress-up clothes. An amusing juxtaposition? A mere play of images? The writer Hans Politzer would disagree. "Man remains a child all his life," he wrote, ". . . the gap that divides [children] from their environment is not likely to decrease; rather it will shift from a vertical to a horizontal position."

As part of our incomplete developmental baggage, we carry around a vestigial being within us: the child, who never entirely disappears in the act of growing up. It is not so much that we outgrow childhood as that we grow up beside childhood. "The child is father of the man," Wordsworth famously wrote. The child, as accurately, may be his other self.

OPPOSITE: Saul Steinberg, "Self-portrait" (1954)

Steinberg himself acknowledged this physical relationship. Speaking of Paul Klee and himself he remarked, "We are both ex-children who never stopped drawing."

To a child, drawing is play, not work, and play is at the very heart of creativity. Once work enters, play ceases. As Steinberg declared in 1992, "I'm spontaneous and completely free when I am alone and I do something without any sense of responsibility. When I'm irresponsible, I'm good. But as soon as responsibility comes in, I feel that I have to perform like a hero, like a real artist, and that of course paralyzes me." Steinberg's wife, the artist Hedda Sterne, from whom he was separated but maintained a constant close relationship, declared, "Saul hated drudgery, any form of drudgery. Homework, that's what he called it. The minute it became that, he stopped."

Always at play, Saul Steinberg perfected the doodle, that archetypal expression of children, and developed it into art of the highest order. Although it had deep unconscious roots, it was not without its calculated aspects. "Look," it says, "I'm only clowning around. Don't take me too seriously. It's all in jest–perhaps." Humor, and the child-like drawing that accompanied it, was his means of disarming the viewer and avoiding the censor. His true feelings, at times, can be seen in his series of paper-bag masks in which an unaccustomed savagery, even a misogyny, jump out from behind the innocent drawings.

Perhaps Saul Steinberg's supreme achievement is the extraordinary range and depth of his graphic vocabulary, a reservoir from which artists of all stripes have endlessly drawn: the lowly speech and thought balloons of the comic strip with all their sophisticated variations; the artful doodle; the synthetic visualizing of all manners of phenomena–speech, music, color, and thought. These are only some of his many contributions to the art world, and to our way of seeing. Few artists have endowed us with so rich a heritage.

Saul Steinberg, from *American Mercury* (September 1942)

Saul Steinberg, "The Coast" (1950)

Feiffer's Gift

Harry Katz

Politically radicalized in the early 1950s by his Army experience during the Korean War, Feiffer created something new for the *Village Voice* in October 1956: a cartoon feature that elevated the genre to new heights of sophisticated social and political satire. First called *Sick, Sick, Sick* and later simply *Feiffer*, it was a comic strip for grown-ups and a vehicle for trenchant soliloquies and dialogues about life, power, hypocrisy, violence, and despair. Powerful, cynical, ironic, sometimes abstract, and often angry, Feiffer's cartoon commentaries helped extend the limits of acceptable intellectual discourse during the early Cold War era. He satirized the military when Cold War tensions were high, wrote and drew about intimate personal relationships when people were loathe to discuss them, and questioned the validity of the American Dream as millions of Americans looked optimistically to the future. Both a student and subject of psychoanalysis, Feiffer brought his knowledge of the process to bear on his cartoons. He created caricatures of the mind and thoughts as well as the faces of his subjects, revealing with devastating clarity the lengths to which people might go to deceive others and themselves.

During the following turbulent decades, Feiffer's graphic ruminations on civil rights, relations between the sexes, poverty, the peace movement, the generation gap, and the Vietnam War struck a responsive chord among Americans seeking insight into the social and political upheaval occurring around them. He was prolific, producing numerous cartoon compilations, including *Feiffer's Album*, *Feiffer on Civil Rights*, and *Feiffer's Marriage Manual*. Expanding the scope of his literary talents to reach a broader audience, he began to create books, plays, and films. He published his first novel, *Harry the Rat with Women*, in 1963 and achieved theatrical success in 1967 with the London opening of his first full-length play, *Little Murders*. This dark satire on family life in a city overwhelmed by violence, predicted the decades of urban chaos to come. *The White House Murder Case* (1970) savaged "spin doctors" years before the phrase entered our political lexicon. The film version of his play *Carnal Knowledge* (1971), a provocative study in American social mores, only enhanced his reputation as a leading American dramatist and one of the country's most influential and versatile satirists.

Feiffer's virtuoso creativity has blossomed even further in recent years. His graphic satires appear regularly in the *New York Times*, *The New Yorker*, *Vanity Fair*, and other leading publications, while his edgy, funny, compassionate books for kids and compelling new plays have won a new young audience for his endeavors. In an age when truth is defined by sound bites, historical revisionism, pop psychologists, reality TV, rampant violence, global terrorism, regional warfare, shadow governments, and expanding domestic surveillance, Feiffer's satirical mind cuts through the mind-bending complexity of our brave new world, separating fact from fiction and mixing our tears of frustration, anger, or sadness with those of laughter, compassion, tolerance, and understanding.

OPPOSITE: Detail, Jules Feiffer (June 25, 1964)

Jules Feiffer, *Clifford* (April 16, 1950)

Jules Feiffer, *Munro* (1954)

Jules Feiffer (June 25, 1964)

Jules Feiffer (May 19, 1968)

Caricature and Communication

David Levine (adapted from an interview with Harry Katz, June 2005)

To me the difference between cartooning and caricature is that cartooning makes fun of something or somebody and there is no sense of responsibility. I think the difference in caricature is that it has a feeling for being a critic and in being a critic, I think there is such a thing as responsibility and how you present certain things.

It's not just a question of making fun of somebody, of some physical problem they've had, or anything like that, it really has to do with hoping that you are raising a person's consciousness, you're talking to the person that you're drawing for–you don't do that in the cartoon. The cartoon stands for just being funny and you probably entertain yourself.

I examine what is available to me. We live in a mass society. We see the masses, they work, every day millions of people are going somewhere. To engage with that, I had to break it down and I came up with people that I observe just as they observe. So going to the theater is a possibility–movies. The problem there is that it's dark and very difficult to draw. Then there are people at play, such as characters, personalities, sports stars, or just people going into the water at Coney Island, people going hard-nosed to get fun out of that day. And so there are categories: work, play, and observation. And that helps because then I can look and possibly be pushed around toward a purpose.

The purpose of doing people at work in a dress shop, first of all, it is what is done, or was done, in Brooklyn. For instance, a dress can be made on the thirty-eighth floor with a designer. That thing is handed in the back elevator to somebody on the nineteenth floor who will do the same dress costing less and that goes down, down, down, each time the same-looking dress costs less, and will also wear less well. But, as a result, even our poor look pretty well-dressed in a major city. Getting into the shops, sketching where you come up against the fairyland, the mythologies of people who are worried about your taking their souls if you get a likeness.

But mostly there is the question, why us? And my answer to them usually is, because you produce something that you don't even get to see sometimes, but the rest of the world is benefiting from something you do. And somebody should pay attention to that. They accept that, but very matter-of-factly. In the other categories, you have to do it often enough to be accepted in the group wherever you are and let you draw while they talk with you, talk with themselves. That's almost like honing in somehow, horning in. But those categories are things I love doing. They're about things I'm interested in. And they present a different possibility to drawing.

My figure sketches don't help me with the editorial work, though. It is a separate thing. My paintings are also editorial. They are my novel. They are more my editorial about the world I live in. I do not use the same technical approach, but I do use humor. In order to get the general that's believable, we need the particulars. Well, an ear, a nose, the elbow, the stance–all the things come into play. It's in my control as to how much humor will be allowed and developed in this character so that it fits in with the crowd and you say, you identify, "I know people like that." My little bunch of friends, one fat guy, one skinny guy, and so on, which they can read into the group that I'm producing. So even from the point of view of teaching, you can't teach some things that just time can produce. You can't teach someone how to paint, but somebody playing a thousand times with that floppy end called a brush will learn a lot more about what happens, and then get better at it. But I notice that people who draw animals are much more relaxed about emphasizing and maybe even overemphasizing certain features and so I believe that kind of thing is useful in teaching. And I think caricature is useful in teaching people how to extend their statement concerning reality that they're standing in the middle of. I don't know whether that all makes sense, but I think it does.

Unfortunately, I exist now in what is really passé in the art world. That is, I am a communicator with a direction of mind, which some would say leads to tendentious product. The public will not be seeing what I do, but they will be seeing 145 feet with scribble at the end of it and told that that's the latest and that's the deepest and most

extraordinary piece of art this year, and so on. That changes all the time, you know, so what are you painting for? Why are you doing any of this? That has to lead internally to a section of your heart that says "because I love to do it."

You have choices to make that will ultimately be what people will take away from your art. Rodin has this incredible sculpture of a group of men that are going to sacrifice their lives for the town, the town has lost some kind of war and here they all are at different ages, and so on, put together and they're going to be probably hung, and how they face and deal with that. But even more, the artist's social thinking, he wanted it on a low pedestal so that people who looked at it could identify with being in that group. And there's nothing about modern contemporary art that suggests that kind of responsibility that goes beyond just "did I get a likeness?"

Simple human and humane understanding is all that's left. We didn't use up all that good stuff yet. I mean, nor will it ever be used up in that sense. A good example is Goya on the *Disasters of War* and then there was Mauldin on the horrors of war. And there'd be plenty of room for somebody to do the war in Iraq.

Without being necessarily aware of the class struggle, with quotes from Marx, Mauldin observed the treatment that the GI gets compared to the officer. And then there is the contradiction in the way the press, who doesn't want to tell the public that their kids are being blown to bits, say things that aren't true. He questioned the media manipulation. We're saying the same thing. We're seeing the same thing.

It's the same with Daumier. You think of that print of the man lying there on the floor [*Rue Transnonain*]. None of us really knows the story. The troops came through, people threw things at them, and the soldiers went up and just killed them. In the image the proportions are maddening there and the identity of that man lying there is religious. I mean, you feel for that body. The body tells you this terrible tragedy of scale, what he threw and what they threw back and so on. Now those are the things that sit in your mind and play a role when you are doing anything. And there's a hope that you'll do something with that sensibility. But it's not so easy. Nor is every situation so easy to be understood in terms of doing that kind of thing. Daumier's selection of who, what, and where in that drawing and the frightening thing that so many people have no idea what that really refers to, or the way we hear that kids don't know the names of famous people who died five years ago. The lack of information to build on can be very dangerous. And of course, the artist who's doing political drawings counts on people having that knowledge.

I feel more isolated now. I simply can't look at the situation the world is in now, especially our particular part of it, without feeling just as damning as possible, and yet the people that I would have assumed would be seeing it the same way are hedging it a little bit here and there. You need that fire in the belly if you're going to come up with your best ideas. And that may become a critical area to your friends, who don't go that far, and so on, and who see you as just too militant. We've already learned that too much militancy always adds to an unattainable and maybe a wrongful result. But it gets you there. So it's a difficult weapon to wield.

I try to stay relevant by concentrating on one basic thing: the class condition. That is, what is a household living on? How are the workers doing? Are they getting enough—old people and so on, their condition that brings me to what they call left, or commie, or whatever—and some of my friends call me bed-wetting commie, so there. But I take responsibility for that as being another militant because there is always a reason: the condition of some human beings.

My whole family was politically active. My cousin Anita was one of five whom NYU threw out and wouldn't allow back when they petitioned to not send NYU's basketball team to play in Alabama because they were going to keep the black players from going. They wanted to keep them here and send just the whites. So she went out with a petition. They kicked her and four other kids out. Two years ago, NYU finally apologized. And I saw her recently. She was in the hospital and I said, "You were my heroine."

The other day I woke up and I wanted to get the time. I turned on the TV and they had an early showing of the movie that was made from *Grapes of Wrath*. And it was right near the end where his mother says, "Where will you go? What will you do?" And he says, "I'll be there wherever men are beaten down" and so on. I had tears in my eyes. That still moves me. That's all I think I should be concerned about; my fellow man. And of course it sounds hokey when you take it out and blow it up like that, but those conditions are still there.

I know who my audience is. I'm talking to a highly literate audience, and lucky me. But that's probably more than Rembrandt ever got. I mean, he in a town where there were maybe 20,000 people? And that was it. And that was from the world, they would come around to this studio. No, I'm influential somewhere and that's all you can hope to be. What would happen to somebody like me if I didn't have this? I don't know; that's really scary.

I was stationed in Egypt for about three months and we had guys who were all Sudanese working in the camp. And they all had scars, different numbers of them, scars on their faces. And I would make drawings of them and I would think that I got a good likeness. They

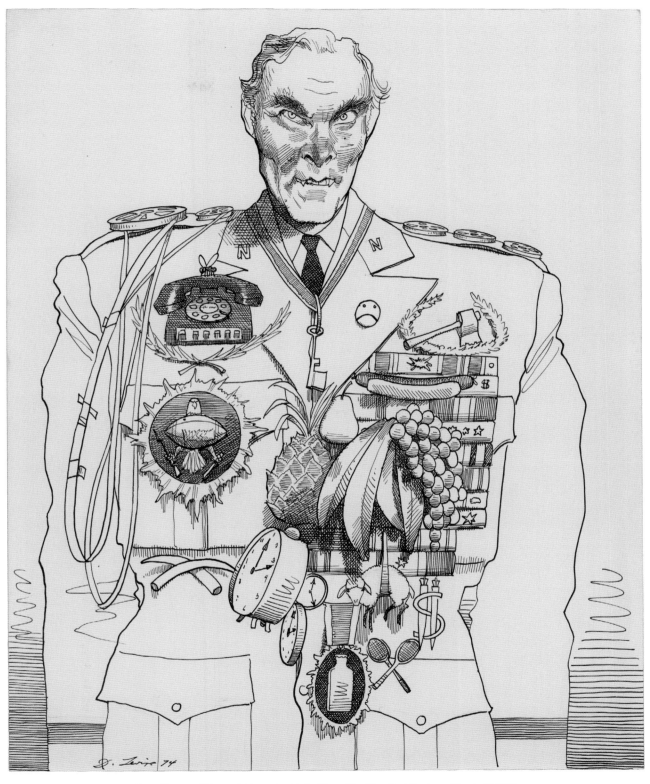

David Levine, "General Alexander Haig," from *The New York Review of Books* (1974)

would point to the scars and laugh and they'd celebrate that I got the scars written right. Then I found out that what those things represented was these were all people who worked as shepherds when they were very little boys and the Arabs would steal them, kidnap them, and put them to work for them. But after ten years there was a rule that allowed you to go home. How do you find which was your tribe? The scars. So even a little line, you know, something so completely away from our tradition could mean so much.

I accept the idea that my thinking is pro-human and I don't want to even limit it to one class. What's good for one class generally should be good for all of them. The other side of it is that if I get to talk to a young group, I suggest that a young artist practice art privately and study classicism or something where all the references have been used for centuries by artists, reinvigorated by how well they apply again and again. To have that as a storeroom for your ideas is more valuable than anything.

I went for some ducks with my wife. We have a pond and we thought it would be nice to have some white ducks. So we went to a place with a huge barn and everything, it's almost biblical-looking.

Very old, and two of everything. Sheep and dogs and ducks and Muscovy ducks and this kind of duck and that. And while the man was going to get certain animals, I looked next door and there was this house, an ordinary farmhouse, and in front of it and behind it for hundreds of yards were every known kind of automobile, and bathtubs, tires, kitchen sinks; everything strewn out there. I said to the guy, "Doesn't that bother you?" and he said, "What?" I said, "All that garbage." He said, "You mean gold mine?" I said, "A gold mine?" He said, "Yeah. That guy never needs to go into town to buy anything. It's out there in one of those things he's got there. He just needs a screw, needs whatever it is, a button, it's there." And it suddenly dawned on me that this was what I used to make fun of at temple, the guy who thought that acres of diamonds could be found in your own backyard. Suddenly I realized wow, this is it! And that is how an artist finds where to start looking for what he's going to build. Looking it all over and saying this is worth keeping, this is worth using, this may have value at some point, this was good for me, and so on. And I think like it'll take some kid thirty, forty years to come to the same conclusion.

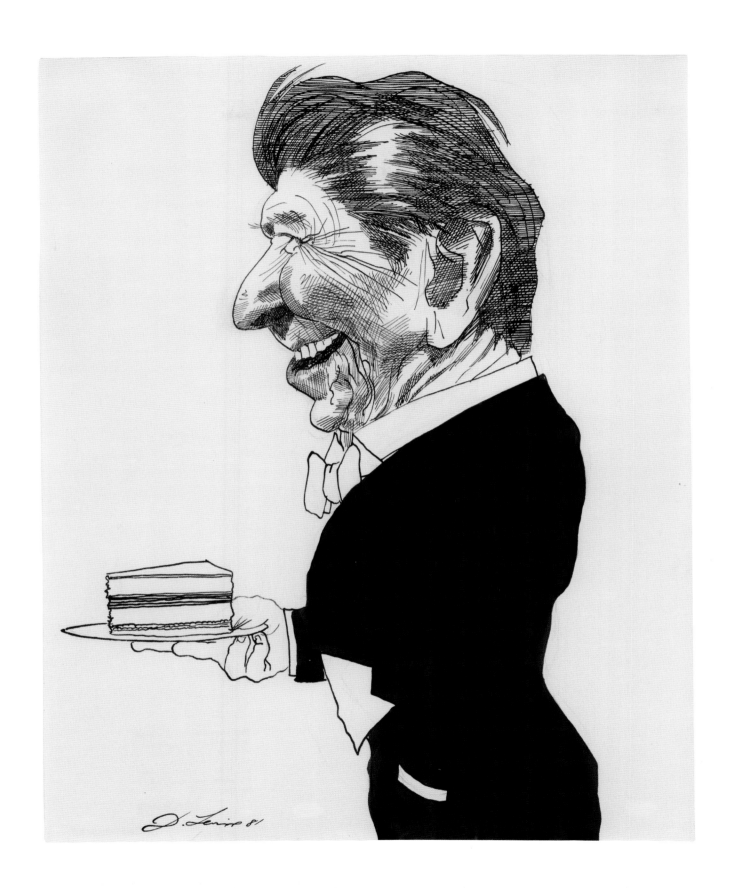

Political Drawings: The British Tradition

Pat Oliphant (adapted from an interview with Harry Katz, July 2005)

Growing up in Australia, I was influenced by the British pen-and-ink tradition. But it went both ways: Australia also contributed to the British condition, because David Low came from New Zealand and trained with *The Bulletin* in Sydney. And then he went to England and was highly successful–probably the best cartoonist around in the first half of the twentieth century.

There was an Australian publication called *Smith's Weekly*, which was nearly all cartoons. That's how strong the tradition was. And *The Bulletin*, a sort of literary as well as a satirical magazine. *Smith's Weekly* spawned a whole school of cartooning illustrators; people went from there to newspapers or working for newspapers at the same time. So talking about the British tradition, I grew up knowing about Giles and Illingworth and Low. There was also the British *Punch*, where I got exposed to those people. And there was not much American cartooning except we'd see an occasional Mauldin and others, but most American cartooning at that time was held up in scorn, over-labeled and under-drawn.

And I'm pleased that I did have that exposure to it because I like drawing so much. And I appreciate good drawing. To me, cartooning is–it's a wretched word, cartooning. Without being precious, when you talk about cartooning you don't know what sort of cartooning you're talking about. Are you talking about Disney? Are you talking about gags? Are you talking about illustrations? It's an all-encompassing word, which drives me crazy.

I'd probably call my work political drawings. Because originally cartoons were what you drew first before you put a drawing on the ceiling. Cartooning itself would be Michelangelo doing Disney features on the ceiling of the Sistine Chapel. Mickey Mouse with his hand out to God!

There's always an argument as to which is the most important– the idea or the drawing? I think it's a 300 percent, maybe more so, but a 300 percent, that's how I score it anyway, a proposition. If you get 100 per idea, you get 100 points per drawing, you can get 100 points for writing the caption. They're equally important.

And so you can score the cartoon by breaking it down that way. And if the idea is great and the drawing no good, and the writing's bad, then you're getting a third of what you could be getting. So I think that those three things have to be brought together in a timely fashion, in a way that can be whimsical, it can be serious, it can be any number of ways of expressing it. The drawing should suit the mood of the idea.

I tend to use different approaches, a very funny cartoon in kind of a whimsical style of drawing as opposed to doing a very serious cartoon where you cut out maybe some of the details. So that's what I think cartooning is all about, plus taking on the establishment. Bill Mauldin said, if you see something big, hit it. That was a pretty good philosophy.

Coming from Australia as I did, you feel like an outsider. I think you develop as an outsider, especially when you're young. You're an observer. And I think it helps to be in another country and fit into that other society, but you're still always an observer. I never wanted to go to London. In the fifties everybody was going off to London from Australia. I never wanted to do that. I wanted to come to the U.S. I found that the American audience was so wonderfully accepting. I had the feeling, where have I been all this time? I could have been working here.

Also, in Britain cartoonists can be prosecuted for libel. And so they had to get around it with humor, in an indirect, more subtle way. And that was part of the tradition I grew up in. And so you learn to use humor and ridicule as two powerful weapons.

And I grew up with another style of drawing. In this country, the use of the grained pencil and the drawings could be smudgy, ugly-looking. It wasn't clean. The only person who I thought handled it that well was Rollin Kirby, his drawings had a wonderful lithographic quality. Mauldin had a Daumier touch to him, which I also thought was wonderful. He used the grease pencil too, but in such a way that it looked lithographic instead of just smudged on the paper. There weren't too many around that I really liked. Herblock earned his stripes but I thought he was heavy-handed. The people in his cartoons in the

OPPOSITE: David Low, "Low's Topical Budget" (May 3, 1938)

Charles Dana Gibson, "Studies in Expression: If Women Were Jurors" (c. 1902)

'NOW, TELL THE JURY WHAT YOU DID WITH THE KNIFE, MRS. BOBBITT...'

Patrick Oliphant, "Now, tell the jury what you did with the knife, Mrs. Bobbitt . . ." (January 12, 1994)

Ronald Searle, *"Troilus and Cressida* at the Punch Theatre" (1955)

seventies looked like people from the fifties. He was not exploring, wasn't doing anything. In terms of the art, I know he could draw because I've seen some of his early drawings.

The great ones could really draw, going back to Gillray and Hogarth. Hogarth developed the art of caricature and created the first popular political art. He didn't draw from the classical model. He didn't draw out of religious purpose. And this was the 1720s, '30s, '40s. So this is a big change from being an academic artist and working in an allegorical style or a historical style or a classical style into somebody who was trying to appeal to the public through popular contemporary images. Those early Brits really took on the establishment and aspired to something higher than simply doing a drawing of a political statement. I grew up believing that cartooning was a noble profession.

Unfortunately, these days nobody seems to care much about drawing. It's a great loss to the profession. We have a whole state of cartoons that pay no attention at all to drawing. Like these people have never seen Charles Dana Gibson.

You use your drawing just to say, "Look at this." I like to explore and see what'll work. My style is variable and adaptable to what I want to say. And if you don't do that, you're limiting your effectiveness, I think.

But you've also got to work yourself into some sort of mild rage every day and say this is bloody ridiculous. And indignation, you know, Conrad, well he always drew in the same way, but he had a sense of indignation. And outrage, which I think is totally essential for a good cartoon. Read the paper and watch television. It's easy to stay angry. It's nice to be able to excite other people to anger, too, and these days there is not the response. You know, in the Nixon days I think–and this is how much things have changed–in the Nixon times or during Watergate, I think political cartooning can claim quite a bit of credit for Nixon's demise.

Ridicule is what we're doing and the best vehicle for that is a cartoon. In fact, there's no better way than with humor. We're trying to bring it to everybody's attention that politicians work for us; we don't work for them. And the overblown politician is what we draw.

Raymond Jackson, "I can't stand any more of this. I think I'll go out and face the unions." (c. 1966)

David Low, "Possiblities at Petsamo" (March 3, 1944)

And humor is the tool in *most* cases. You know, we've got things like 9/11, you're not going to be using humor.

Recalling Vietnam and Watergate I had a sense of having achieved something. Now we're trying to do this to Bush. And it's not working. It's not working because the newspaper publishers won't run controversial stuff and it's all about the bottom line. It's different now. How people have changed since the early days is amazing. I've still got a constituency that is just outraged as I am. As a syndicated cartoonist I don't have a forum anymore. If I send out a controversial cartoon, it will probably be squashed. People just won't run it. They don't want controversy. Controversy is dead, unfortunately. And that's where we are with cartoons.

I still get the same charge out of doing them. Each cartoon is a little piece of theater in which society and politics merge. I like the merging. It's like life itself. You carry it onto the human side and make an observation. A lot of things going on at once. It's a complex sort of art, really. But it is an art. I'm drawing these for myself. A dozen people get it, that's good.

I've been doing it for fifty years now. I learned on the job. And my first several years were just agonizing. This is what I wanted to do more than anything on earth. But I had to learn on the run so I think it's always been a study for me. I never stop learning how to do things, change things. Early on I had influences that I would slavishly emulate. Searle was one of them, along with Low and Illingworth. I have them in mind at certain times when I draw. Low's caricatures are outstandingly good. He didn't mess around with whimsicality, so he was ideal for wartime. His people were recognizable without going to a formula. They were people you could actually see in the street.

I have found that drawing from life and actually being in a studio with a model and drawing is one of the best things any artist can do. And I've always tried to do that. There have been gaps in there where I haven't done that and have gotten into bad habits. But in the last twenty years I've gone back to that, drawing from models as often as I can. It made me pay attention because a cartoonist can't get into bad habits. During my Searle period everything looked like Searle, for God's sake. I had to stop that.

Leslie Illingworth, "Mideast War-Peace" (July 18, 1958)

Thank You, Ollie Harrington!

Brumsic Brandon, Jr.

Thank You, Ollie Harrington!

Although I did so in the mail, I wish I could have thanked Oliver Wendell Harrington face-to-face for blazing the trail I chose to follow. His work has meant more to me than I am capable of putting into words, but I will give it a try nonetheless.

Each of Harrington's cartoons is a piece of art, worthy of an expensive frame and a prime location in a prestigious gallery. Each is cleverly conceived and deftly drawn. His cartoons have inspired me more than anything else to be a cartoonist. In spite of fleeting flirtations with music and periods of playing with poetry, I can't remember ever wanting to be anything but a cartoonist.

Some well-meaning people with my best interests in mind tried, with various degrees of intensity, to steer me in other directions to no avail. Later I learned that in most instances those attempts were made to protect me. My advisors felt there were many opportunities in other areas where my chances of success would be much greater.

In my idealistic, teenaged eyes, that did not matter. Failure was not an option! I knew and enjoyed the work of two black cartoonists: E. Simms Campbell and Ollie Harrington, and that was more than enough to make me stay the course.

While the excellent draftsmanship of both of them greatly impressed me, I came to choose the work of Harrington as my beacon because of its content, its substance, its social consciousness. Harrington's work addressed issues that were, and still are, near and dear to my heart. I had, as have most artists, assumed the responsibility of observing, interpreting, and recording my time. To me there was no better way to point out the many injustices and indignities endured by black Americans than with cartoons . . . à la Ollie Harrington. Thanks to him for that.

During my youth there were very few black characters on comics pages of the nation's "mainstream" newspapers and the ones that were there were detestable. Without dwelling on the degrading details, animal characters were assigned more human qualities than were black people. However, in the black press, I noticed that Harrington was able to depict black characters without being demeaning or derisive. His characters were human beings. They were real people. Because of that, when my impatiently awaited chance to do a syndicated comic strip came along, I knew I wanted to incorporate that human quality in *Luther*. Due to Harrington's trail-breaking, I knew better what I wanted to

ABOVE: Brumsic Brandon, *Luther* (June 12, 1969)

OPPOSITE: Oliver Harrington, *Dark Laughter*, "Well, naturally I believe in nonviolence but the cops don't seem to know that!" (1952)

OLLIE HARRINGTON - 52

do in my strip. Thanks again to Ollie Harrington and his Bootsie for that.

This tribute would be suspiciously incomplete if I did not make a reference to Harrington's difficulties with the United States government. My admiration of his work and Ollie Harrington, the man, was not the least bit diminished by allegations of his Communist ties. Such an accusation may have carried more weight with me at the time if I had not been falsely accused of the same thing and I am not now, nor have I ever been, a Communist.

Thanks to Ollie Harrington's pioneering efforts, I reached a point in my development where I could look upon my Pandoran collection of bad memories related to racial injustice in this country in a new light. While neither forgiving nor diminishing the seriousness of those events, I didn't want them to become a weak, but often too widely accepted, reason for not trying. Clearly, that would have been unacceptably unproductive. Harrington's work demonstrated to me that bitter memories could become an ironic source of material, an abundant supply of grist for a cartoon mill. Nowadays, when I hear myself referred to as a "pioneer" in the area of black cartooning, I am taken aback. Ollie Harrington was the true pioneer. I am honored to be one of the following foot soldiers. Each time I visit, or revisit, his work my respect for his contribution to American culture grows more and more.

BOY, IF THE WHITE FOLKS KNEW HOW MUCH FUN WE HAVE ALL BY OURSELVES THEY WOULD FORCE US TO INTEGRATE!

Oliver Harrington, *Dark Laughter,* "Boy, if the white folks knew how much fun we have all by ourselves they would force us to integrate!" (1962)

Oliver Harrington, *Dark Laughter,* "Now I ain't so sure I wanna get educated!" (1963)

Oliver Harrington, *Dark Laughter*, "Brother Bootsie, we really appreciate you droppin' in
to wish us Merry Chris'mus. But we got a few things to do right now,
so drop by some other time . . . Aroun' the first of April for instance!" (1961)

Oliver Harrington, "Lady Liberty Leading Contra Rebels," from *Eulenspiegel* (1986)

Born of Upheaval: Cartoons of the Vietnam War

Tony Auth

In the late 1960s, I was a recent graduate of UCLA. I was working as a medical illustrator at a large teaching hospital, when friends with whom I'd worked at the UCLA *Daily Bruin*, where I had done decidedly non-political cartoons, approached me. The war in Vietnam was escalating, and more American troops were being committed. Vietnam became the dominant issue in American politics. My friends were starting a weekly newspaper, and invited me to become their political cartoonist.

At that time some great cartooning was being done in college and "underground" papers. Ron Cobb at the L.A. *Free Press* stood out. His work was a revelation and inspiration. It was so full of life and energy. It was also irreverent and impolite, compared to the bland and predictable editorial cartoons I was used to seeing in the *Los Angeles Times*. All that was about to change, however. Paul Conrad came to the *Times* from the *Denver Post*, and, in a move that would change the history of American political cartooning, the *Denver Post* hired a young Australian named Pat Oliphant as their staff cartoonist. What a turn-on their work was for a young aspiring cartoonist. I was now reading voraciously, and therefore seeing the work of Herb Block, Jules Feiffer, David Levine, and others who were creating inspired, funny, beautiful, angry, and, above all, honest images. As my commitment to political cartooning became a passion, I began to feel I was part of a raucous and iconoclastic fraternity of commentators, most of whom I would not meet for several years.

Meanwhile, the Vietnam War went on. Casualties mounted and more Americans questioned the wisdom of our involvement. Opinion journalism, investigative reporting, political cartooning, stand-up comedy, folk music, protest songs, rock 'n' roll, poetry, plays, teach-ins all became part of a robust, seething period of questioning in America.

In 1971, my alternative and underground cartooning led to big leagues, in Philadelphia. Conservative press baron Walter Annenberg had just sold his *Philadelphia Inquirer* to Knight Newspapers, and new publisher John Knight was making big changes. He hired me as his new cartoonist and placed me under the direction of editorial page editor (and former Nixon administration official) Creed Black. Suddenly, I was in a tougher, more combative arena, forced to defend and justify my ideas to get them into the paper. I lost some battles, won more, and–greatly aided by the government's ham-handed war policy–had the chance to draw compelling commentary.

It is difficult for those who weren't there to imagine just how divided and passionate the country was from the late sixties through the mid-seventies. We think of America as divided now, between red and blue states. During Vietnam the divide was generational, with families torn apart, some parents not speaking to their children, and some young people burning their draft cards or fleeing to Canada. And the Civil Rights movement, desegregation orders, Martin Luther King's assassination, the rise of the Black Panthers, and a new women's movement all provided incendiary ink for cartoonists. I have long believed that political cartoonists are born of social upheaval, and that generation of unrest gave us, among others, Jeff MacNelly, Garry Trudeau, Mike Peters, and Doug Marlette.

The tipping point was 1968, the time when citizens' growing awareness of government deception produced a new majority who understood they were getting cooked books, exaggerated numbers of Viet Cong dead, and fairy tales about the success of "Vietnamization." Reporting by David Halberstam, Seymour Hersh, and Walter Cronkite, among others, ate away at the natural tendency of Americans to trust, especially in time of war, that the president means well and that to support the troops means supporting the government. Finally, the Pentagon Papers–a Pentagon-sponsored history of the war in Vietnam, leaked to the *New York Times* by Daniel Ellsberg (which led to the "plumbers," which led to Watergate)–were published in spite of the government's vigorous opposition. The Pentagon Papers documented years of deception, lies, folly, and the monumental sacrifice of lives in service to misguided notions of Cold War pathology and national pride. In a democracy the people are supposed to have the power, and to exercise that power wisely, they must have accurate information.

OPPOSITE: Paul Szep (c. 1967)
President Johnson haunted by the ghosts of Vietnam.

"THEY WON'T GET US TO THE CONFERENCE TABLE . . . WILL THEY?"

Pat Oliphant, "They won't get *us* to the conference table . . . will they?" (1965)
For this editorial cartoon, Oliphant was awarded the Pulitzer Prize in 1966.

John Fischetti, "I'm *never* too busy to devote some time to kids." (July 24, 1967)

A question political cartoonists are often asked is, do you think you have any effect? Does your work help bring about change, progress, or reform? Yes, but only in the sense that any of us contributes one particle a day to the torrent of news, opinion, argument, spin, exaggeration and lies that people are exposed to constantly. All that any of us who comment on "current events" want to do is to be part of the robust and ongoing conversation of American democracy. We say what we have to say, as best we can, and we expect disagreement, controversy, and tumult. As Bill Mauldin once famously said: "When you do this for a living, you get two things: awards and hate mail."

As I mentioned earlier, one thing leads to another. Vietnam led to Watergate, Nixon's resignation, Jimmy Carter, the Iranian hostage crisis, a backlash against "the sixties," and Ronald Reagan. Now, with President George W. Bush, we are involved in a war in Iraq, another war of choice, accompanied by deceptions, exaggeration, hype, and spin, with eerie echoes of that previous quagmire (defined, by the way, as a difficult, precarious, or entrapping position). It would appear that whether we know the past or not, we may be doomed to repeat it.

Who are the cartoonists being born of the current battles in American politics? We don't yet know, of course, but they will emerge. A more intriguing question, and one which cannot as yet be answered, is where their work will appear, and whether they will be able to make a living at it. This has always been a tiny profession. It requires, after all, a fairly rare confluence of talent, interests, and temperament. Thirty-four years ago, when *The Philadelphia Inquirer* hired me, there were two hundred of us doing daily political cartoons. Now, with newspapers losing circulation and looking for ways to save money, our number is little more than eighty. We know a couple of things for sure. There will always be artists doing impolite, raucous, iconoclastic, and irreverent political drawings. And nothing could be more American.

Tony Auth (1973)

Underground Comix

Bill Griffith

Like most cultural explosions, Underground Comix had its heyday, its glory years, its first wave. The year was 1968 and I was living in New York. My unheralded entry into comic art was a raunchy half-page, two-row strip published in 1968 in an early issue of *Screw*, the local sex and counterculture newspaper. At the time, I was supporting myself as a painter, always hot on the trail of the next elusive gallery show. The day my first strip was published, I put down my brushes and oils, never to stand before the easel again.

When I was informed by *Screw*'s art director Steve Heller, now the art director of the *New York Times Book Review*, that my crude scribbles would be seen by an audience of at least 10,000, I was thrilled. Overnight, I decided I was a cartoonist. Such chutzpah! Luckily for me, the Underground bar was low and I learned while I earned, at the rate of twenty-five dollars per page, contributing pages to the *East Village Other* as well as their comics supplement, *Gothic Blimp Works*. Over the next few years, I gradually made the migration from New York to San Francisco and the Underground comic book scene in 1970, where things really took off.

Three things inspired and fueled me in those early days–the pioneering work of Robert Crumb, abundant low-grade marijuana, and a burning need to not just draw from my experience, but to write about it. Comics seemed the perfect medium for me, a bastard form combining art and literature and infinitely malleable. By the age of twenty-six, I'd published a batch of strips in various Underground papers and penned my first thirty-two-page comic book, *Tales of Toad* no. 1, featuring my first continuing character, Mr. Toad, an egomaniacal amphibian. This was followed quickly by my first big-seller, *Young Lust* no. 1, an attack on bourgeois values under the guise of a parody of the cheesy mainstream romance comics still popular at that time.

With a small but steady income (still a measly twenty-five dollars per page), I was able to devote my energies full-time to comics. *Real Pulp* no. 1 (1971) debuted my first Zippy story, "I Fell for a Pinhead and He Made a Fool out of Me." Within a year, Zippy had shoved Mr. Toad aside and grabbed the driver's seat, a position he still holds today.

Along with fellow cartoonist Art Spiegelman, I coedited two issues of *Short Order Comics*, which, a few years later in 1975, morphed into *Arcade, The Comics Revue*. *Arcade* showcased the Underground "crème de la crème," as we boasted, with covers and work by Robert Crumb and stories by Underground luminaries Justin Green, S. Clay Wilson, Spain Rodriguez, Robert Williams, Aline Kominsky, Diane Noomin, and Kim Deitch, among others. It also featured short illustrated fiction and nonfiction by Charles Bukowski, Paul Krassner, and Jim Hoberman and revisited forgotten comic classics from the early twentieth century, like *Count Screwloose of Tooloose* (Milt Gross), *Among Us Mortals* (W. E. Hill), and *Sex Comics of the Thirties* ("Tijuana Bibles").

We were a fairly tightly knit community in those heady years, working for a few San Francisco-based publishers (The Print Mint, Rip-Off Press, and Last Gasp), brainstorming with each other over new ideas and projects, throwing parties, and even at one point, forming a kind of a union, the Cartoon Workers of the World. I remember hoping we might get a discount on art supplies. During a sales slump in 1974, several of us (Kim Deitch, Willy Murphy, Jay Lynch, Diane Noomin, and myself) got together and published our own work under the banner Cartoonists Co-op Press. The entire operation worked out of a table in my apartment hallway.

The Underground Comix scene in San Francisco in the early-to-late 1970s was as much of an art movement as it was a counterculture phenomenon. It pumped new energy into the comic book, a form that had grown formulaic and was relegated almost entirely to a children's audience. The early Undergrounds demonstrated that comics were a vital medium for adult self-expression, presaging the graphic novels and "alternative" comics of today. The Underground sensibility, with its emphasis on confessional, uncensored storytelling and individualistic rather than corporate art styles, gave comics back to cartoonists, restoring the medium to its place beside jazz and rock and roll, as an important indigenous American art form.

OPPOSITE: Detail, R. Crumb, *Sleezy Snot Comics* (c. 1975)

R. Crumb, *Sleezy Snot Comics* (c. 1975)

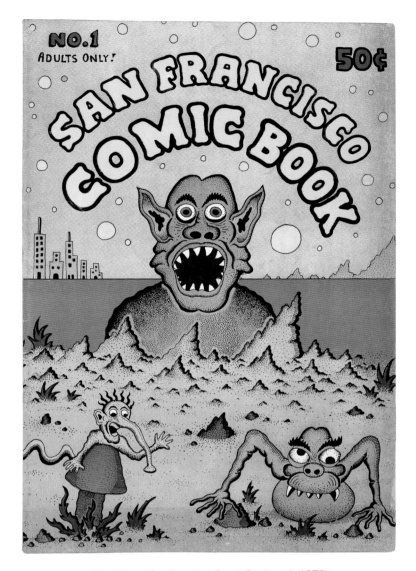

Rory Hayes, *San Francisco Comic Book* no. 1 (1970)

R. Crumb, *Zap Comix* no. 0, Apex Novelties (1968)

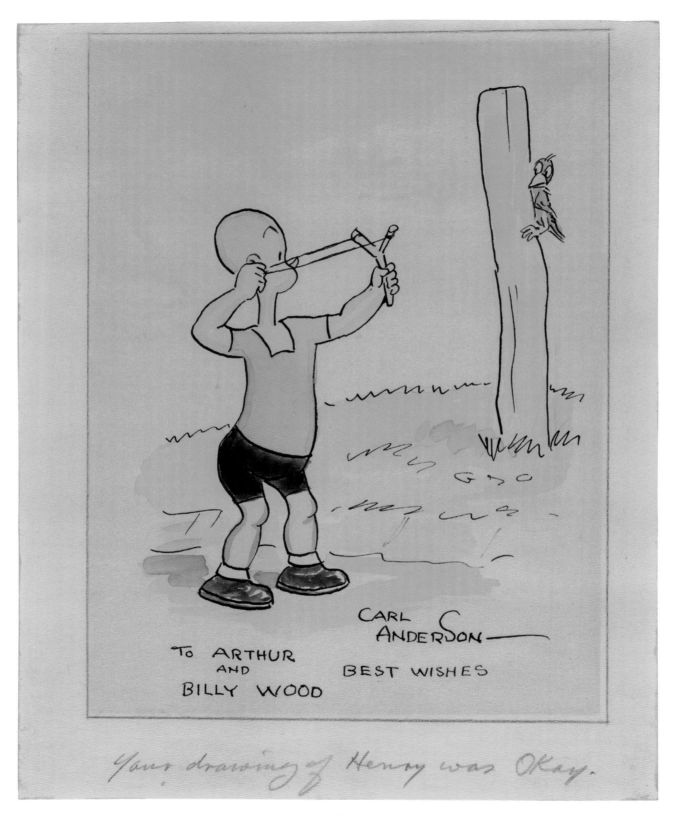

Carl Anderson, "Henry" (c. 1940)

Bill Griffith, *Zippy* (June 7, 1988)

On Cartooning

Roz Chast

The thing I like most about the medium of cartooning is its versatility. It can be a one-panel drawing, with or without words; a three- or four-panel serialized strip in a newspaper; a super hero comic book; an animated film (and all the varieties thereof); a graphic novel–in other words, it can be almost anything the cartoonist wants it to be. It can be sharply sarcastic or gently silly, political or not. It doesn't even have to be funny. Look at Prince Valiant, for example. Or any of those Marvel musclemen.

Another thing about cartooning that I like is that it's a pretension-free, portable medium. All you really need is pen and ink and paper, or a laptop. You don't need a potter's wheel or a gigantic loft so you can paint a 20-by-10-foot canvas or a staff of assistants or welding tools, which I would be afraid of, anyway. Generally speaking, no toxic fumes are emitted. When I go into my studio, it's quiet and I can draw the blinds down, turn on my desk lamp (I hate natural light; it moves across the drawing table in a very annoying way), and listen to my own thoughts. Or have them run away from me, just at the moment I'm supposed to be having an epiphany, or at least meeting a deadline.

In the magazine cartoon world of the past, the art of making a cartoon was divided between the gag writer and the visual artist. This, for the most part, is no longer true. It's a one-man-band, which has advantages and disadvantages. The disadvantage, some would say, is that the admirable drafting skills of the earlier days seem to be gone or greatly diminished. On the plus side, what you get is a more personal feel from the work because the artist and the writer are the same. When I look at my favorite cartoonists' stuff, I feel as if I'm getting a glimpse into a particular artist's inner world. I don't care that much about perfect perspective or the ability to render bulging muscles. I'm more interested in story and feeling. And, of course, the style of the enterprise. I like both simple graphic styles and complicated messy styles. It just depends on what style works best with the ideas.

My first cartoon love was Charles Addams. I discovered him when I was a child. My Brooklyn schoolteacher parents used to spend the summers at Cornell University with other Brooklyn schoolteachers, and when they were going to lectures or sitting around with other grown-ups, they used to park me in the browsing library in the student center which had a huge collection of cartoon books. I spent many happy hours looking at those books, but I was never more absorbed than when I was looking through *Monster Rally*, *Addams and Evil*, *Black Maria*, *Drawn and Quartered*, or any collection of cartoons that included ones by "Chas" Addams. I loved his macabre yet cheery way of looking at the world. They affected me profoundly–i.e., I laughed out loud. I also loved the way his drawings looked–the spooky, lush blacks and grays drew me in. Like most kids, I'd always loved cartoons, but these were different from anything I'd ever seen. Really black, really dark. But funny. And, of course, subversive. I knew I wasn't supposed to be laughing at Christmas carolers having a cauldron of boiling oil poured on them from the Addams family's rooftop, but I swear, I couldn't help it.

I'm glad that magazine cartooning is not a collaborative effort. Decisions, for better or worse, are not made by committee. We magazine cartoonists mostly work in solitude on our drawings, which either get published and get seen by a wider audience or get rejected and shoved into a filing cabinet. If you enjoy office politics, or even a lot of socializing, this is probably not the field for you. Most cartoonists I know are not misanthropes–in fact, we like to see one another from time to time–but for God's sake, not all day long, day after day. Like most writers and artists I know, we need time to process daily interactions and turn them over and around and inside out and occasionally, find the cartoon locked inside one of them.

OPPOSITE: Detail, Charles Addams, cover for *The New Yorker* (June 11, 1960).

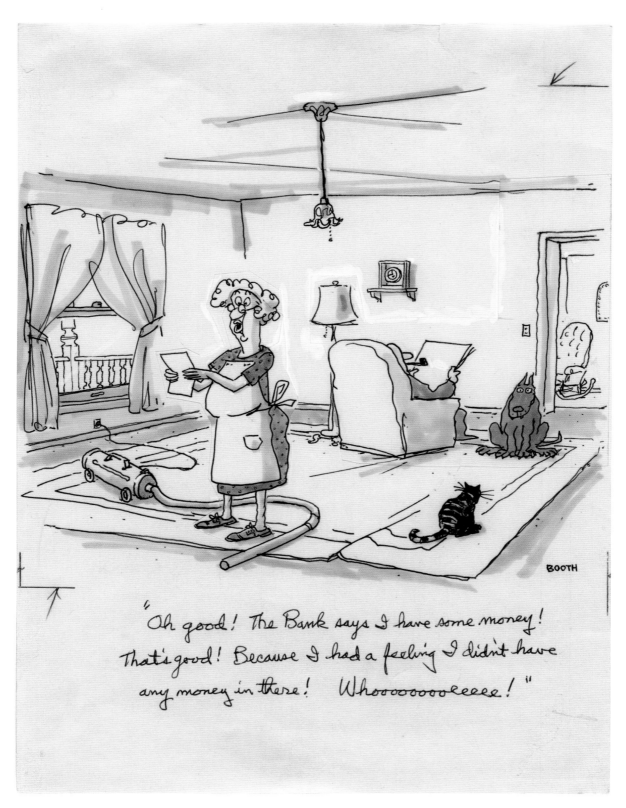

George Booth, "Oh good! The Bank says I have some money! That's good!
Because I had a feeling I didn't have any money in there! Whoooooooooeeeeee!" (March 21, 1983)

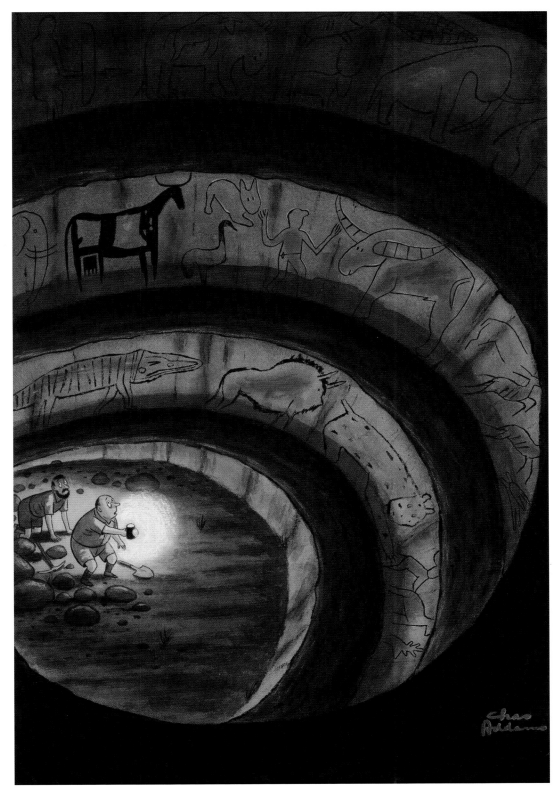

Charles Addams, cover for *The New Yorker* (June 11, 1960)

Mothers, Don't Let Your Daughters Grow Up to Be Cartoonists!

Nicole Hollander

I think boys pop out of the womb, capes flung over their shoulders, pens in hand, ready to draw action figures. But how did some of us girls find ourselves part of that most masculine of professions, political cartooning? Did lightning strike our pink bassinets or did we come under the influence of a Girl Scout leader who said, let's not make cookies, let's put on gorilla suits, take to the streets, and ask why there are so few women artists in museums!

Alison Bechel says she was minding her own business when she fell in with a rough crowd, "women who were throwing blood on the Pentagon or blockading Wall Street, or going to Nicaragua to help the Sandinistas with the coffee harvest. I wasn't much of an activist myself, but as I tagged along after these women to marches and demonstrations and watched them get hauled off by police, these activities and issues began creeping into my cartoons."

Alison frets about the mix of art and politics in her strip. Do political discussions fit seamlessly into her fictional character's lives or does their addition jar the reader? I think it's a perfect blend, interesting and captivating. It seems to me that her success is due to a flawless fusion of the funny, awkward, intricate lives of her characters with the political climate that we all share. And I appreciate her characters calling each other out when their doom and gloom scenarios are over the top.

Ann Telnaes was working late one night on a humorous illustration when a thunderbolt blasted her out of her apolitical sleep: retelevised scenes of the Chinese government's brutal suppression of the 1989 pro-democracy demonstrations in Tiananmen Square. Then she watched the Senate's brutal treatment of Anita Hill during Clarence Thomas's 1991 confirmation hearing. Her revulsion at these events changed the direction of her career.

Ann remains indignant about abuse of power by those in high places, threats to freedom of expression, suppression of First Amendment rights, the erosion of the separation between church and state, the disappointing performance of the media in exposing lies and corruption, the denial of women's basic civil and human rights at

ABOVE: Nicole Hollander, *The Clone Fairy* (February 26, 1998)

OPPOSITE: Detail, Nicole Hollander, *Love Cop* (March 26, 1998)

Nicole Hollander, *Love Cop* (March 26, 1998)

home and worldwide. And she makes her moral points with clarity and elegance. Of course, she has to be timely and honest and get to the heart of the matter. And if the matter in question is yet another version of the same old political chicanery, she must find fresh images and fresh ways to represent those repetitive outrages.

Pity the poor political cartoonists faced over and over with familiar wrongs. Ancient issues rise like the undead in a horror movie, reappearing tattered and disgusting and pesky as ever. Didn't we just get rid of that one by putting a stake through its heart and burying it at the crossroads? No, they come back and take us by surprise every time, and because the policies seem so ridiculous, we wonder how anyone can take them seriously—but they manage to be dangerous and funny at the same time.

Here we are again faced with our government's resolute conviction that to protect us they must withhold information; that denial of civil rights will not compromise civil liberties; that bombing brings democracy; that television news is real news; that they did not authorize torture at Abu Ghraib and Guantanamo. And look out, here it comes–the government's deeply held and convenient belief that anyone who dissents from the official version of the truth is anti-American.

I like to think of us cartoonists as Sisyphus's sillier sisters, fated to repeatedly draw the story of the erosion of our civil liberties, images of sexism, racism, and creationism. Once again we're confronting unvarying Orwellian legislation with names like Clear Skies and Clean Water or No Child Left Behind; or the "reform" of Social Security–they haunt our dreams. Late at night we ask ourselves: Is it bad government or bad karma?

It's hard not to fall into a coma of despair from the sheer weight and monotony of all the injustice. But we cartoonists, just like pizza delivery guys, we keep our outrage hot and our delivery quick.

Ann Telnaes, *Six Chix* (November 13, 2003)

Alison Bechdel,"Dearth in the Balance" from *Dykes to Watch Out For* (December 20, 2000)

Ann Telnaes, "Afghan Radicals" (October 10, 1996)

Jimmy Misses Superman: Jeff MacNelly

Mike Peters

All my life I thought I was Superman until I met Jeff MacNelly.

The effect Jeff MacNelly had on me was the same effect he had on the whole profession. The profession was dominated by Mauldin and Herblock and hadn't changed much in a hundred years. The only other new influence was Pat Oliphant, who was a disciple of British cartoonist, Ronald Searle. Oliphant brought the British influence and dry sense of humor to America in the 1960s, but it was MacNelly who turned editorial cartooning into an art form.

The first time that I met Jeff MacNelly was in San Antonio at an AAEC Meeting (Association of American Editorial Cartoonists; yes, they actually have conventions). Jeff and I were sitting together on a bus going to some event and he was telling me about how his newspaper was on strike. Because of this, he was helping out in the engraving department working on a linotype machine, a machine only Gutenberg or a teamster could run. This would foreshadow his lifelong fascination with machinery. I saw him draw on napkins, armrests, toilet paper, always constant and flowing. I left the convention early and when I got home, my wife asked what was wrong and I said I had just met this young guy who was brilliant and I had better start working harder.

During the Carter Democratic Convention (against Reagan) in New York, we went to Madison Square Garden. Along the way, the traffic was bedlam. People were yelling, there were flowers being put into policemen's lapels, there were street mimes, cab drivers screaming in all languages, people in chicken outfits, Secret Service men, and an Abe Lincoln on stilts. We walked across the street to go into the convention where we sat together taking notes of all the political nuances and machinations. Later that night we went to separate hotel rooms and I proceeded to draw an agonizing cartoon about Carter with his head in a basket and Ted Kennedy holding it or something. The next morning, I saw Jeff's cartoon, and it wasn't about anything that went on at the convention. He saw that the real story was what went on outside: the cops, the cab drivers, the Abe Lincoln on stilts, everything we saw, he had put into that cartoon! I had seen the same things but they passed right by me. Seeing and looking was what made Jeff so great. He trusted what he saw and if it interested him, he knew it would interest us. This was his genius.

Also, you never saw Jeff work. I don't know if it was intentional subterfuge on his part, but he always looked–dormant. He was always sitting drinking a coffee or a beer, watching some basketball game on TV, smoking a cigar, or painting. But he was never working. He was like a mother salmon just sitting there for days on end not doing anything and then suddenly, *THHHHPPTTT!* she spits out five hundred eggs. It was mystical. I would get up in the morning and he would have finished seven cartoon strips, five editorial cartoons, and an illustration for a book on golf or something.

I was Jimmy Olsen to Jeff MacNelly's Superman.

Somewhere around 1982, after two Pulitzers and two wives, Jeff dropped out of sight for a while. For some reason, even though he hated the phone to the point of phone-a-phobia, he continued to return my calls. I guess I always made him laugh while all of his other calls were either lawyers or accountants or just plain bad news. Anyway, people somehow found out that I had a connection with the Big Guy. Soon the syndicates started calling for deadlines and the *Washington Post* would call to find him for various social events. In fact, the *Post* would contact me in order to contact Jeff to attend a dinner for their syndicated cartoonists, during which very famous Beltway folks did very crazy things. For twenty-five years this dinner weekend provided the chance for Jeff and me to enjoy the company of about eight other editorial cartoonists. We would hang out and tell stories and get the chance to meet the Washington elite.

Jeff and I traveled together, did speeches together, and became great friends in the process. One of the great trips we took was to Tahiti. As always, I would cook up silly adventures and he would go along, rather embarrassed and bemused. These memories I will cherish always. He left us on June 8, 2000. There never was anyone quite like Jeff MacNelly and there never will be. He was the Best.

Jimmy misses Superman.

Jeff MacNelly (August 11, 1994)

Wishbone of Contention

Jeff MacNelly, "Wishbone of Contention" (March 5, 1991)

Jeff MacNelly, *Shoe*, February 21, 1990 (top), January 17, 1990 (bottom)

The Joy of Writing
Lynn Johnston

When I began *For Better or for Worse* in 1979, I had no intention of doing a "reality based" strip–other than that the contents would reflect life as I saw it. The characters were loosely based on my family and being a mom with not much patience and the need for "order," comedy saved us all. If I could put a particularly irritating scenario into the strip I felt better. Drawing facial expressions, creating believable scenarios made me feel good. I waited every day to see my work in the paper (a day late because we lived so far north) and as I read the strip from a readers' point of view, I wondered if others saw things the way I did.

I began to receive letters first from Canada and the United States, and then from all over the world. Families recognized themselves. I wasn't the only one who felt inadequate, frustrated, overwhelmed, and totally consumed by parenthood. I also felt blessed and lucky and so many times Rod and I collapsed in tears of laughter when one of the kids did something only a kid would do.

Here's an example: When Kate had her third birthday, she asked for a spice cake–her favorite, made by the local bakery. When I brought it home, she wanted to dig her fingers into the icing, but I said she had to wait until the guests (soon to arrive) had played some games, eaten their lunch, and had sung the birthday song. I put the cake on the counter well out of reach and prepared for the party.

Surprisingly, the matter of the forbidden icing was not brought up again. The party happened and I reached for the cake. All of the icing on the hidden side, next to the wall was gone.

I couldn't confront my smiling culprit in front of her friends, thus the candles were lit, the song was sung and Kate asked for a big piece "wif flowers on it." She was called "Cake Johnston" for months afterwards.

It was the little things that crept into the strip ("How to load a dishwasher, who used the last of the toilet roll? How come the *new* pants get the grass stains and how do you find a bathing suit that fits a mature female form?") that were so much fun to poke fun at.

Then I noticed that our kids had changed. Their habits and abilities and adventures were altering day by day, thus altering the rather insular life we led. Our personal situation was changing, too. As the children started school and gained more independence, we no longer had baby stuff to contend with. The reality was that my subject matter had to change, or I would have to stop the clock and keep all of the characters static–the same age forever.

I tried for about three years. This was a good thing, because as long as Aaron and Kate were small, they were oblivious to the fact that a lot of people–including neighbors and friends–thought I was writing a true chronicle of our own daily life.

People would ask questions about "Connie" or "Annie"–who didn't exist. They would wonder why Rod (my long-suffering anchor) wasn't limping when the character "John" dropped a turkey on his foot and was wheezing about on crutches. And they believed that everything the kids did in the strip had really happened.

The three static years separated our children from the kids in the strip, which was a very good thing. During this time I continued writing gag-a-day strips, but more and more, one gag would lead to a follow-up which would beget yet another related set of panels. I had done short vignettes from the beginning, but stories were happening, which was not my intent.

I once explained to Mike Peters (*Mother Goose and Grimm*) how this storyline thing had come about. "I would do a gag," I said, "but it would often beg the question–and *then* what happened?" This meant I had to immerse myself in the imaginary world of the Pattersons and find out!

Writing, for me, is like wakeful dreaming. I am the characters, I'm watching the characters, I can hear them, I can anticipate their moods and feelings and responses–and every response or strip ending must have a punch line, or I'm not doing my job! At least, that's how I feel. If I was going to write short stories, every daily strip had to be worth reading–and, somehow stand alone. I wanted to give the audience my best work (Sparky's words) every day, which meant the best art I could do and the best writing.

Aaron and Kate saw my work as both a plus–we traveled, did fun stuff, met great people, had our own plane–and a minus: their personal lives were exposed despite creative writing and they were

Lynn Johnston, *For Better or for Worse* (April 21, 1985)

Lynn Johnston, *For Better or for Worse* (December 4, 1988)

Lynn Johnston, *For Better or for Worse* (January 2, 1985)

expected to be cartoonists or heaven knows what because their parents were sometimes in the news.

Sometimes even the three-year gap wasn't enough to separate them. When Michael had a girlfriend, Aaron was teased, when Elizabeth got sick, Kate's teachers hoped it wasn't contagious. All of us were associated with *For Better or for Worse* whether we liked it or not. I liked it. I thrived on the publicity. I had fun with it! Rod resigned himself to being Mr. Lynn Johnston. He became my soul mate and grounding wire. He was and is the reason I've retained my sanity–such as it is. Writing is something that happens to you!

Writing is something that happens to you. If stories were coming from my pen, then I would do stories. I started with short ones, putting spot gags in between. Then the stories melted one into the other, overlapping, intersecting, becoming more complicated. I enjoyed the challenge now of doing a "chronicle" of this family's life which included everything I thought a normal family would experience.

Funny stories are a joy. Serious ones are difficult. Both must be balanced so that a sense of reality exists. Reality–despite the fact that I still draw Elly and John like cartoon characters while the others, with a few exceptions, have fairly believable features. This is because a cartoon has a "signature," a style, and after a while, everyone starts to look the same.

Charles Schulz (Sparky) once said to me "if it wasn't for hair and clothing, all of my characters–except Snoopy–would look the same!" I didn't want my characters to look the same. I practiced drawing different-shaped heads, different features, and finally started using faces from magazines to help me break away from my "signature."

Once my characters morphed from cartoon to almost comic-book style, I lost something. I think it was comedy.

I once saw a great *MAD* Magazine article. If cartoon characters had skeletons, what would they look like? Popeye's was one of the funniest, with a giant jaw and massive forearms. Even Mickey Mouse was x-rayed; I believe his ears had bones in them! When I think about the skeletal structure of my own characters, they're not cartoons. They're structurally human. Just the noses (inflatable, according to our son, Aaron) are exaggerated and when the characters laugh–I allow them to stretch to the max. But they've become too "real."

Drawing funny stuff is my favorite thing to do, so by having realistic characters, I deny myself the fun of stretching and flattening them–except for the pets.

First Farley, and now Edgar the dog, gave me the freedom to personify animals. Their gestures and expressions fill me up. They make me laugh out loud. You can have your pills and powders. Laughter is my drug of choice!

So why do I now do provocative stories about love and loss, poverty, retirement, moving, living in a small Native community, getting pregnant, growing old? I don't know. All I can tell you is that it's easier than doing gag-a-day. I don't know how people like John MacPherson can be so wonderfully funny, creating a different comic idea for every single day of the week! I wouldn't be able to sustain this. Despite the death of characters and complicated storylines I'm more comfortable doing what I do. When I look back at my earlier work I can see how much I've matured as an artist and a storyteller. (That's not to say I'm better–I've matured!)

Lynn Johnston, *For Better or for Worse* (January 16, 1987)

Panels are no longer filled with torsos and talking heads. My characters have houses with floor plans. They have furniture and stairwells and windows and walls. If they are in a car, it looks like a car. If someone drives a forklift, it looks like one.

My studio resembles a toy store. I have models of everything from city buses to motorcycles to tennis shoes to cars. One of my greatest finds was a fridge magnet in the shape of a metal wheeled shopping cart. Few things are more difficult to draw in perspective and from an angle than a shopping cart! One of the hardest things to draw has been Sharon Edwards's wheelchair. This may be one reason she didn't appear in the strip as often as I wanted her to. When she appeared, I got mail from folks with wheelchairs who advised me that the chair she used was out of style or that her shoes were wrong–even though I thought I'd done my homework! So I got catalogues from a local store, took photographs of our wheelchair rugby team in action and asked more questions, hoping that readers would say "she got it right."

I once saw a strip where the artist had a character using a chainsaw. The machine had been drawn without any reference whatsoever and looked awful. I wondered why anyone with an audience so large and varied wouldn't go that extra step and use a photograph! I keep catalogues and magazines on every topic from tattoos to sports fishing. I have the *Macmillan Visual Dictionary*–if you're a cartoonist, get one.

Reality isn't just getting a story to be believable, it's designing the props, painting the hallways, and buying the car. All of this takes time and effort–which is ultimately so worthwhile.

I am at the stage now where I can see an end to the saga. One can sustain a strip like this for only so long and then you get tired. If I'm tired, I know my writing and my drawing will reflect that fatigue and I don't want that to happen. I've thought about finding someone else to continue *For Better or for Worse*. Once I even offered it to someone! Fortunately, they turned me down–and, it was for the better.

A great guy who has been doing one of the classic long-running story features told me he was so happy when the original artist died, because then he could have the strip to himself!

That made me think. Whoever continued *For Better or for Worse* would suffer the shadow of *me* over their shoulder, constantly nattering about how things should be done. This would neither foster a great relationship nor inspire creativity. It's better, I thought, to make this a complete story with a beginning, middle, and end. This has taken courage, but it's the right thing to do.

So, now as I'm facing my last two years, I'm looking back to see where loose ends need to be picked up and tied. I'm looking ahead to see how and when the storyline will finish and I'm looking even farther to see what we'll do with a lifetime of work–and the life of a family who, to everyone, including me, has become "real." This is the biggest challenge of all, and I'm up for it.

I write for my audience, but most of all, I write for the joy of writing. I was given the opportunity to do cartoons about an ordinary family and it turned into an extraordinary career. How lucky can one get. This is a statement, not a question. Bill Hoest (*The Lockhorns*) said shortly before he died, "Being a cartoonist has been the most wonderful experience I can imagine–and if I get to come back some day, I'll do it all again!" I agree.

Caricature as Weapon
Kevin "KAL" Kallaugher

The first caricature I remember drawing was of my fifth-grade music teacher. I was at St. Thomas's grade school in Norwalk, Connecticut. My subject was a nun who made a practice of singing passionately with her eyes closed. The subject matter was too much for me to resist. I captured her on paper in profile with her button nose, flowing habit, closed eyes, and a mouth the size of a battleship. The caricature was soon finding its way around the classroom. The reaction to the drawing was immediate. My fellow twelve-year-olds delighted in its naughtiness. I was a star.

The nun, on the other hand, was less impressed with me when she intercepted the offending artwork. She marched me down to the boys' lavatory where she instructed me to take a bite out of a bar of soap.

"Don't you draw another cartoon like that again!" she barked.

I've been drawing them ever since.

It turns out that the nun was really quite a good teacher. She taught me about the power of a good caricature.

Since that early experience I have drawn thousands of caricatures from the streets of Trafalagar Square in London to the pages of prominent publications worldwide. After over thirty-five years of drawing I have come to a conclusion. For the visual satirist, there is no more potent weapon for assaulting the powerful than a good caricature.

Throughout the years the most revered editorial cartoonists have most often been devastating caricaturists. These artists have provided history books with sardonic images of politicians past.

These portrayals are powerful and memorable. Once you have seen Honoré Daumier's portrayal of King Louis-Philippe turning into a pear or Thomas Nast's "Boss" Tweed as a vulture, it is hard to forget them. In the nineteenth century, when these cartoons appeared, their effectiveness must have been profound. With no television or photographs readily available to educate the public as to a politician's likeness, these wicked caricatures would have been among the sole images of the politicians on display. The potency and importance of these critical pictures must have been quite significant–significant enough to land Daumier in jail.

Politicians throughout the years have recognized caricature's terrible potential and have endeavored to limit it. In 1903 the Pennsyl-vania legislature, at the behest of Governor Pennypacker, tried to enact anti-cartoon legislation. This was prompted by the cartoons of Walt McDougell, who during Pennypacker's election bid constantly drew him as a parrot sitting on the shoulder of a prominent Philadelphia businessman. The law decreed that no person could be drawn as a bird, insect, fish, or any other such living thing. The law was short-lived.

Such harassment of caricaturists is not the sole province of American politicians. In the young democracy of Turkey, Musa Kart, cartoonist for the daily *Cumhuriyet*, was sued by Prime Minister Erdogan in a case that reached the nation's supreme court. His crime? Depicting the Prime Minister as a cat. And in 2006 there was an international storm that began in Denmark over cartoon drawings of the Muslim prophet Mohammed.

Many of America's most noted political cartoonists can be best remembered for their blistering caricatures. There's Herb Block's portrayal of Joe McCarthy as a heavy-browed thug, David Levine's devious Richard Nixon, Jeff MacNelly's shrinking Jimmy Carter, Pat Oliphant's handbag-toting George H. W. Bush. These are images that are apt to fill the history books of the future.

It is true that not all successful political cartoonists are gifted caricaturists in the traditional sense. They may not be able to dismember a face and reassemble it with the sardonic effectiveness of Daumier or Nast. Instead, their effectiveness comes in recreating their targets as belittled cartoon characters. Joel Pett, the Pulitzer Prize-winning cartoonist for the *Lexington Herald-Examiner*, uses this tactic to great effect. He will be long remembered in Kentucky for his devastatingly simple portrayals of Governor Wallace Wilkinson as a weasel.

Then there's Garry Trudeau, who eschews caricature altogether, instead opting for floating symbols to represent different politicians.

Still for me, the power of a well-conceived and executed caricature cannot be denied. Those cartoonists who can successfully wield the caricature pen have a formidable weapon at their disposal. By attacking a target's face you are assaulting a public figure's most prized possession. As has been seen throughout history, a devastating caricature can permanently stain the way a person is remembered.

Just ask my fifth-grade music teacher.

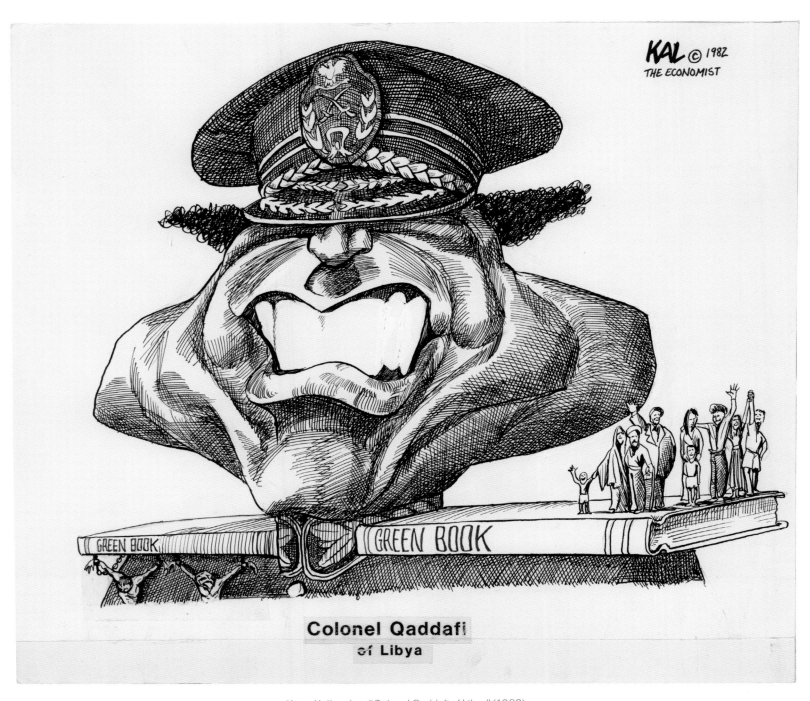

Kevin Kallaugher, "Colonel Qaddafi of Libya" (1982)

Kevin Kallaugher, "Attorney General John Ashcroft" (2001)

Kevin Kallaugher, "CIA Director William Casey" (1986)

God, We Had Fun: To Herblock

Paul Conrad

Herb Block was one of the first to revolutionize the editorial cartooning field. He took many of the words out of his cartoons, in fact most of them, and put them in a line underneath. I thought his work was so impressive and powerful that I decided that's the way to go. Just to go for the jugular.

When we'd have dinner, we'd just talk about Washington; he knew Washington inside and out. I think his drawing of Nixon climbing out of the sewer, with a band coming up the street, was hilarious. And also the one of a guy climbing a ladder up Liberty's arm, which is holding the flame—he's got a bucket of water and it says "hysteria" on it—now *that* was a cartoon.

There just aren't that many cartoonists doing that kind of work anymore. I just wish the rest of the cartoonists would study his work and learn what they're doing wrong.

Both he and I read. We read everything. We were drawing about the same things. We had an absolute ball on Watergate; I kind of miss that. The country doesn't, but I do.

He got robbed on the Watergate Pulitzer. He was named, along with the *Washington Post*, but he should have won a Pulitzer himself. I was on the jury, and his stuff was just fantastic. They had a vote, and then they said, "Nobody gets one," so what are you going to do? I couldn't fight them. I called and told them how angry I was.

I went back to Washington for a couple of Gridiron dinners—you've got to wear tails to go to them. And there he was, standing there in a tuxedo, and he had his tennis shoes on. And I said, "Jesus Christ, Herb, what are you doing?" and he said, "Well, they're more comfortable than the rest of my shoes." I said, "That's good enough for me."

God, we had fun.

Paul Conrad "Reflections" (2001)

Herb Block, "Tick-Tock Tick-Tock" (January 11, 1949)

Herb Block, "President Reagan" (March 5, 1987)

Herb Block, "President Clinton" (February 4, 1998)

Cartoons of 9/11

Martha Kennedy

Amid the shattering global impact from the terrorist attacks on New York City's World Trade Center and the Pentagon on September 11, 2001, the first in America's artistic community to react creatively were creators of cartoon art. Not only did they do so quickly, they made some of the most compelling imagery to emerge from a rich body of 9/11-related art.

What might account for such an outpouring of artistic expression during this period? Some cartoonists stated that when they could find no direct means of aiding those in need, they turned to creative expression as the only way to react constructively. During great crises and wars of the past, the arts have flourished. Powerful imagery by Goya, Daumier, and Picasso, for example, captured the grief and horror that are commonly felt during such times. The graphic art created in response to 9/11 has a fresh, spontaneous quality in keeping with the appalling events that unfolded so rapidly that day.

Cartoon art, whether comic book or single panel, editorial cartoon or illustration, typically tells a story or expresses a point of view, often combining image and word. Such art requires extraordinary flexibility and inventiveness. The arresting union of form and meaning that distinguishes this artistic mode from others, enabled these artists to respond to 9/11 with immediacy and ingenuity.

Cartoonists Will Eisner and Peter Kuper evolved dramatic yet strikingly different visions of the World Trade Center's destruction. During his legendary career, Will Eisner pioneered the development of American comic books and later the creation of modern graphic novels. His remarkable contributions–including "Reality 9/11" (2002), his compassionate, haunting response to the terrorist attacks of September 11, 2001–continued to his death at age eighty-seven in January 2005. "Reality 9/11" exemplifies the narrative and expressive capacity of the single-panel genre, which, Eisner said "enables people to talk with images." His deeply dejected Everyman viewing a broadcast image of Ground Zero at the site of the Twin Towers captures universal emotions of horror and dismay–it also underscores the shocking physicality of destruction by showing blood spilling from

the exploding TV monitor, smoke, and debris covering the man. The screen frames the towers' twisted ruins, forms that become iconic and run like a leitmotiv through other 9/11-related works of art.

In contrast with Eisner's compressed narrative, Kuper took a more conceptual approach in "Missing" (2002). His compact, vivid symbol of destruction depicts the city's devastation metaphorically with an upright hand disfigured by two ghostly missing fingers representing the World Trade Center towers in ruins. Other fingers represent the Empire State Building and the Chrysler Building. The palm of the hand is a subway map of Lower Manhattan.

Sue Coe's print "9/11" (2002) projects an epic, Brueghelian panorama of disaster. Within it she conflates key phases of the events: the first tower burning, the plane approaching the second tower, people jumping or falling from the towers to their deaths, rescue workers helping the injured amid a deadly landscape. Unlike Eisner and Kuper, Coe gave visible form to the enveloping, deadly chaos of destruction and portrayed many tragedies occurring simultaneously.

Creating artistic tributes to the thousands of lives lost proved daunting to many cartoonists. Keiron Dwyer depicted the Twin Towers as dark rectangular forms filled with several hundred human faces, which are "representational and not literal" depictions of the victims. His single panel memorializes the thousands who perished at the World Trade Center and counterpoints Paul Levitz's story "Tradition" (illustrated by Joe Staton and Bob Smith), which commemorates one victim. Opening frames recount *Yahrzeit*, the tradition of lighting a candle on the anniversary of a loved one's death. The frames show a mother and her son, now ten years later, listening on a cell phone to a farewell message sent by the father before his death.

Many 9/11-related editorial cartoons focus on the curtailment of civil liberties that followed the attacks. In "Attorney General Ashcroft Testifies" (2002), Kevin Kallaugher sequenced caricatures in a comic strip-like manner. Successive images of Ashcroft's head loom, tilt, and heighten the realistic impact of his words referring to the U.S.A. Patriot Act. Garry Trudeau's pre-holiday Sunday *Doonesbury* strip (December

OPPOSITE: Kieron Dwyer and Mark Chiarello, *9-11* vol. 2 (2002)

Peter Kuper, "Missing," cover for *World War III Illustrated* no. 32 (2002)

Will Eisner, "Reality 9/11," from *9-11: Emergency Relief* (2002)

Garry Trudeau, *Doonesbury* (December 23, 2001)

23, 2001) devoted most of the nine-panel space to one horizontal that celebrates human hope: across the snowy bleakness of World Trade Center ruins, Zonker Harris and B.D. wish each other peace. Each artist adapts comic-strip format to attain a strong expressive effect.

Renowned comic-book painter Alex Ross invoked the time-honored super-hero tradition by depicting Superman and his dog, Krypto, admiring the heroes of September 11, 2001. His moving synthesis of the general and specific turns tradition on end by portraying the legendary icon as a smaller figure standing in awe before larger-than-life figures of firemen, rescue workers, health care professionals, and other ordinary people who proved themselves superhuman in heroic deeds of sacrifice. Based on the classic comic-book

cover of *The Big All-American Comic Book* from 1944, Ross places them in an elevated realm above the super hero and the viewer.

In addition to chronicling the events and aftermath of September 11, 2001, or commemorating those who perished, the artists who responded creatively to the tragedies worked in the spirit of their artistic predecessors. Each sought to uncover the meaning of 9/11 for themselves and for posterity. The flexible, resilient nature of cartoon art, with its distinctive union of image and message, moves its practitioners to renew and expand pictorial languages to illuminate critical events with immediacy and insight. It is to be hoped that the best examples of this art form will endure and receive recognition for technical excellence, imaginative power, and eloquent meaning.

Sue Coe, "September 11, 2001," from *World War III Illustrated* no. 32 (2002)

AFTERWORD

Harry Katz

Ending a book about comics art on a note of tragedy seems ironic and yet just. Humor heals and helps people move on through unexpected grief and tragic loss, or simply the grinding routine of daily living. Cartoons see us through the hardest times. Not just with humor, but rather with empathy. Cartoonists are regular folks, bound by earthly laws and financial realities–deadlines to meet, mortgages to pay, and mouths to feed. They need to know their audience and respond effectively, or risk losing it. Their job is to communicate directly to their readers through art.

Cartoonists rarely have time for art for its own sake, which only means that they apply artistry as needed to the task at hand: to convey the message, joke, product, or political opinion. The great cartoonists know that humor without art is unlikely to endure, that readers won't linger, and no instant visual connection will be made. They use art to advantage, transcending the genre's commercial limits to create works of lasting beauty. Their true skill lies in blending caption and drawing into a funny moment, a moving image, or otherwise memorable graphic gag or commentary. Cartoonists generally get better with time and can best be judged by the quality of work done over decades. Even well into his nineties model senior citizen Al Hirschfeld would have said "the next drawing" was always his favorite.

The process of selecting several hundred drawings from tens of thousands and several dozen artists from hundreds more began with a list of acknowledged treasures from the Art Wood Collection and the Library's related holdings. Added to these were suggestions from friends and colleagues, including many cartoonists who were generous with their time and knowledge, along with additional drawings encountered during past projects.

The Library's otherwise outstanding collections do reveal gaps. For example, a few contributors to this book who also happen to be cartoonists are not yet represented. Richard Williams, whose magnificent Mount Rushmore graces the cover of *Cartoon America*, stands in for the generations of *MAD* Magazine artists whose work has not yet found its way to Washington and Capitol Hill. More work needs to be done toward acquiring drawings for Underground Comix, comic books, and graphic novels. With such a strong collection foundation, however, along with continued administrative support and acquisitions, those gaps, and others too, will close in time. The Library is, after all, primarily a historical research library where contemporary acquisitions typically lie in future relationships with retiring creators and collectors.

The Library specifically seeks to represent with original drawings the most influential American comics artists and illustrators working at their best. These men and women have created much-loved characters we embrace as family–images that capture our imaginations and our attention, make us think, act, vote, buy, dream, and above all, laugh. Many of the really good ones persist in our minds as shared memory. They live on, too, within the Library of Congress as exemplary works of history and art.

OPPOSITE: Alex Ross, cover for *9-11* vol. 2 (2002)

CONTRIBUTORS' BIOGRAPHIES

TONY AUTH was born in Akron, Ohio, and raised in southern California. He began drawing while listening to the radio and looking at comic books and children's books while bedridden for a year and a half at the age of five. Auth graduated from UCLA in 1965 with a degree in biological illustration and worked for six years as chief medical illustrator at a large teaching hospital affiliated with the medical school of the University of Southern California. In 1967 he began doing political cartoons: first a weekly cartoon, then, after a year, three a week for the UCLA *Daily Bruin*. In 1971 *The Philadelphia Inquirer* hired Auth as staff editorial cartoonist. Auth has won five Overseas Press Club Awards, the Society of Professional Journalists' Award for Distinguished Service in Journalism, the Thomas Nast Prize, and the Pulitzer Prize. In 2005 he received the newly created Herblock Prize. The author/illustrator of several books for children, Auth lives in Wynnewood, Pennsylvania, with his wife and two daughters.

JAMES H. BILLINGTON was sworn in as the Librarian of Congress on September 14, 1987. He is the thirteenth incumbent of that position since the Library was established in 1800. An author and historian, as well as educator and administrator, Dr. Billington was formerly the director of the Woodrow Wilson International Center for Scholars in Washington, D.C. A native of Pennsylvania, he received his undergraduate degree from Princeton University in 1950. Three years later, he earned his doctorate from Oxford University, where he was a Rhodes Scholar at Balliol College. He is the author of *The Icon and the Axe*, *Fire in the Minds of Men*, and *Russia Transformed: Breakthrough to Hope*. Dr. Billington was a longtime member of the editorial advisory board of *Foreign Affairs*, a former member of the editorial advisory board of *Theology Today*, a member of the Board of Foreign Scholarships, and a visiting lecturer or research professor at numerous universities and research centers in America and overseas.

R. O. BLECHMAN has long been a force in the worlds of illustration and animation. His first book of text and illustrations, *The Juggler of Our Lady*, was published a year after graduating from Oberlin College in 1952. Working with his distinctive shaky line, Blechman has created a number of graphic novels, among which are *The Life of Saint Nicholas* and *The Book of Jonah*. He has produced editorial art for prominent magazines and newspapers, including covers for *The New Yorker* as well as op-ed and book review illustrations for *The New York Times*. In 1978 Blechman directed and produced a Christmas special for PBS, *Simple Gifts*. In 1983, Great Performances aired his Emmy award-winning adaptation of Igor Stravinsky's *L'Histoire du Soldat*. His current animated project is an adaptation of Nathanael West's *A Cool Million*. Among his honors has been his election to the Art Director's Hall of Fame in 1999, and a retrospective of his animated films at the Museum of Modern Art in 2001.

BRUMSIC BRANDON, JR. was born in Washington, D.C., on April 10, 1927. While a student at NYU he began selling cartoons to national magazines. In 1968 he created the comic strip *Luther* for *Newsday*. From 1969 until 1982 Brandon was Mr. BB on a children's television show in New York called *Time for Joya*, which later became *Joya's Fun School*. In the mid-1970s Brandon fashioned several *Luther* segments for *Vegetable Soup*, a children's television series. He also created several "Bebop Fables" for that show. Concurrently, Brandon drew cartoons for *Freedomways Magazine* and for Black Media. Upon relocating to Florida, where Brandon and his wife, Rita, now live, he drew editorial cartoons and wrote op-ed columns for *Florida Today*, from 1992 to 2002. Now retired, Brandon considers the inclusion of his work in the collections of the Library of Congress to be his highest honor.

JOHN CANEMAKER is an independent animator and animation historian whose work has won international honors, including the 2006 Academy Award for Best Animated Short Film for his autobiographical animated film, *The Moon and the Son: An Imagined Conversation*. His personal films are in the permanent collection of the Museum of Modern Art and have been released on DVD (*John Canemaker: Marching to a Different Toon*). He also created animation for the Peabody Award-winning *Break the Silence: Kids Against Child Abuse* (CBS, 1994), the Academy Award-winning documentary *You Don't*

Have to Die (HBO, 1988), and *The World According to Garp* (Warner Bros., 1982). Canemaker has written nine books on animation history, including *Winsor McCay: His Life and Art* (Abrams, 2005) and *Walt Disney's Nine Old Men and the Art of Animation* (2001), and contributes articles on animation to *The New York Times* and *The Wall Street Journal*. Canemaker is a full professor and the director of animation studies at New York University's Tisch School of the Arts.

LUCY CASWELL is the founding curator of the Ohio State University Cartoon Research Library, the largest and most comprehensive academic research facility documenting printed cartoon art in the United States. Professor Caswell teaches courses in the history of comic strips and the history of American editorial cartoons. She has curated more than thirty cartoon exhibits and is the author of several books and articles. Her most recent article is "Drawing Swords: War in American Editorial Cartoons" for *American Journalism* (spring 2004).

ROZ CHAST was born in Brooklyn, New York. She attended Rhode Island School of Design and graduated with a BFA in painting. In 1978 she sold her first cartoon to *The New Yorker*, where she has been a staff member since 1979. Her work also has appeared in *Scientific American*, *Redbook*, *Town & Country*, *Mother Jones*, *The Harvard Business Review*, and many other magazines. She has also published several cartoon collections, most recently, *The Party, After You Left*, in 2004. She is also the illustrator of several children's books. In 2006 Chast will publish another collection of her cartoons, *Theories of Everything*.

PAUL CONRAD was chief editorial cartoonist of *The Los Angeles Times* from 1964 to 1993. His trenchant political observations appear in newspapers nationwide and abroad, and are syndicated four times a week by Tribune Media Services. His favorite distinction: his 1973 inclusion on Richard Nixon's Enemies List. His favorite irony: holding the Richard M. Nixon Chair at Whittier College in California (1977-78). In addition to three Pulitzers (1964, 1971, and 1984), Conrad has won two Overseas Press Club awards (1970 and 1981). His books include *Drawing the Line* (1999), *CONartist* (1993), *Drawn and Quartered* (Abrams, 1985), *Pro and Conrad* (1979), *The King and Us* (1974), and *When in the Course of Human Events* with Malcolm Boyd (1973).

SARA DUKE, associate curator of popular and applied graphic art in the Prints and Photographs Division, has been at the Library of Congress since 1991, working intimately with cartoon and carica-

ture collections. She has contributed to several Library of Congress exhibitions, including *Featuring the Funnies* (1995), *Jules Feiffer* (1997), *Life of the People* (1999), and *Herblock's History* (2000). In addition, she served as curator for the exhibition *Cartoon America*, scheduled to coincide with the publication of this book. She has also created an Internet memorial, *Bill Mauldin: Beyond Willie and Joe* (2003): http://www.loc.gov/rr/print/swann/mauldin/.

ALAN FERN, in his twenty-one years at the Library of Congress, has served as curator of fine prints (1962-64), assistant chief (1964-73) and chief (1974-76) of the Prints and Photographs Division, and director for special collections (1978-82), among other posts. He received a PhD in the history of art from the University of Chicago, where he taught prior to coming to the Library in 1961. In 1982 he was appointed director of the National Portrait Gallery, Smithsonian Institution, where he served until his retirement in 2000. He has published several books and articles on the history of prints, posters, and photographs. Alan Fern currently resides in Chevy Chase, Maryland.

BILL GRIFFITH began his comics career in New York City in 1969. His first strips were published in the *East Village Other* and *Screw Magazine,* and featured an angry amphibian named Mr. The Toad. He ventured to San Francisco in 1970 to join the burgeoning Underground Comix movement, and made his home there until 1998. His first major comic book titles included *Tales of Toad* and *Young Lust*, a best-selling series parodying romance comics of the time. Griffith was co-editor of *Arcade, The Comics Revue* (for its seven-issue run in the mid-1970s), and worked with the important underground publishers throughout the seventies and up to the present: Print Mint, Last Gasp, Rip Off Press, Kitchen Sink Press, and Fantagraphics Books. Griffith's most famous creation is Zippy the Pinhead. "Are we having fun yet?"–the non sequitur utterance by the clown-suited philosopher/media star–has become so much a part of our culture that it is in *Bartlett's Familiar Quotations*. Zippy is an international icon, even appearing on the Berlin Wall. The first *Zippy* strip appeared in *Real Pulp* no. 1 in 1970. The strip went weekly in 1976, first in the *Berkeley Barb* and then syndicated nationally through Rip Off Press.

ROBERT C. HARVEY, PhD (English literature), is a cartoonist and comics historian whose books include three volumes about magazine cartooning, *Cartoons of the Roaring Twenties* (1991-92), an aesthetic history of newspaper comic strips, *The Art of the Funnies* (1994), and its sequel, *The Art of the Comic Book* (1996). He has contributed cartoonists' biographies to Oxford University Press's American National

Biography (both online and in print), and for *A Gallery of Rogues: Cartoonists' Self-Caricatures* (1998). Harvey curated a comic art exhibition for the Frye Art Museum (September–November 1998) and assembled a book from the show *Children of the Yellow Kid: The Evolution of the American Comic Strip* (1998). He also conducts a Website at *www.RCHarvey.com*, where he reviews current comics and books about cartooning. Present works-in-progress include a book about Ham Fisher (*Joe Palooka*) and Al Capp (*Li'l Abner*), a biography of Milton Caniff, and a history of print cartooning in America for high school journalism courses.

NICOLE HOLLANDER is the creator of the nationally syndicated cartoon strip *Sylvia*, which appears in newspapers across the country. Nicole's character Sylvia is a woman in the tradition of the fast-talking "dames" of Hollywood screwball comedies, but with politics as well as attitude. She is a freelance pundit and appears to earn her living by giving advice and holding seminars in her home, but this may be fiction. The other characters who populate her world are The Woman Who's Easily Irritated, The Woman Who Does Everything Better Than You Possibly Could, and The Woman Who Lies In Her Journal. *Sylvia* appears in over thirteen cartoon collections and Sylvia's well-behaved cats can be seen in a forthcoming collection called *Psycho Kitties*.

LYNN JOHNSTON was born in Collingwood, Ontario, Canada, and grew up in British Columbia, the daughter of creative, artistic, musical parents who shared with her their love of laughter. Johnston attended the Vancouver School of Art aspiring to a career in animation but instead found work as a medical artist at McMaster University in Ontario. During her first pregnancy, Johnston's obstetrician challenged her to produce comic drawings for his examination rooms. These were soon published in her first book, and in 1978, after two successful sequels, Universal Press Syndicate invited her to create a daily comic strip. Remarried and loving her new life, Johnston drew upon what she knew best–her family. Her editor, Lee Salem, suggested the title *For Better or for Worse*, and the syndicate gave her a twenty-year contract. The strip now appears in more than 2,000 papers in Canada, the United States, and twenty other countries, and is translated into eight languages.

KEVIN "KAL" KALLAUGHER is the editorial cartoonist for *The Economist* magazine of London. After graduating from Harvard College with honors in 1977, he drew caricatures of tourists in Trafalgar Square and on Brighton Pier. In March 1978, *The Economist* recruited him to become their first resident cartoonist in their 145-year history. Kallaugher spent the next ten years working in London as a cartoonist for such publications as *The Observer*, *The Sunday Telegraph*, *Today*, and *The Mail On Sunday*. He returned to the U.S. in 1988 to join *The Baltimore Sun* as its editorial cartoonist. Over the course of seventeen years, he has drawn over four thousand cartoons for *The Sun* while continuing to draw two cartoons per week for *The Economist*. KAL's work for *The Sun* and *The Economist* has appeared in more than one hundred publications worldwide, including *Le Monde*, *Der Spiegel*, *Pravda*, *Krokodil*, *Daily Yomiuri*, *The Australian*, *The New York Times*, *Time*, *Newsweek*, *U.S. News and World Report*, and *The Washington Post*. His cartoons are distributed worldwide by Cartoonarts International and the *Times*. A new collection, *KAL Draws Criticism*, is due out in 2006.

HARRY KATZ, an independent curator and writer, is a specialist in American historical and comic graphic art, and former head curator in the Prints and Photographs Division at the Library of Congress. Katz is coauthor of *Eyes of the Nation: A Visual History of the United States* (1997) and *Oliphant's Anthem: Pat Oliphant in the Library of Congress* (1998), and editor of *Life of the People: Realist Prints from the Ben and Beatrice Goldstein Collection* (1999), *Herblock's History: Political Cartoons from the Crash to the Millennium* (2000), and *Humor's Edge: Cartoons by Ann Telnaes* (2004). Katz curated eighteen graphic arts exhibitions at the Library of Congress and led the Library's initiative to collect pictorial works representing the documentary and artistic response to the terrorist attacks of September 11, 2001. He divides his time between Washington, D.C., and his family home in Del Mar, California.

MARTHA KENNEDY, curatorial project assistant in the Prints and Photographs Division at the Library of Congress, has curated three Swann Gallery exhibitions, co-curated with Harry Katz *Humor's Edge: Cartoons by Ann Telnaes*, and contributed an essay to the exhibit's companion volume. She has also contributed to the *International Journal of Comic Art*, the *Encyclopedia of the Great Plains*, *The Plains Indian Photographs of Edward S. Curtis*, and the *Great Plains Quarterly*. Formerly curator of the Great Plains Art Collection, University of Nebraska-Lincoln, Martha currently works on the development, preservation, and exhibition of the Library's collections of caricature, cartoon, and illustration art.

DAVID LEVINE was born in Brooklyn, New York, in 1926 and studied at the Brooklyn Museum of Art School, Pratt Institute, the Tyler School of Art at Temple University in Philadelphia, and with Hans

Hofmann at the Eighth Street School of New York. His influences run from Will Eisner and Harold Foster to Édouard Vuillard and Thomas Eakins. Levine's many awards began with the Louis Comfort Tiffany Foundation Award in 1955, and include the George Polk Memorial Award, a Guggenheim Fellowship, the Childe Hassam Purchase Prize (American Academy of Arts and Letters), and the Gold Medal of the American Academy and Institute of Arts and Letters in 1993. David Levine is represented in the collections of the Hirshhorn Museum and Sculpture Garden, the Cleveland Museum of Art, the Brooklyn Museum, The Newark Museum, the Library of Congress, the National Portrait Gallery, the Fine Arts Museums of San Francisco, the National Portrait Gallery of England, and the Metropolitan Museum of Art.

PAUL LEVITZ is a lifelong comic-book fan. He has been an editor (*The Comic Reader, Batman,* and *9-11,* a benefit anthology) and has written more than 300 stories, including an acclaimed run on *The Legion of Super-Heroes.* His "The Great Darkness Saga" was voted among the dozen best comic stories of the twentieth century by readers of the *Comics Buyer's Guide.* Levitz has been a staffer at DC Comics (the largest English-language comics publisher) for more than three decades, currently serving as president and publisher of both DC and *MAD* Magazine. He lives with his wife and three children in the hills of Westchester County, New York.

PATRICK McDONNELL, a native of New Jersey, attended the School of Visual Arts in New York on scholarship, and graduated with a BFA in 1978. He then launched a successful career as a freelance illustrator, drawing Russell Baker's "Observer" column for *The New York Times Sunday Magazine* from 1978 to 1993, and *Bad Baby,* a monthly comic strip for *Parents Magazine,* which ran for ten years. He is the coauthor of *Krazy Kat: The Comic Art of George Herriman* (Abrams, 1986). In 1994 McDonnell created *Mutts,* and has since received numerous awards for his strip, including the Reuben Award for Comic Strip of the Year (1997) and Cartoonist of the Year (1999) from the National Cartoonist Society, Germany's Max and Moritz Award for Best International Comic Strip (1998), and the PETA Humanitarian Award (2001).

ELENA MILLIE spent thirty-five years working with the poster collection in the Prints and Photographs Division of the Library of Congress, first as a cataloger and later as curator. She began her Library career working on the J. and E. R. Pennell Collection of Whistleriana, and compiled a checklist of the British Satirical Print holdings for publication. During her long and distinguished tenure as curator of posters, she produced many exhibitions including: *Art Becomes the Poster,*

Everybody's Uncle Sam, and *The Paper Weapon.* Millie also published numerous articles on posters and poster artists, and contributed to journals on the subject of poster art. She served as co-ordinator and as a co-author for *Eyes of the Nation: A Visual History of the United States* (1997). Millie retired from the Library of Congress in 2006.

PAT OLIPHANT, a native of Adelaide, Australia, began his career at his hometown newspaper before moving to the United States in 1964 to work as the political cartoonist at *The Denver Post.* In 1967, only two years after relocating to America, he was awarded the Pulitzer Prize. His cartoons have been distributed by Universal Press Syndicate since 1980. His commissioned work appears regularly in *The New Yorker, The New York Times,* and *The Washington Post.* In addition to the Pulitzer, Oliphant has received two Reubens and a Best Editorial Cartoonist Award from the National Cartoonists Society, the Thomas Nast Prize in Germany, and the Premio Satira Politica of Italy. Most recently, Oliphant was the recipient of the 2005 New Mexico Governor's Award for Excellence in the Arts for his contributions as a cartoonist, painter, and sculptor. Oliphant and his wife, art gallery owner Susan Conway, live in Santa Fe, New Mexico.

MIKE PETERS has been interested in cartooning since childhood. Born in St. Louis, Missouri, he graduated from Christian Brothers College High School in 1961. In 1965, he received a BFA from Washington University and immediately began his career on the art staff of the *Chicago Daily News.* The following year he began two years of service with the U.S. Army as an artist for the Seventh Psychological Operations Group in Okinawa. After Vietnam, the renowned artist Bill Mauldin mentored Peters and helped him find a cartooning position on the *Dayton Daily News* in 1969. In 1972 his editorial cartoons became syndicated nationally. In 1981 he was awarded a Pulitzer Prize for Journalism, and in 1984, he created the award-winning *Mother Goose & Grimm* comic strip.

WENDY WICK REAVES, curator of prints and drawings at the Smithsonian Institution's National Portrait Gallery, started the graphic arts department there in 1974. The collections she has developed now include rare books and illustrated journals, editorial cartoons, caricatures, and posters, as well as fine art prints and drawings. She has curated numerous exhibitions for the gallery on eighteenth- through twentieth-century subjects and has lectured widely. Her publications have included books on the graphic portraits of George Washington, American portrait prints of the nineteenth century, and the editorial cartoons of Pat Oliphant. Her book *Celebrity*

Caricature in America (1998) reintroduced a once-prevalent twentieth-century portrait genre. Her most recent study is the coauthored volume, *Eye Contact: Modern American Portrait Drawings* (2002) and she also contributed an essay to *The Covarrubias Circle* (2004).

TRINA ROBBINS, an award-winning writer-historian, has been writing comics and books for more than thirty years, including *From Girls to Grrlz: A History of Women's Comics from Teens to Zines* (1999) and *The Great Women Cartoonists* (2001). Her subjects range from women cartoonists, dark goddesses, women who kill, and Irish women, to teenage super heroines and shojo manga, but what they all have in common is that they're for and about girls and women. Robbins has also written articles on shojo for libraries and comics publications, and has presented papers on the subject for colleges. Currently she's writing a series of educational graphic novels for classrooms, as well as providing the English-language rewrites for three shojo manga graphic novels, as well as writing her own series in manga format.

JERRY ROBINSON is an accomplished artist, writer, historian, and curator. He is president and editorial director of Cartoon Arts International, Inc., and Cartoonists and Writers Syndicate (CWS), which is affiliated with the New York Times Feature Service and syndicates and exhibits the work of 350 leading cartoonists from 75 countries. While a journalism student at Columbia University, Robinson began his cartooning career at age seventeen on the original Batman comic book, for which he created the Joker, comics' first super-villain. Among Robinson's thirty published works is *The Comics: An Illustrated History of Comic Strip Art*, soon to be issued in a revised edition. Robinson has served as president of both the Association of American Editorial Cartoonists (AAEC) and the National Cartoonists Society (NCS), the only person so honored by his peers. Robinson, renowned for his pioneering work as a comic-book artist, is also known as a leader in creator rights, representing numerous artists in high-profile international cases involving copyright, trademark, censorship, U.S. First Amendment, and human rights.

EDWARD SOREL has produced forty-five covers for *The New Yorker*, and his cartoons and satires have appeared for decades in *The Atlantic Monthly*, *Vanity Fair*, *GQ*, *Esquire*, and *The Nation*. Born in the Bronx in 1929, he studied at Cooper Union, and after graduating formed Pushpin Studios with two of his classmates, Seymour Chwast and Milton Glaser. Sorel is the author/illustrator of several children's books, including *The Saturday Kid* (2000). A collection of

his caricatures, *Unauthorized Portraits*, was published in 1997. His most recent book, *Literary Lives*, was published in 2006. Sorel is the recipient of the George Polk Award for his satirical drawing, and the 2002 Den Karikaturpreis der Deutschen Anwaltschaft. In 1998 the National Portrait Gallery in Washington, D.C., mounted an exhibit of Sorel's drawings.

ART SPIEGELMAN won the Pulitzer Prize in 1992 for his masterful Holocaust narrative *Maus*, while *Maus II* continued the remarkable story of his parents' survival of the Nazi regime and their lives later in America. In 1980 Spiegelman founded *RAW*, the acclaimed avant-garde comics magazine, with his wife, Françoise Mouly. His work has been published in many periodicals, including *The New Yorker*, where he was a staff artist and writer from 1993 to 2003. In 2004 he published *In the Shadow of No Towers*, in response to the terrorist attacks of September 11, 2001, on the World Trade Center, which stood near his Lower Manhattan home. In his spare time Spiegelman is working on the libretto and the sets for a music-theater piece about the rise and fall of comic books entitled *Drawn to Death: A Three Panel Opera*, with composer Phillip Johnston, to be produced with the Improbable Theater company in 2007. In 2005, Spiegelman was made a Chevalier de l'Ordre des Arts et des Lettres in France.

RON TYLER is director of the Amon Carter Museum in Fort Worth, Texas. He is a former professor of history at the University of Texas at Austin, and director of the Texas State Historical Association. He is the editor of *Posada's Mexico* (Library of Congress, 1979) and author of *The Image of America in Caricature and Cartoon* (1976).

JOHN UPDIKE, American novelist, short-story writer, and poet, internationally known for the *Rabbit* novels featuring Harry Angstrom. Updike was born in Shillington, Pennsylvania, and from earliest childhood wanted to be a cartoonist. He went to Harvard in hopes of joining the *Lampoon*, the nation's leading college humor magazine, and eventually became its president, contributing not only cartoons but light verse and humorous prose. In 1955 he joined the staff of *The New Yorker*, writing editorials, poetry, stories, and criticism in the course of a fifty-year association. His novels *Rabbit Is Rich* and *Rabbit at Rest* have won Pulitzer Prizes. In 1976 he became a member of the American Academy of Arts and Letters. In November 2003 Updike received the National Medal for Humanities at the White House, joining a very small group of notables who have been honored with both the National Medal of Art and the National Medal for the Humanities.

BRIAN WALKER has a diverse background in professional cartooning and cartoon scholarship. He is a founder and former director of the Museum of Cartoon Art (now the National Cartoon Museum) in New York, where he worked from 1974 to 1992. Since 1984 he has been part of the creative team that produces the comic strips *Beetle Bailey* and *Hi and Lois*. Walker has written and edited more than a dozen books on cartoon art, including a two-volume history for Abrams, *The Comics Since 1945* (2002) and *The Comics Before 1945* (2004), as well as numerous exhibition catalogues and magazine articles. Walker taught a course in cartoon history at the School of Visual Arts (1995-96) and has served as curator for more than sixty-five cartoon exhibitions, including three major retrospectives: *The Sunday Funnies: 100 Years of Comics in American Life* (Barnum Museum, Bridgeport, Connecticut), *100 Years of American Comics* (Belgian Center for Comic Art, Brussels), and *Masters of American Comics* (Hammer Museum and the Museum of Contemporary Art, Los Angeles).

CHRIS WARE was born in Omaha, Nebraska, in 1967 and currently lives in the Chicago area with his wife, Marnie, and their daughter, Clara. He produces a weekly newspaper strip, the irregular ongoing periodical *The ACME Novelty Library*, and is the author of *Jimmy Corrigan–The Smartest Kid on Earth* (2000), which received the American Book Award in 2000 and the Guardian First Book Award in 2001. His work has been published in *The New Yorker* and *The New York Times*, and was also included in the 2002 Whitney Biennial. In 2004 Ware edited the thirteenth issue of *McSweeney's*, and in 2005 he was the first cartoonist chosen to regularly serialize an ongoing story in *The New York Times Magazine*. His work was also the focus of an exhibition at the Museum of Contemporary Art in Chicago (2006).

JUDITH WECHSLER, the National Endowment Professor at Tufts University, is an art historian who writes about nineteenth-century French art, particularly Honoré Daumier and the topic of caricature. She is the author of *A Human Comedy: Physiognomy and Caricature in 19th Century Paris* (1983) and *Daumier: Le Cabinets des dessins* (1999); two books on Cézanne; articles on Daumier (with a focus on physiognomy and gesture); and articles on relationships between art and theater. Professor Wechsler has made twenty films on art, including two on Daumier (*Drawing the Thinking Hand* for the Musée du Louvre and *Rachel of the Comédie Française* with the Comédie

Française); as well as films on Harry Callahan, Jasper Johns, and Aaron Siskind; and a six-part television series, *The Painter's World*, with WGBH-Boston and Channel Four London.

RICHARD WEST is the owner of Periodyssey, which buys and sells significant and unusual American periodicals and maintains the largest stock in the U.S. of nineteenth-century magazines. West is an authority on American political cartooning and American humor magazines. He is the author of *Satire on Stone: The Political Cartoons of Joseph Keppler* (1988), *The San Francisco Wasp: An Illustrated History* (2004), and the editor of four collections of political cartoons. He was the founder and editor of *The Puck Papers*, a newsletter on the history of political cartooning (1978-81); the founder and editor of *Target: The Political Cartoon Quarterly* (1981-87); and the political cartoon editor of *Inks, the Magazine of Cartooning*, published by the Cartoon Research Library at Ohio State University in Columbus, Ohio (1994-97). West has served as guest curator for cartoon shows at the Puck Building in New York (1982), the Woodrow Wilson House in Washington, D.C. (1994), and the Museum of Cartoon Art in San Francisco (2004).

ART WOOD, as a child, learned to read by scanning the Sunday comics. Fascinated by the work of the master artists, he was determined early on to be a cartoonist. At age twelve he began contacting his favorite creators, requesting an original drawing for his bedroom walls. Over the years this compilation grew into one of the world's largest of this genre. He contributed his massive collection to the Library of Congress during its bicentennial year (2000). Wood worked at the Library of Congress while in high school, doing various jobs and giving tours. Every spare minute he spent in the stacks studying the work of Eugene Zimmerman, Thomas Nast, Joseph Keppler, Charles Dana Gibson, James Montgomery Flagg, and numerous others–his only art training. During World War II he was a cartoonist for the Navy's *All Hands* magazine and the Sea Syndicate. After graduating from Washington and Lee University, Wood was contributing cartoonist for *The Washington Star*, political cartoonist for the *Richmond News Leader*, and the chief political cartoonist for the *Pittsburgh Press*. Later he did weekly cartoons for the *Farm Bureau News* and became editor and director of information for the Telephone Association in Washington, D.C. Now retired, Wood lives in Charlottesville, Virginia.

ABOUT THE ILLUSTRATIONS/PERMISSIONS

Most of the art in this book is shot from the originals. Unless otherwise noted, these cartoons and illustrations are housed in the Prints and Photographs Division of the Library of Congress (LOC). Copyright information and reproduction numbers from the Library's Photoduplication Service are provided below. For more information contact *www.loc.gov*.

Numbers in **bold** refer to book pages.

Jacket front: © Richard Williams. Gift of Richard Williams. Charlie Brown © United Feature Syndicate; Ignatz Mouse © King Features Syndicate, Inc.; Zippy the Pinhead © Bill Griffith; Popeye © King Features Syndicate, Inc.

6 Gluyas Williams, "National Capital. Library of Congress," from *The New Yorker* (March 20, 1943). © Condé Nast Publications. [LC-USZC4-12965]

8 Art Young, "World of Creepers," from *Life* (1907). © LIFE Inc. Art Wood Collection, LOC. [LC-DIG-ppmsca-04662]

9 Paul Revere, "The Bloody Massacre" (March 28, 1770). [LC-DIG-ppmsca-01657; LC-USZC4-4600]

10 Al Hirschfeld, "The Stage Door Canteen Reopens" (1944). © Al Hirschfeld / The Margo Feiden Galleries Ltd. [LC-DIG-ppmsc-05888]

11 Miguel Covarrubias, "The Paul Whiteman Cycle," from *Vanity Fair* (August 1924). © Condé Nast Publications. [LC-USZC4-12991]

12 A. B. Frost, "He made some hootch and tried it on the dog" (1880s). Swann Collection, LOC. [LC-DIG-ppmsc-05880]

14 Charles Dana Gibson, "Summer Sports," from *Life* (June 2, 1904). © LIFE Inc. Gift of Charles Dana Gibson. [LC-DIG-ppmsca-01580; LC-USZC4-10351]

15 Walt Kelly, *Pogo* (May 5, 1953). © Okefenokee Glee & Perloo Inc. Gift of Walt Kelly. [LC-USZC4-13082]

15 Garry Trudeau, *Doonesbury* (November 10, 1970). Doonesbury © 1970 G. B. Trudeau. Used courtesy of the creator and Universal Press Syndicate. All rights reserved. Gift of Garry Trudeau. [LC-USZC4-13021]

17 Walt Disney Studios, *Snow White and the Seven Dwarfs* (1937). © Disney Enterprises, Inc. Art Wood Collection, LOC. [LC-DIG-ppmsc-02838; LC-USZC4-9474]

19 David Claypool Johnston, *Scraps* (1832). Rare Book and Special Collections Division, LOC.

20 George McManus, *Bringing Up Father* (1912). © King Features Syndicate, Inc. Art Wood Collection, LOC. [LC-USZC4-13046]

21 Bud Fisher, *Mutt and Jeff* (1913). Art Wood Collection, LOC. [LC-DIG-ppmsca-07730]

22 Charles Dana Gibson (c. 1905). [LLC-DIG-ppmsca-01590]

23 James Montgomery Flagg (1920s). Art Wood Collection, LOC. [LC-DIG-ppmsca-03307]

24 Alex Raymond, *Flash Gordon* (September 1, 1935). © King Features Syndicate, Inc. Art Wood Collection, LOC. [LC-DIG-ppmsca-03299]

25 Walt Disney Studios, *Snow White and the Seven Dwarfs* (c. 1937). © Disney Enterprises, Inc. Art Wood Collection, LOC. [LC-DIG-ppmsca-03342]

25 Art Wood, "Memorial Day" (May 29, 1962). Art Wood Collection, LOC. [LC-DIG-ppmsca-09433]

26-27 George Herriman, *Krazy Kat* (April 1944). © King Features Syndicate, Inc. Art Wood Collection, LOC. [LC-DIG-ppmsca-07862]

28 Benjamin Franklin, "Join or Die," from *The Pennsylvania Gazette* (May 9, 1754). Serial Record Division, LOC. [LC-USZC4-5315]

28 James Akin, "The Prairie Dog" (c. 1804). [LC-DIG-ppmsca-01659; LC-USZC4-12953]

29 William Charles, "Josiah the First" (1812). [LC-DIG-ppmsc-05876; LC-USZC4-12937]

29 William Hogarth, "Characters & Caricaturas" (1743). Art Wood Collection, LOC. [LC-DIG-ppmsca-07511]

30 James Gillray, "L'Assemblée Nationale" (June 18, 1804). [LC-USZC4-13054]

31 William Heath, "The Royal Milling Match" (1811). [LC-DIG-ppmsca-04321]

32 Thomas Rowlandson, "Prodigal Son" (c. 1785). [LC-USZC4-12973]

33 Unattributed, "Le Calculateur Patriote" (c. 1742). [LC-DIG-ppmsca-07186; LC-USZC4-12945]

34-35 Anthony Imbert, "Let Every One Take Care of Himself" (1833). [LC-USZC4-12984]

36 Unattributed, "Mr. Clay Taking a New View of the Texas Question," from *Yankee Doodle* (February 6, 1847). [LC-USZC4-13033]

37 Winslow Homer, "Arguments of the Chivalry" (1856). [LC-USZC4-12985]

38 Edward Williams Clay, "The Times" (1837). [LC-USZC4-12948]

39 Honoré Daumier, "Émotions Parisiennes" (c. 1840). Art Wood Collection, LOC. [LC-DIG-ppmsca-07529; LC-USZC4-13011]

40 John Childs, "Social Qualities of Our Candidate" (1852). [LC-USZC4-12947]

41 Winslow Homer, "Life in Camp," Part 2 (c. 1864). [LC-USZC4-11459]

42 Adalbert Volck, "The Knight of the Rueful Countenance" (c. 1861). Stern Collection, Rare Book and Special Collections Division, LOC.

43 J. H. Howard, "I Knew Him, Horatio" (1864). [LC-USZC4-12950]

44 Thomas Nast, original woodblock for "Let Us Prey" (1871). [LC-DIG-ppmsca-10607]

45 Thomas Nast, "Let Us Prey," from *Harper's Weekly* (September 23, 1871). [LC-DIG-ppmsc-05890]

46 Thomas Nast, "His Attempt at Suicide" (1880s). Art Wood Collection, LOC. [LC-DIG-ppmsca-03470; LC-USZC4-12951]

47 Grant Hamilton, "To begin with, 'I'll paint the town red,'" from *The Judge* (January 31, 1885). [LC-USZC4-5418]

48-49 Bernard Gillam, "Phryne before the Chicago Tribunal," from *Puck* (June 4, 1884). [LC-USZC4-12969]

50 George Luks, "That Man Clay Was an Ass," from *The Verdict* (March 13, 1899). [LC-DIG-ppmsca-01660; LC-USZC4-4111]

50 Carlo Pellegrini, "J. W. Bruce" (1870s). Art Wood Collection, LOC. [LC-DIG-ppmsca-07515]

51 John Tenniel, "The Old Story" (1884). [LC-USZC4-12999]

52-53 Daniel Beard, frontispiece for *A Connecticut Yankee in King Arthur's Court* (1889). [LC-DIG-ppmsca-06661; LC-USZC4-12976]

53 John Tenniel, "A Contented Maid" (1894). [LC-DIG-ppmsca-07526]

54 Jessie Willcox Smith, frontispiece for *The Water-Babies* (1916). Gift of Jessie Willcox Smith. [LC-DIG-ppmsc-05892]

55 Leon Barritt, "War of the Yellow Kids," from *Vim* (June 29, 1898). [LC-USZC4-3800]

56 Homer Davenport, "William Randolph Hearst" (1896). Art Wood Collection, LOC. [LC-DIG-ppmsca-03334]

56 Homer Davenport, "Dollar Mark Hanna" (1900). [LC-USZC4-13013]

57 Frederick Opper, *Happy Hooligan* (October 11, 1914). Art Wood Collection, LOC. [LC-DIG-ppmsca-06588]

58 Winsor McCay, *Dreams of the Rarebit Fiend* (c.1906). [LC-DIG-ppmsca-10597]

59 Winsor McCay, *Little Nemo in Slumberland* (1910). Art Wood Collection, LOC. [LC-DIG-ppmsca-03302]

60 John Sloan, "There Was a Cubist Man," from *The Masses* (April 4, 1913). [LC-USZC4-12995]

61 Oscar Cesare, "The Rude Descending on Sulzer" (1913). Gift of Valentine Cesare. [LC-USZC4-12990]

62 Rea Irvin, "Clubs We Do Not Care to Join: The Professional Humorists' Club," from *Life*, (October 22, 1914). © LIFE Inc. Swann Collection, LOC. [LC-USZC4-12994]

63 Stuart Davis, "Hoboken," from *The Liberator* (August 1922). Ben and Beatrice Goldstein Collection, LOC. [LC-USZC4-5707]

63 Ethel Plummer, cover for *Vanity Fair* (June 1914). Swann Collection, LOC. [LC-DIG-ppmsca-01591; LC-USZC4-12993]

64 Georges Lepape, cover for *Vanity Fair* (December 1919). Swann Collection, LOC. [LC-DIG-ppmsca-01583; LC-USZC4-10355]

65 Alfred Henry Maurer, cover for *Vanity Fair* (April 1930). Swann Collection, LOC. [LC-DIG-ppmsc-00177]

66 Robert Minor, "Morgan, Mellon, and Rockefeller" (c. 1922). Ben and Beatrice Goldstein Collection, LOC. [LC-USZC4-5709]

66 Boardman Robinson, "You Cant Eat an Act of Parliament" (c. 1915). Willner Collection, LOC. [LC-DIG-ppmsca-04288]

66 Henry Glintenkamp, "Physically Fit" (1917). Willner Collection, LOC.

67 John Sloan, "After the War, a Medal and Maybe a Job," from *The Masses* (September 1914). [LC-USZC4-12974]

68 Ralph Barton, "Oh–do it again!" from *The New Yorker* (1927). © Condé Nast Publications. [LC-USZC4-13039]

69 Ralph Barton, *The First Miss Fraser,* from *The New Yorker* (1930). © Condé Nast Publications. [LC-USZC4-13040]

70 Burne Hogarth, *Tarzan* (May 9, 1948). © United Feature Syndicate. [LC-USZC4-13079]

71 Milton Caniff, *Terry and the Pirates* (April 8, 1945). © Tribune Media Services. Swann Collection, LOC. [LC-DIG-ppmsca-09850; LC-USZC4-12592]

71 Hal Foster, *Prince Valiant* (May 13, 1956). © King Features Syndicate, Inc. Swann Collection, LOC. [LC-DIG-ppmsca-10591]

72 Harold Gray, *Little Orphan Annie* (1925). © Tribune Media Services. George Sturman Collection, LOC. [LC-USZC4-3813]

73 Elzie Segar, *Thimble Theatre* (June 4, 1921). © King Features Syndicate, Inc. Art Wood Collection, LOC. [LC-DIG-ppmsca-05776]

74-75 Alex Raymond, *Secret Agent X-9* (May 14, 1934). © King Features Syndicate, Inc. Swann Collection, LOC. [LC-USZC4-13074]

76 Elzie Segar, *Thimble Theatre* (January 2, 1932). © King Features Syndicate, Inc. Art Wood Collection, LOC. [LC-DIG-ppmsca-09521]

76 Harold Gray, *Little Orphan Annie* (March 8, 1962). © Tribune Media Services. [LC-DIG-ppmsca-07743]

76 Chester Gould, *The Girl Friends* (1930). © Chicago Daily News. Art Wood Collection, LOC. [LC-DIG-ppmsca-10594]

77 Milton Caniff, character studies for *Terry and the Pirates* (c. 1941). © Tribune Media Services. Art Wood Collection, LOC. [LC-DIG-ppmsca-10599]

77 Milton Caniff, *Terry and the Pirates* (November 3, 1934). © Tribune Media Services. Art Wood Collection, LOC. [LC-USZC4-13049]

78-79 Chester Gould, *Dick Tracy* (December 18, 1931). © Tribune Media Services. Art Wood Collection, LOC. [LC-DIG-ppmsca-07736]

80 Theodore Geisel [Dr. Seuss], "So you're the _ _ _ who fouled me!" (1932). © Dr. Seuss Estate. Swann Collection, LOC. [LC-USZC4-13059]

81 Peter Arno, "I love this country, Higgins! It's been good to me!," from *The New Yorker* (April 4, 1959). © Condé Nast Publications. [LC-USZC4-13061]

82-83 Milt Gross, *Banana Oil!* (May 28, 1924). Swann Collection, LOC. [LC-DIG-ppmsca-10841]

84 Milt Gross, *Dave's Delicatessen* (November 6, 1933). © King Features Syndicate, Inc. [LC-DIG-ppmsca-10859]

84 Cliff Sterrett, *Polly and Her Pals* (1933). © King Features Syndicate, Inc. Art Wood Collection, LOC. [LC-DIG-ppmsca-07744]

84 Percy Crosby, *Skippy* (1926). Art Wood Collection, LOC. [LC-DIG-ppmsca-07729]

85 Milt Gross, *He Done Her Wrong* (1930). General Collections, LOC.

86 Kenneth Russell Chamberlain, "Radio City Music Hall" (1935). © Chamberlain estate. [LC-DIG-ppmsca-10596]

87 William Cotton, "H. G. Wells" (1935). © Cotton estate. [LC-DIG-ppmsca-09441]

88 Alice Harvey, "But, Mother! You haven't lived yet" from *The New Yorker* (March 15, 1930). © Condé Nast Publications. [LC-DIG-ppmsca-06563]

89 Helen Hokinson, "They're all staying for supper, Nora. Any inspirations?" from *The New Yorker* (c. 1940). © Condé Nast Publications. [LC-USZC4-13014]

90 Rea Irvin, "D-Day Bayeux Tapestry," cover for *The New Yorker* (July 15, 1944). © Condé Nast Publications. [LC-DIG-ppmsca-05364; LC-USZC4-11918]

91 Bill Mauldin, "I won the Nobel Prize for literature. What was your crime?" (October 30, 1958). © Mauldin estate. [LC-DIG-ppmsca-03231]

91 Vaughan Shoemaker, "When Blackest, Remember Lincoln" (1963). [LC-USZC4-13038]

92 Herb Block, "It's okay–we're hunting communists" (October 31, 1947). © 1947 The Herb Block Foundation. [LC-DIG-ppmsc-03380]

93 Herb Block, "I have here in my hand–" (May 7, 1954). © 1954 The Herb Block Foundation. [LC-USZ62-126910]

94 Rube Goldberg, "Rube Goldberg Views the News for His Latest Invention" (1950). © Goldberg estate. [LC-USZC4-13003]

94 Robert Osborn, "Silence Dissenters!" (1954). © Osborn estate. Swann Collection, LOC. [LC-DIG-ppmsca-07747]

95 Burris Jenkins, "No Answer" (1962). © Jenkins estate. [LC-DIG-ppmsca-07173]

96 William Steig, cover for *The New Yorker* (June 18, 1960). © Condé Nast Publications. [LC-USZC4-13063]

97 William Steig, "And are you very wise, Grandpa?," from *The New Yorker* (March 27, 1965). © Condé Nast Publications. [LC-USZC4-13062]

96 Paul Conrad, "Black Teen-agers 40% Unemployed" (December 1, 1977). © Los Angeles Times. [LC-USZC4-13019]

98 Morrie Turner, *Wee Pals* (May 13, 1968). © Creators Syndicate. [LC-USZC4-13073]

99 Al Capp, *Li'l Abner* (May 30, 1943). © Capp Enterprises, Inc. All rights reserved. Swann Collection, LOC. [LC-USZC4-13078]

100-101 Al Capp, *Li'l Abner* (September 25, 1943). © Capp Enterprises, Inc. All rights reserved. Art Wood Collection, LOC. [LC-USZC4-11765]

102 Johnny Hart, *B.C.* (February 5, 1969) © Creators Syndicate, reprinted by permission of John L. Hart FLP and Creator's Syndicate, Inc. [LC-DIG-ppmsca-09129]

102 Garry Trudeau, *Doonesbury* (May 29, 1973). Doonesbury © 1973 G. B. Trudeau. Used courtesy of the creator and Universal Press Syndicate. All rights reserved. Gift of Garry Trudeau. [LC-USZC4-13064]

103 Edward Sorel, "Milhous I," from *Rolling Stone* (March 14, 1974). © Edward Sorel / Rolling Stone. Swann Collection, LOC. [LC-DIG-ppmsc-05884]

104 Herb Block, "National Security Blanket" (May 27, 1973). © 1973 The Herb Block Foundation. [LC-DIG-ppmsc-03469]

104 David Levine, "G. Gordon Liddy," from *The New York Review of Books* (July 17, 1980). © David Levine / Forum Gallery / The New York Review of Books. [LC-USZC4-13016]

105 Robert Pryor, "Richard Nixon" (1974). © Robert Pryor. [LC-USZC4-4887]

106 Maira Kalman and Rick Meyerowitz, napkin sketch for "New Yorkistan" (2001). © and gift of Maira Kalman and Rick Meyerowitz. [LC-DIG-ppmsca-02127]

107 Maira Kalman and Rick Meyerowitz, "New Yorkistan," cover for *The New Yorker* (December 10, 2001). © Condé Nast Publications. Gift of Maira Kalman and Rick Meyerowitz. [LC-DIG-ppmsca-02120]

108 Anita Kunz, "Saint Hillary," from *The New York Times Magazine* (1993). © Anita Kunz / The New York Times Magazine. Gift of Anita Kunz. [LC-DIG-ppmsca-03313; LC-USZC4-11593]

109 Aaron McGruder, *The Boondocks* (January 6, 2002). The Boondocks © 2001 & 2002 Aaron McGruder. Used courtesy of the creator and Universal Press Syndicate. All rights reserved.

112 Robert Osborn, "Hiroshima. Nagasaki to Come" (1945). © Osborn estate. Swann Collection, LOC. [LC-DIG-ppmsca-10601]

113 Al Frueh, "Mary Nash," from *Stage Folk* (1922). [LC-USZC4-7615]

114 José Guadelupe Posada Aguilar, "Galeria del Teatro Infantil" (c. 1910). [LC-DIG-ppmsc-03453]

115 Miguel Covarrubias, "The Four Dictators" (1933). © Condé Nast Publications. [LC-DIG-ppmsc-05886]

117 Honoré Daumier, "Le Jardin des Plantes à Pékin" (1854). [LC-USZC4-12938]

118 Honoré Daumier, "Le ventre législatif," from *L'association mensuelle* (1834). [LC-USZC4-12935]

119 Honoré Daumier, "Rue Transnonain," from *L'association mensuelle* (1834). Rosenwald Collection, Rare Book and Special Collections Division, LOC.

121 Frank Beard, cover for *The Judge* (September 27, 1884). [LC-USZC4-7230]

122 Joseph Ferdinand Keppler, "Editorial Conclave of *Puck*" (1887). Art Wood Collection, LOC. [LC-DIG-ppmsca-05875]

123 George Luks, "Annual Parade of the Cable-Trolley Cripple Club," from *The Verdict* (March 20, 1899). [LC-USZC4-4112]

125 José Guadelupe Posada Aguilar, "Calaveras del montón, número 2" (1910). [LC-DIG-ppmsc-04594]

126 José Guadelupe Posada Aguilar, "El Purgatório Artístico, (c. 1900). [LC-DIG-ppmsc-04599]

127 José Guadelupe Posada Aguilar, "Don Quijote" (c. 1910). [LC-DIG-ppmsc-04597]

130 Richard Felton Outcault, *McFadden's Row of Flats* (1896). Art Wood Collection, LOC. [LC-DIG-ppmsca-03344; LC-USZC4-12981]

131 Richard Felton Outcault, "The Yellow Dugan Kid" (September 7, 1896). [LC-USZC4-12966]

133 Richard Felton Outcault, *Buster Brown* (July 7, 1907). Art Wood Collection, LOC. [LC-USZC4-9439; LC-DIG-ppmsca-02833]

135 Lyonel Feininger, *The Kin-der-Kids* (May 3, 1906). [LC-DIG-ppmsca-09511]

136 Lyonel Feininger, *Wee Willie Winkie's World* (September 26, 1906). [LC-DIG-ppmsca-09515; LC-USZC4-8248]

137 Lyonel Feininger, *Wee Willie Winkie's World* (November 25, 1906). [LC-DIG-ppmsca-09516; LC-USZC4-12593]

138 Lyonel Feininger, *The Kin-der-Kids* (September 1, 1906). [LC-DIG-ppmsca-09514; LC-USZC4-8246]

139 Lyonel Feininger, *The Kin-der-Kids* (June 29, 1906). [LC-DIG-ppmsca-09513; LC-USZC4-5175]

142 Rose O'Neill, "Signs," from *Puck* (August 17, 1904). [LC-USZC4-13008]

143 Rose O'Neill, "Kewpies" (October 12, 1935). [LC-DIG-ppmsca-08333]

144 Nell Brinkley, "Uncle Sam's Girl-Shower" (1918). Art Wood Collection, LOC. [LC-DIG-ppmsca-03341]

145 Nell Brinkley, "Golden Eyes with Uncle Sam" (1918). [LC-DIG-ppmsca-01603; LC-USZC4-10514]

146 Reginald Marsh, "Metropolis at the Rialto," from *The New Yorker* (1927). © Condé Nast Publications. [LC-USZC4-13030]

147 Reginald Marsh, "Pretty, Isn't It?" from *The New Yorker* (September 19, 1925). © Condé Nast Publications. [LC-DIG-ppmsc-03576]

149 Winsor McCay, "Mental and Moral Courage" (1920s). [LC-USZC4-13028]

150 Winsor McCay, "Wheels of Industry" (1920s). [LC-USZC4-13034]

150 Winsor McCay, "City Crime Skyline" (c. 1930). [LC-USZC4-13031]

151 Winsor McCay, "Fame, Fortune, Wealth" (c. 1928). [LC-USZC4-13027]

152 John Held, Jr., *Joe Prep* (1927). © Held estate. [LC-USZC4-12955]

154 John Held, Jr., "Jazz Combo" (c. 1927) © Held estate. [LC-USZC4-12960]

155 John Held, Jr., "Apothecary," from *The New Yorker* (1920s). © Condé Nast Publications. [LC-USZC4-12954]

157 John Held, Jr., "Julian and Julienne" (1916). [LC-USZC4-13023]

158 Billy DeBeck, *Barney Google* (November 15, 1926). Swann Collection, LOC. [LC-DIG-ppmsca-10602]

159 Sidney Smith, *The Gumps* (October 17, 1926). Art Wood Collection, LOC. [LC-USZC4-11769] Tribune Media Services

160 George McManus, *Bringing Up Father* (December 8, 1923). © King Features Syndicate, Inc. Art Wood Collection, LOC. [LC-USZC4-13048]

160 George McManus, *Bringing Up Father* (April 12, 1927). © King Features Syndicate, Inc. Art Wood Collection, LOC. [LC-USZC4-11753]

161 Roy Crane, *Wash Tubbs* (1935). © NEA Service. Art Wood Collection, LOC. [LC-DIG-ppmsca-07742]

162 Frank King, *Gasoline Alley* (January 19, 1935). © Tribune Media Services. Art Wood Collection, LOC. [LC-DIG-ppmsca-10600]

164 Frank King, *Gasoline Alley* (1921). © Tribune Media Services. Art Wood Collection, LOC. [LC-DIG-ppmsca-10592].

165 Frank King, *Gasoline Alley* (June 24, 1923). © Tribune Media Services. Art Wood Collection, LOC. [LC-DIG-ppmsca-03292]

167 Frank King, *Gasoline Alley* (March 8, 1921). © Tribune Media Services. Swann Collection, LOC. [LC-USZC4-13007]

168 George Herriman, *The Family Upstairs* (c. 1911). © King Features Syndicate, Inc. [LC-DIG-ppmsca-10593]

169 George Herriman, *Krazy Kat* (1942). © King Features Syndicate, Inc. Art Wood Collection, LOC. [LC-DIG-ppmsca-03340]

170 George Herriman, *Krazy Kat* (1917). © King Features Syndicate, Inc. George Sturman Collection, LOC. [LC-USZC4-13057]

171 George Herriman, *Krazy Kat* (1941). © King Features Syndicate, Inc. George Sturman Collection, LOC. [LC-USZC4-7106]

173 George Herriman, *Krazy Kat* (March 19, 1944). © King Features Syndicate, Inc. George Sturman Collection, LOC. [LC-USZC4-13058]

174 Chic Young, *Blondie* (February 17, 1933). © King Features Syndicate, Inc. Gift of Jeanne Young O'Neill. [LC-DIG-ppmsca-02857]

177 Clare Briggs, "The Days of Real Sport: The Valentine" (1920s). Art Wood Collection, LOC. [LC-DIG-ppmsca-03652]

178 Clare Briggs, *When a Feller Needs a Friend* (November 5, 1923). Art Wood Collection, LOC. [LC-DIG-ppmsca-03607]

179 Clare Briggs, *When a Feller Needs a Friend* (June 25, 1923). Art Wood Collection, LOC. [LC-DIG-ppmsca-04668]

181 Miguel Covarrubias, "Emily Post," from *Vanity Fair* (December 1933). © Condé Nast Publications. [LC-USZC4-12988]

182 Miguel Covarrubias, "Mae West" (c. 1930). [LC-DIG-ppmsc-00773; LC-USZC4-6538]

183 Miguel Covarrubias, "Robert Benchley" (1920s). [LC-USZC4-12989]

184-185 Al Hirschfeld, "Jumbo Opens October 26th at the Hippodrome" (1935). © Al Hirschfeld / The Margo Feiden Galleries Ltd. Art Wood Collection, LOC. [LC-DIG-ppmsca-08332]

186 Al Hirschfeld, "Betty Hutton at the Palace" (1940s). © Al Hirschfeld / The Margo Feiden Galleries Ltd. Art Wood Collection, LOC. [LC-USZC4-12979]

187 Al Hirschfeld, "Marie Cahill in *Merry Go Round*" (c. 1927). © Al Hirschfeld / The Margo Feiden Galleries Ltd. Art Wood Collection, LOC. [LC-DIG-ppmsc-00763]

188 Marc Davis and Walt Disney Studios, *Victory Through Air Power* (1943). © Disney Enterprises, Inc. Art Wood Collection, LOC. [LC-USZC4-13070]

190 Ferdinand Horvath and Walt Disney Studios, *Snow White and the Seven Dwarfs* (1937). © Disney Enterprises, Inc. Art Wood Collection, LOC. [LC-USZC4-13077]

191 Tyrus Wong and Walt Disney Studios, *Bambi* (1942). © Disney Enterprises, Inc. Art Wood Collection, LOC. [LC-USZC4-13071]

192 Max Fleischer Studios, King Bombo from *Gulliver's Travels* (1939). © Fleischer Studios. Art Wood Collection, LOC. [LC-USZC4-13083]

193 Walt Disney Studios, Jiminy Cricket from *Pinocchio* (1940). © Disney Enterprises, Inc. Art Wood Collection, LOC. [LC-DIG-ppmsca-03346]

194 Walt Disney Studios, Mickey Mouse as the Sorcerer's Apprentice, from *Fantasia* (1940). © Disney Enterprises, Inc. Art Wood Collection, LOC. [LC-USZC4-13060]

195 Walt Disney Studios, Mickey Mouse (1928). © Disney Enterprises, Inc. Art Wood Collection, LOC. [LC-USZC4-13068]

196 Walt Disney Studios, *Two-Gun Mickey* (1934) © Disney Enterprises, Inc. [LC-DIG-ppmsca-06458]

197 Hanna-Barbera Studios, Tom of *Tom and Jerry* (1940). © Turner Entertainment / Warner Bros. Art Wood Collection, LOC. [LC-DIG-ppmsca-06460]

197 Hanna-Barbera Studios, Jerry of *Tom and Jerry* (1940). © Turner Entertainment / Warner Bros. Art Wood Collection, LOC. [LC-DIG-ppmsca-06459]

200 Frederick Opper, editorial cartoon, (c. 1900). Art Wood Collection, LOC. [LC-USZC4-13009]

201 John T. McCutcheon, "Becoming More Visible" (1913). [LC-USZC4-13012]

202 John T. McCutcheon, "The Mysterious Stranger" (November 10, 1904). Art Wood Collection, LOC. [LC-DIG-ppmsca-07170]

203 Ding Darling, "Caught in His Own Bear Trap" (1942). © Ding Darling Foundation. Art Wood Collection, LOC. [LC-DIG-ppmsca-03338]

205 Rollin Kirby, "Hanging on to the Demagogue" (February 1, 1933). Gift of Rollin Kirby. [LC-USZC4-13002]

206 Clifford Berryman, "Spring 1939!" (March 21, 1939). Gift of Clifford Berryman. [LC-USZC4-13020]

207 Bill Mauldin, "Didn't we meet at Cassino?" (c. 1944). © Mauldin estate. [LC-DIG-ppmsca-03236]

208 Arthur Szyk, "Hawaiian Melodies" (December 1941). © Alexandra Szyk Bracie. Swann Collection, LOC. [LC-USZC4-1414; LC-DIG-ppmsc-02730]

209 Richard Yardley, "The Lord High Self Executioner" (July 27, 1945). [LC-USZC4-12998]

211 Charles Schulz, *Peanuts* (October 19, 1952). © Schulz estate / United Feature Syndicate. [LC-USZC4-12588]

212 Mort Walker, *Beetle Bailey* (December 18, 1962). King Features Syndicate, Inc. [LC-USZC4-13067]

213 Charles Schulz, *Peanuts* (January 20, 1963). © Schulz estate / United Feature Syndicate. [LC-DIG-ppmsca-09123]

214 Mort Walker, *Beetle Bailey* (December 22, 1970). © King Features Syndicate, Inc. [LC-DIG-ppmsca-07727]

215 Charles Schulz, *Peanuts* (March 30, 1951). © Schulz estate / United Feature Syndicate. [LC-DIG-ppmsca-09534]

215 Charles Schulz, *Peanuts* (November 6, 1958). © Schulz estate / United Feature Syndicate. [LC-DIG-ppmsca-09536; LC-USZC4-12596]

213 Charles Schulz, *Peanuts* (October 5, 1964). © Schulz estate / United Feature Syndicate. Art Wood Collection [LC-DIG-ppmsca-03343]

218 James Thurber, from *The New Yorker* (December 3, 1932), later collected in *Men, Women and Dogs* (1940). © Thurber estate / Condé Nast Publications. [LC-USZC4-13022]

219 James Thurber, from *The New Yorker* (March 16, 1935), later collected in *Men, Women and Dogs* (1940). © Thurber estate / Condé Nast Publications. [LC-USZC4-13025]

220 James Thurber, "Oh, Mr. Benholding, I never saw that look in your eyes before!" (c. 1934). © Thurber estate. [LC-DIG-ppmsca-05862]

221 James Thurber, from *The New Yorker* (January 30, 1932), later collected in *The Seal in the Bedroom and Other Predicaments* (1932) © Thurber estate / Condé Nast Publications. [LC-USZC4-13035]

223 Bill Mauldin, "Better grab th' kid. He's been at them comic books ag'in" (November 10, 1948). © Mauldin estate. Gift of Bill Mauldin. [LC-USZC4-13072]

224 Fred Ray and DC Comics, *Superman* no. 14 (January–February 1942). ™ & © DC Comics. Serial Record Division, LOC.

224 C. C. Beck, Pete Costanza, and Fawcett Comics, *Whiz Comics* no. 72 (March 1946). ™ & © DC Comics. Serial Record Division, LOC.

225 Al Hartley and Atlas / Marvel Comics, *Girl Confessions* no. 21 (December 1953). © Marvel Comics Group. Serial Record Division, LOC.

225 Lou Cameron, *The War of the Worlds*, *Classics Illustrated* no. 124 (January 1955). © Gilberton Publications. Serial Record Division, LOC.

226 Marie Severin, Frank Giacoia, Sam Rosen, and Marvel Comics, *The Incredible Hulk* (June 1968). © Marvel Comics Group. [LC-USZC4-13010]

227 Johnny Craig and EC Comics, *Crime SuspenStories* no. 22 (April-May 1954). © William M. Gaines, Agent, Inc. Serial Record Division, LOC.

229 Saul Steinberg, "Self-portrait" (1954). © Saul Steinberg Foundation / Artist's Rights Society. Gift of Saul Steinberg. [LC-DIG-ppmsca-05870]

230 Saul Steinberg, from *American Mercury* (September 1942). Saul Steinberg Foundation / Artist's Rights Society. Gift of Saul Steinberg. [LC-USZC4-13011]

231 Saul Steinberg, "The Coast" (1950). Saul Steinberg Foundation / Artist's Rights Society. Gift of Saul Steinberg. [LC-USZC4-12996]

234 Jules Feiffer, *Clifford* (April 16, 1950). © Jules Feiffer / Will Eisner estate. Gift of Jules Feiffer. [LC-USZC4-13043]

235 Jules Feiffer, *Munro* (1954). © Jules Feiffer. Gift of Jules Feiffer. [LC-DIG-ppmsca-10598]

236 Jules Feiffer, "A Dance to Summer" (June 25, 1964). © Jules Feiffer/ Universal Press Syndicate. Gift of Jules Feiffer. [LC-DIG-ppmsc-00183; LC-USZC4-13044]

237 Jules Feiffer, "I Pledge Allegiance to the Flag" (May 19, 1968). © Jules Feiffer/ Universal Press Syndicate. Gift of Jules Feiffer. [LC-USZC4-13045]

238 David Levine, "Andrew Young," from *The New York Review of Books* (1978). © David Levine / Forum Gallery / The New York Review of Books. [LC-DIG-ppmsca-07233]

241 David Levine, "General Alexander Haig," from *The New York Review of Books* (1974). © David Levine / Forum Gallery / The New York Review of Books. [LC-DIG-ppmsca-07229]

243 David Levine, "Ronald Reagan," from *The New York Review of Books* (1981). © David Levine / Forum Gallery / The New York Review of Books. [LC-DIG-ppmsca-10604]

245 David Low, "Low's Topical Budget" (May 3, 1938). Art Wood Collection, LOC. [LC-USZC4-13051]

246 Charles Dana Gibson, "Studies in Expression: If Women Were Jurors" (c. 1902). Gift of Charles Dana Gibson. [LC-DIG-ppmsca-03059]

247 Patrick Oliphant, "Now, tell the jury what you did with the knife, Mrs. Bobbitt . . ." (January 12, 1994). © Universal Press Syndicate. [LC-DIG-ppmsc-00739]

248 Ronald Searle, "*Troilus and Cressida* at the Punch Theatre" (1955). Swann Collection, LOC. [LC-DIG-ppmsca-07180]

249 Raymond Jackson "I can't stand any more of this. I think I'll go out and face the unions" (c. 1966). Art Wood Collection, LOC. [LC-DIG-ppmsca-03297]

250 David Low, "Possibilities at Petsamo" (March 3, 1944). Art Wood Collection, LOC. [LC-DIG-ppmsca-07177]

251 Leslie Illingworth, "Mideast War-Peace" (July 18, 1958). Art Wood Collection, LOC. [LC-DIG-ppmsca-07527]

252 Brumsic Brandon, Jr., *Luther* (June 12, 1969). © Black Media. Gift of Brumsic Brandon, Jr. [LC-USZC4-13053]

253 Ollie Harrington, *Dark Laughter* (1952). © Harrington estate. [LC-USZC4-13005]

254 Ollie Harrington, *Dark Laughter* (1962). © Harrington estate. [LC-USZC4-13006]

255 Ollie Harrington, *Dark Laughter* (1963). © Harrington estate. [LC-DIG-ppmsca-05518; LC-USZC4-4871]

256 Ollie Harrington, *Dark Laughter* (1961). © Harrington estate. [LC-DIG-ppmsca-03492]

257 Ollie Harrington, "Lady Liberty Leading Contra Rebels," from *Eulenspiegel* (1986). © Harrington estate. [LC-USZC4-13075]

259 Paul Szep, "Vietnam" (c. 1967). © Boston Globe. Swann Collection, LOC. [LC-DIG-ppmsc-05883]

260 Pat Oliphant, "They won't get *us* to the conference table . . . will they?" (1965). © Denver Post / Los Angeles Times Syndicate. [LC-USZC4-13036]

261 John Fischetti, "I'm *never* too busy to devote some time to kids" (July 24, 1967). © Publishers-Hall Syndicate. [LC-DIG-ppmsca-03643]

263 Tony Auth, "I Should Not Have Gone Into Vietnam" (1973). © Chicago Tribune / New York News Syndicate. [LC-USZC4-13037]

266 R. Crumb, *Sleezy Snot Comics* (c. 1975). © R. Crumb. George Sturman Collection, LOC. [LC-DIG-ppmsca-10603]

267 Rory Hayes, *San Francisco Comic Book* no. 1 (1970). © Rory Hayes. Serial Record Division, LOC.

267 R. Crumb and Apex Novelties, *Zap Comix* no. 0, (1967). © R. Crumb / Rip Off Press. Goldstein Collection, LOC. [LC-USZC4-13024]

268 Carl Anderson, "Henry" (c. 1940). © Anderson estate. [LC-DIG-ppmsca-05774]

269 Bill Griffith, *Zippy* (June 7, 1988). © Bill Griffith. [LC-DIG-ppmsca-09117]

272 George Booth, "Oh, good! The bank says I have some money!" (c. 1968). Art Wood Collection, LOC. [LC-DIG-ppmsca-05880]

273 Charles Addams, cover for *The New Yorker* (June 11, 1960). © Condé Nast Publications. [LC-DIG-ppmsca-01587]

274 Nicole Hollander, *The Clone Fairy* (February 26, 1998) © Los Angeles Times. Gift of Nicole Hollander. [LC-DIG-ppmsca-05094]

276 Nicole Hollander, *Love Cop* (March 26, 1998). © Los Angeles Times. Gift of Nicole Hollander. [LC-DIG-ppmsca-05099]

277 Ann Telnaes, *Six Chix* (November 13, 2003). © Ann Telnaes. Gift of Ann Telnaes. [LC-DIG-ppmsca-04790]

278 Alison Bechdel, "Dearth in the Balance" from *Dykes to Watch Out For* (December 20, 2000). © Alison Bechdel. Gift of Alison Bechdel. [LC-DIG-ppmsca-04897]

279 Ann Telnaes, "Afghan Radicals" (October 10, 1996). © Ann Telnaes. Gift of Ann Telnaes. [LC-DIG-ppmsca-04674]

281 Jeff MacNelly, "I suppose it would be pointless to ask for an estimate . . ." (August 11, 1994). © MacNelly estate / Tribune Media Service. Gift of Susie MacNelly.

282 Jeff MacNelly, "Wishbone of Contention" (March 5, 1991). © MacNelly estate / Tribune Media Service. Gift of Susie MacNelly.

283 Jeff MacNelly, *Shoe* (February 21, 1990). © MacNelly estate / Tribune Media Service. Gift of Susie MacNelly.

283 Jeff MacNelly, *Shoe* (January 17, 1991). © MacNelly estate / Tribune Media Service. Gift of Susie MacNelly.

286 Lynn Johnston, *For Better or For Worse* (April 21, 1985). © Lynn Johnston Productions. Art Wood Collection, LOC. [LC-USZC4-12997]

287 Lynn Johnston, *For Better or For Worse* (December 4, 1988). © Lynn Johnston Productions. Art Wood Collection, LOC. [LC-DIG-ppmsca-10605]

288 Lynn Johnston, *For Better or For Worse* (January 2, 1985). © Lynn Johnston Productions. Art Wood Collection, LOC. [LC-USZC4-12982]

289 Lynn Johnston, *For Better or For Worse* (January 16, 1987). © Lynn Johnston Productions. Art Wood Collection, LOC. [LC-USZC4-13001]

291 Kevin Kallaugher, "Colonel Qaddafi of Libya," from *The Economist* (1982). © The Economist. Art Wood Collection, LOC. [LC-DIG-ppmsca-07183]

292 Kevin Kallaugher, "Attorney General Ashcroft" (2001). © Baltimore Sun. Gift of Kevin Kallaugher. [LC-DIG-ppmsca-01954]

293 Kevin Kallaugher, "CIA Director William Casey," from *The Economist* (1986). © The Economist. Art Wood Collection, LOC. [LC-DIG-ppmsca-07884]

295 Paul Conrad, "Reagans" (May 1, 1990). © Paul Conrad / Los Angeles Times. Gift of Paul Conrad. [LC-USZC4-13017]

296 Paul Conrad, "Reflections" (2001). © Tribune Media Service. Gift of Paul Conrad. [LC-DIG-ppmsca-10606]

297 Herb Block, "Tick-Tock Tick-Tock" (January 11, 1949). © 1949 The Herb Block Foundation. [LC-DIG-ppmsc-03384]

298 Herb Block, "Cardboard Reagan" (March 5, 1987). © 1987 The Herb Block Foundation. [LC-DIG-ppmsc-03284]

299 Herb Block, "Balance" (February 4, 1998). © 1998 The Herb Block Foundation. [LC-DIG-ppmsc-03502]

301 Kieron Dwyer and Mark Chiarello, *9-11* vol. 2 (2002). ™ & © DC Comics. Gift of Kieron Dwyer and Mark Chiarello. [LC-DIG-ppbd-00100]

302 Peter Kuper, "Missing," cover for *World War III Illustrated* no. 32. © Peter Kuper. Gift of Peter Kuper. [LC-DIG-ppmsca-01865]

303 Will Eisner and Alternative Comics, "Reality 9/11," from *9-11 Emergency Relief* (2002). © Will Eisner estate. Gift of Will Eisner. [LC-DIG-ppmsca-02030]

304 Garry Trudeau, *Doonesbury* (December 23, 2001). Doonesbury © 2001 G. B. Trudeau. Used courtesy of the creator and Universal Press Syndicate. Gift of Garry Trudeau [LC-DIG-ppmsca-02039]

305 Sue Coe, "September 11, 2001," from *World War III Illustrated* no. 32. © Sue Coe, Courtesy Galerie St. Etienne, New York. Gift of Sue Coe. [LC-DIG-ppmsca-01739]

306 Alex Ross and DC Comics, cover for *9-11* vol. 2 (2002). ™ & © DC Comics. Gift of Alex Ross. [LC-DIG-ppmsca-02028]

320 William Gropper, "Mannerheim and Hitler" (c. 1941). [LC-DIG-ppmsca-03645]

323 Patrick McDonnell, *Mutts* (November 15, 2003). © King Features Syndicate, Inc. Gift of Patrick McDonnell and Karen O'Connell.

324 Patrick McDonnell, *Mutts* (November 1, 2000). © King Features Syndicate, Inc. Gift of Patrick McDonnell and Karen O'Connell.

INDEX

Page numbers in *italics* refer to illustrations.

Editor: Charles Kochman
Designer: Laura Lindgren
Production Manager: Jane Searle

Library of Congress Cataloging-in-Publication Data

Cartoon America : comic art in the Library of Congress / edited by Harry Katz.

p cm.

Includes index.

ISBN 10: 0-8109-5490-7

ISBN 13: 978-0-8109-5490-8

1. Caricatures and cartoons–United States. 2. American wit and humor, Pictorial. 3. United States–Caricatures and cartoons. 4. Caricatures and cartoons–Washington (D.C.) 5. Library of Congress–Art collections. I. Katz, Harry L.

NC1427.W18C37 2006

741.5'973–dc22 2006005991

HNA ■■■■■
harry n. abrams, inc.
a subsidiary of La Martinière Groupe
115 West 18th Street
New York, NY 10011
www.hnabooks.com

CASE FRONT (*first row, from left to right*): Arthur Szyk, Al Capp, Fred Ray, Thomas Nast, Peter Arno; (*second row*): Billy DeBeck, Miguel Covarrubias, Garry Trudeau, Thomas Rowlandson, John Childs; (*third row*): Winslow Homer, Walt Kelly, Aaron McGruder, David Levine, George Luks; (*fourth row*): Robert Pryor, Marc Davis, Winsor McCay, José Guadalupe Posada Aguilar, John Held, Jr.; (*fifth row*): Al Frueh, Frederick Opper, Ollie Harrington, Burne Hogarth, and Rose O'Neill

SPINE: Walt Disney Studios (*top*); Lyonel Feininger (*bottom*)

CASE BACK (*first row, from left to right*): Grant Hamilton, Jules Feiffer, Winsor McCay, Miguel Covarrubias, George Herriman; (*second row*): Charles Schulz, Walt Disney Studios, Lyonel Feininger, John Sloan, Johnny Hart; (*third row*): Milt Gross, Maira Kalman and Rick Meyerowitz, Theodore Geisel [Dr. Seuss], Miguel Covarrubias, George McManus; (*fourth row*): Harold Gray, Al Capp, Richard Felton Outcault, William Gropper, Percy Crosby; (*fifth row*): Frank King, Peter Kuper, Bill Griffith, Alex Raymond, and William Steig

FRONT ENDPAPER: Winsor McCay

BACK ENDPAPER: George Herriman

HALF-TITLE PAGE: Frederick Opper

FRONTISPIECE: Grant Hamilton

TITLE PAGE (*from top left, clockwise*): Frank King, Walt Disney Studios, George McManus, Richard Felton Outcault, James Akin, Jules Feiffer, George Herriman, Charles Schulz, Lyonel Feininger, William Gropper

CONTENTS: Frederick Opper